KOWLOON

Unknown Territory

KOWLOON
Unknown Territory

Pictures by Ira Chaplain
Text by Nicole Chabot

BLACKSMITH BOOKS

Kowloon: Unknown Territory

ISBN 978-988-16139-1-2

Published by Blacksmith Books
5th Floor, 24 Hollywood Road, Central, Hong Kong
Tel: (+852) 2877 7899
www.blacksmithbooks.com

Supported by

Hong Kong Arts Development Council fully supports freedom of artistic
expression. The views and opinions expressed in this project do not
represent the stand of the Council.

Contents

Introduction

In Cantonese, Kowloon means 'nine dragons', which indicates that, like so many of Hong Kong's place names, there's more to the place than meets the ear. Legend has it that the name of the peninsula is derived from eight mountain peaks and a ninth – the '*kau*' – said to represent Emperor Bing, the last Chinese emperor of the southern Song dynasty in the 13th century.

Kowloon is relatively small. It covers 47 sq km of Hong Kong's 1,104 sq km. To its south is Hong Kong Island and north, beyond a mountain range including Lion Rock, are the New Territories. Victoria Harbour is to the south, with the Lei Yue Mun strait in the east and Stonecutter's Island in the west.

Small in size, Kowloon is, nonetheless, big in personality. It's home to 2.1 million of Hong Kong's total 7 million population, and consists of five of Hong Kong's 18 districts: Yau Tsim Mong, and, then clockwise, Sham Shui Po, Kowloon City, Wong Tai Sin, and Kwun Tong. Like Kowloon, the names of many of these districts are evocative. As its name hints, Yau Tsim Mong is a combination of three areas: Yau Ma Tei, Tsim Sha Tsui and Mong Kok – respectively meaning 'oil-sesame field' or 'oil and jute ground', 'sharp sandy point' and 'busy corner'. Meanwhile, Sham Shui Po means 'deep water pier' and Wong Tai Sin is 'Great Immortal Wong', a Taoist deity. Last, but not least, Kwun Tong translates as 'mandarin pond'.

To many foreigners, Kowloon is unknown territory. This may be due to language – only about 85,400 of Kowloon's population usually speak English or a non-Chinese dialect. But, it's not just to non-locals that Kowloon is uncharted. The psychological gap between Kowlooners and Hong Kong-islanders is well known. Meanwhile, the five Kowloon districts, while sharing similarities, each have their own flavour, and those who live in one

district may be unfamiliar with the goings-on in the other four.

Kowloon is changing. Since the 1998 relocation of the airport from Kai Tak in eastern Kowloon to Chek Lap Kok, new multi-storey buildings have punctuated the Kowloon skyline as if in exultation – on the part of Hong Kong's land developers – for being allowed to be erected, and the Urban Renewal Authority has a number of projects underway which some say put at risk the cultural heritage of the peninsula.

Of course, change is nothing new to the peninsula. Large-scale development of Kowloon began in the early 20th century, with the construction of the Kowloon-Canton Railway and the Kowloon Wharf, though the brick tomb at Lei Cheng Uk in the district of Sham Shui Po, discovered in 1955, indicates that the peninsula had been settled by the Chinese as far back as the Eastern Han dynasty (AD25-220).

While once there was 'Kowloon' and 'New Kowloon' demarcated by Boundary Street, the division is now largely obsolete. Instead, the terms Kowloon East and Kowloon West are commonly used when referring to the peninsula. These are two of the five geographical constituencies for the Legislative Council of Hong Kong. The others are Hong Kong Island, New Territories East and New Territories West. Kowloon East includes Wong Tai Sin and Kwun Tong, while Kowloon West covers Yau Tsim Mong, Sham Shui Po and Kowloon City.

This book is a socio-cultural perspective on Kowloon. It looks at facets of the five districts of the peninsula from the viewpoints of community, consumerism, art, food, and fashion and sex; and is designed to provoke the reader to think about the environment of Kowloon – and, by extension – Hong Kong, in new ways.

Those wishing to shine a light on Hong Kong's 'dark side' and dispel some of the myths about Kowloon can use this book to do so, and once read, continue with their own explorations.

I know I will.

Nicole Chabot
October, 2012
Hong Kong.

1: COMMUNITY

Yau Tsim Mong

Multicultural kaleidoscope

Despite a dated reputation for vice, peace is common among Chungking Mansions' diverse types and ethnic groups

Its five connected blocks were once described as a 'gigantic decaying tooth', but this is no longer an apt description for the newly renovated and neon lit Chungking Mansions on Nathan Road. However, despite its new lease of life, the 50,000 sq ft, 17-storey building of cheap guesthouses, restaurants and retail and wholesale businesses is still distinguishable from other nearby buildings such as the 31-storey iSQUARE and six-storey K11 malls. The uniqueness of the building has long grabbed it attention, one example being that it served as one of the locations in Wong Kar-wai's film *Chungking Express* (1994). Thankfully, its face lift hasn't changed its inner workings or sense of community.

'The biggest nightmare would be for Chungking Mansions to become yet another third-rate Hong Kong mall,' says Gordon Mathews, professor at the department of Anthropology at the Chinese University of Hong Kong, whose extensive research of the building culminated in *Ghetto at the centre of the world, Chungking Mansions, Hong Kong,* adding that Chungking Mansions was built in 1961 which makes it a historic building by Hong Kong standards, predating neighbours iSQUARE and K11 which opened in December 2009 by almost 50 years. Chungking Mansions 'was luxurious by Hong Kong Chinese standards because it was 17-storeys tall at a time when there were few skyscrapers in Hong Kong. Some sources say that Chinese celebrities lived there,' he says.

Whatever the truth, it wasn't long before the mansions deteriorated due to myriad ownership. In

the 1970s and 1980s, the Mansions became a centre for south Asian merchants who opened restaurants and other businesses catering to Western and south Asian clientele. Its reputation as a 'heart of darkness' in Kowloon gathered pace in 1988, when a fire killed a Danish tourist, and then in 1993, when the Mansions lost power for 10 days. Africans began coming in the 1990s and by the early 2000s they made up over half of the people staying at the mansions. Then, in 1995, Sushila Pandey, a 37-year-old Indian tourist was killed in the building by her Sri Lankan partner, and the same year about 1,750 people were questioned in a police swoop, and 45 men and seven women from various Asian and African countries were arrested. In 2006, 52 men and seven women from 14 countries were arrested for violating immigration regulations.

Despite the above, Dennis Cheung Ka-yuen, management trainee of the Incorporated Owners' Corporation of Chungking Mansions and resident in the building since the age of two, says that it is a safe place. 'Our present chairlady, Lam Wai-lung, supervised the building of a new transformer room, so that the electricity capacity increased which solved the problem of fires and blackouts. As of 1999, the building [introduced] a CCTV system to reduce crime. Today, 310 CCTV cameras are monitored by the management office; they cover 60 per cent of the public areas of the building,' he says, though he admits that things were not always this way. 'Chungking Mansions used to be notorious. In those days, the Management Ordinance was not that structured and the owner's corporation was not in operation. There were all sorts of illegal activities.' Cheung adds that the reputation of the building was at its worst in the late 1980s, at which time 'the building had nicknames such as fire building, dark spot, unruly, and so on.'

According to Mathews, there are four major groups at Chungking Mansions: traders, owners or managers and their employees, asylum seekers, and sex workers; transient groups of tourists and business travellers – the latter which include some of the traders – and local Hong Kong Chinese and expatriates who go to eat at the many restaurants of the building.

Mathews says that the pursuit of profit makes ethnic and religious discord no more than an unwelcome distraction. He says, 'The degree of friendliness is something you don't typically find elsewhere in Hong Kong. So too is class tension muted. Each person wants to rise up the ladder – the system is not questioned, only one's place in the system compared to others. The poor are

unlikely to become rich.' According to Mathews, the poor and rich buy into the basic assumptions of capitalism and, in this sense, Chungking Mansions is no different from anywhere else in Hong Kong or China or throughout most of the capitalist world. He says it differs only in being more visible, unlike exploitation by faceless corporations.

'As the people here have to make a living through business, they put away all their national hatred and work together,' says Cheung.

Of the groups that he names, Mathews says the traders are the majority. 'During the trade fairs of Hong Kong and Guangzhou, they occupy almost every bed in the building. Traders are from sub-Saharan Africa but also Bhutan, Yemen, the Maldives, France, Israel, and Jamaica who buy goods to sell in their own countries,' he says, adding that some carry goods of up to 40 kg in their luggage, while others pay for air freight or share containers. An array of low-end goods can be bought wholesale in the mansions at different quality and price levels.

The taping of boxes and zipping of bags is part of the soundtrack of the building, as is the sound of ringing phones. '"China made" is the locution for a fake phone. No one ever mentions the word "fake",' says Mathews. But, what at first glance appears to be a name-brand phone, turns out to be an almost identical design perched on a stand bearing the brand's logo. 'There are new European and Japanese phones. There are 14-day phones, which are warehoused European models – last year's model with a 14-day guarantee. There are used phones, there are refab phones which have been redone by factories in China, often not as good because their motherboards have been replaced. There are A-grade fakes, B-grade fakes and C-grade fakes.'

Many of the traders stay in Hong Kong for just a few days before or after their visits to factories in south China. 'African traders are often from wealthy families that provide them with the capital to fly to Hong Kong and make an initial investment in goods for resale at home. Only they have sufficient capital to finance such a step,' says Mathews.

Sixty to 70 per cent of owners are Chinese, many of who emigrated from the Mainland decades ago and bought property in the one place in Hong Kong that they could afford. 'Some of these owners still live and work in the mansions, but many have withdrawn from daily life there and just return once a month to pick up the rent from the managers they have appointed,' says Mathews.

The Incorporated Owners of Chungking Mansions (the 'OC') was set up on 28th January 1972, and is currently in its 15th session making it one of the oldest owners' corporations in Hong Kong. 'The reason for setting up the corporation was to resolve disputes among the owners, and to make general decisions for the benefit of the whole building on subjects such as renovations, security and cleaning. All owners become general members of the OC when they own a unit, and are obliged to pay management fees, according to the Building Management Ordinance. Every year there is a general meeting, where all owners can take part and vote,' says Cheung.

To encourage a sense of community and keep the peace, the OC holds events such as a dinner party at the end of the year. About 10 restaurants from Chungking Mansions enter their best dish in a competition which popular local food experts and the OC judge.

According to Mathews, South Asian managers often hire their countrymen to work for them. Sometimes they have residency; more often they have a tourist visa which requires returning home every two months. 'Because the employees, who probably work illegally, are prohibited by immigration rules from staying in Hong Kong more than 180 days per year it is virtually impossible for them to climb the ladder of success. Many come from Kolkata in India and are paid about HK$3,000 a month, but can finance 50 to 80 per cent of their plane tickets to and from home by carrying goods for traders. Without these illegal workers many of the building's businesses could not afford to exist and if prices were raised, many African entrepreneurs could no longer afford to come,' says Mathews. This is just one example of the economic dynamics of the building.

Mathews holds a weekly class for asylum seekers and refugees on the premises of Christian Action, and says there are about 6,000 asylum seekers in Hong Kong, mostly from war-torn countries in South Asia and Africa such as Sri Lanka, Nepal, Pakistan, Bangladesh, Somalia, Uganda, the Democratic Republic of Congo, and Eritrea.

'The term "asylum seeker" refers to all people who apply for refugee protection, whether or not they are officially determined to be refugees. According to the United Nations Convention and Protocol relating to the Status of Refugees, a "refugee" is someone who is outside their own country and cannot return due to a well-founded fear of persecution because of their race, religion,

nationality, membership of a particular social group, or political opinion,' says Mathews. Many asylum seekers congregate at Chungking Mansions. Most enter on a tourist visa and then just blend in. They live all over Hong Kong – in places where rent is typically very cheap,' says Mathews.

Hong Kong hasn't signed the 1951 Refugee Convention, so the situation for asylum seekers and refugees in Hong Kong is dire. Most asylum seekers pursue refugee status through the United Nations High Commissioner for Refugees (UNHCR), but this may involve many years of waiting. 'The UNHCR definitions regarding asylum seekers are remarkably narrow. You can't easily draw the line between who is "real" and who is "fake",' says Mathews, adding that there certainly are people who are economic asylum seekers who are looking to make a living, and others who are political asylum seekers. 'But, there are also a lot who are in the middle who are fleeing for entirely legitimate reasons,' he says.

The concern of many countries is that asylum seekers would take away jobs. 'The Hong Kong government is terrified of having plane load after plane load of these people arriving in the country. But they could do a great job as native-speaking English teachers in schools, and be cultural ambassadors in that way,' says Mathews. Asylum seekers in Hong Kong are not allowed to take up legal employment, but are given so little money by the Hong Kong government that they almost have to work. At Chungking Mansions, they play a central role because they can be paid HK$3,000, while legal workers have to be paid $5,000 to $7,000, says Mathews.

Particularly vulnerable are women, their children, and unaccompanied minors seeking asylum. Some of the women, mostly Chinese and Indian – but also from Nepal, Indonesia, Mongolia, Kenya, and elsewhere – have turned to sex work to survive. They ply their trade in and just outside Chungking Mansions, though tourists and business travellers, locals and expatriates will see almost no evidence of this.

The building contains the largest number of guesthouses in one building in Hong Kong, and since it offers some of the cheapest rates in town, Chungking Mansions has become a haunt for backpackers and budget travellers. Some of Hong Kong's business travellers are in Hong Kong to do business in Chungking Mansions, and they may stay there too. Between the guesthouses and residences, approximately 4,000 people stay in the building on any given night and about 10,000 people pass through it each day from over 100

countries, attracted by the inexpensive goods, food, and guesthouses, and its location close to the Tsim Sha Tsui and the East Tsim Sha Tsui stations of the MTR; airport buses also run past the building.

'There are five blocks A, B, C, D and E, though in reality there are really just three as B and C and then, D and E are connected. There are two lifts in each block, one of which serves even-numbered floors, the other odd-numbered floors,' says Mathews.

'A block is mostly guesthouses as it faces the street. Half of all of the 90 or so guesthouses are in block A. Guesthouses are segmented into those that are distinctly for tourists as they accept payment by credit card (although many tourist hotels don't) and those that evidently cater to business people, which have measuring scales at their entrances,' he says. A list of guesthouses by block is posted on the Chungking Mansions Owner's Corporation website.

Mathews continues, 'If tourists come in that's what many guesthouses prefer because you can charge them and make them pay by credit card. Business travellers are coming from developing countries and typically don't have much money to spend. They might pay about HK$120 to $140 a night.' He adds that some, like the Chungking House Hotel established in A block in 1962, are

pricier. Rooms there start at HK$200 in low season. April, September and October are busy because of trade shows in the territory.

'There are guesthouses that deal in a particular clientele such as the Dragon Inn in block B which deals with tourists from Japan and Korea, and from the Mainland,' says Mathews. According to him, due to the Internet and other media advertising, the number of Mainland Chinese tourists has risen dramatically, and 'there has been an upsurge in Europeans and Australians due to the decline of the US dollar to which the Hong Kong dollar is pegged.'

Blocks BC and DE are more residential, while the ground and first floor and the upper floors in the towers are the domains of restaurateurs. Touts attempt to reel in customers to the small, sometimes family-run restaurants serving traditional Indian curry and Nepalese food such as the Taj Mahal Club in Block B, the Delhi Club in Block C, and the Everest Club in Block D. Although some members of Hong Kong's Indian elite deem the food at Chungking Mansions merely 'Indian fast food', some of the restaurants cater to clubs, associations, businesses, and private parties outside the building.

The shopkeepers' rent in the mall varies widely. 'You can go anywhere from HK$8,000 for a really small stall in a corner to $50,000 to $60,000 per

month for a good location. It's still comparatively cheaper than surrounding places, but it's not that cheap.' Many shops in the building are import or export businesses dealing in goods that are predominantly sold to Asian and African countries.

It's easy to get caught up in the atmosphere of the mansions. It's a heady experience with money changers lining both sides as you enter, multicultural faces and rows of shops crammed with mobile phones – according to one estimate, 20 per cent of the mobile phones now in use in sub-Saharan Africa have passed through the building – jewellery, and luggage. The South Asian men touting for customers to visit their shops and eateries and the heady aromas of food from some of these places make up more of the ambience – and this is just the first two floors of the building where visitors can wander around.

'You see scenes you never would find in other places in the world. In one elevator, there might be five people all with different skin colours, talking different languages, having different religions, and dressing differently, but they all belong to Chungking Mansions,' Cheung says, adding that New Year is another case in point. 'There are four New Year periods that people celebrate at Chungking Mansions: the Western, Chinese, Indian and Pakistani New Years. They are at different times of year and are different in form, but we all respect each other, wish each other Happy New Year and celebrate together. For example, some of the South Asians will give out red *lai see* packets during the Chinese New Year. During the Muslim fast, others will not eat in front of them to show their respect,' he says.

These scenes are example of why *Time* magazine voted Chungking Mansions the 'Best Example of Globalisation in Action' in one of its annual 'The Best of Asia' features. According to Mathews, Flushing in Queens, New York, Roppongi in Tokyo, Yuexiu district of Guangzhou, and Willesdon in London are similar, however, the difference between these places and Chungking Mansions is that the former are neighbourhoods, and Chungking mansions is a single building. But, like Flushing for example, the ethnic majority of the host country is a minority at Chungking Mansions, while Cantonese is barely spoken in the building. 'At Chungking Mansions, most ethnic interaction is practical and the spoken language is English. Conversations tend to be civil regardless of whether parties are from antagonistic societies like India and Pakistan. Fights are infrequent,' says Mathews, adding that there are 16 TV channels available to

residents, including those from India, Pakistan and Nepal, the BBC, TV5 Monde, and a number of Hong Kong and Mainland Chinese stations. These have a significant effect on life at the mansions where, he writes, 'each nationality is immersed in life on its own particular screen.'

Mathews says that the mansions continues to exist for a couple of reasons – first, the divided ownership of the building. 'There are some 920 owners but the unified ownership has been remarkably weak and, because of this, property developers have not been able to buy the building and replace it with an expensive structure as has happened to numerous nearby buildings, but a recent change in Hong Kong property laws may result in its replacement,' he says.

He adds that a second reason is Hong Kong's visa regulations. 'Visitors from most developing countries can obtain their visas at the airport in Hong Kong: 14-day visas for most, although there are 30-day or 90-day visas for some. This enables entrepreneurs from most countries in Africa and Asia to enter Hong Kong without bureaucratic difficulty,' he says. 'Even on a 14-day visa, they can come to Chungking Mansions, inspect various goods, obtain a visa for China to visit the factory making such goods, come back to Hong Kong,

and depart with the goods in their luggage or as air freight or by container.' A tightening of visa restrictions could transform or destroy Chungking Mansions, he says.

The third reason for the continued existence of Chungking Mansions is the emergence of China as a world manufacturing centre. 'Jakarta was where traders used to go. Now it is Guangdong. They go to buy goods not found in their own countries, or manufactured there at such expense so as to make imports from many thousands of miles away preferable,' says Mathews.

'The planned renovation of the façade of the building should help make the building appear nicer and the ownership committee is concerned about property values, which is understandable though equally, most managers are not.' According to Mathews, major renovations will make the building more expensive resulting in it losing a lot of its business and becoming less international.

References

Chungking Mansions, 36–44 Nathan Road, Tsim Sha Tsui

Incorporated Owners of Chungking Mansions; Web: www.chungkingmansions.com.hk

Gordon Mathews, *Ghetto at the Centre of the World, Chungking Mansions, Hong Kong,* 2011, The University of Chicago

Wong Tai Sin

Nun's the word

Chi Lin sisters address the public to encourage contemplation in the midst of Kowloon

Disneyfication is a term that is often used to refer to Hong Kong's redevelopment plans. Is it also impacting spirituality? Two places where this is in question are the Buddhist Chi Lin Nunnery and Nan Lian Garden, the latter which is co-managed by the Chi Lin nuns and the Leisure and Cultural Services Department (LCSD) of the Hong Kong government. Together, the sites form a 350,000 sq ft complex in Diamond Hill, Wong Tai Sin district, which includes a nunnery, temple halls, visitors' hostels, a tea pavilion, Chinese gardens and a vegetarian restaurant.

Though the present-day buildings date from 1990, the nunnery was founded in 1934. Today,

the order consists of about 20 nuns. The process of joining the order is lengthy. 'You must be over 20 years old before you can be ordained, and you must be healthy and able bodied – and even then you may not be accepted,' says an insider, adding that you must have the consent of your parents and husband if you are married, before you get divorced – before you can shave your head.

'This dates from the Indian tradition as traditionally, in Asian societies, offspring must look after their parents and their spouse,' says the insider. Once joined, the community of nuns is like a family. Every day, they gather for morning and evening services at 5 to 6 a.m. and 4 to 5 p.m., and breakfast and lunch are taken together. Duties are divided by ability. The main focus of the nuns is serving the aged – the nuns have run an elderly home since the 1960s, and today, about 600 elderly men and women live in this home within the Chi Lin Nunnery compound.

The community premises are steeped in tradition. A planned renovation became a total overhaul of the compound. Based on Tang dynasty (618–907) style architecture, traditional Chinese woodwork techniques were employed. No iron nails were used in the construction. The end of one member, the tenon, is inserted into a hole cut into another, the mortise. The joint may be glued, pinned, or wedged to lock it in place, and the wood is able to expand and contract according to the humidity. The mortise and tenon system has been used for thousands of years by woodworkers, stonemasons and blacksmiths around the world, but the buildings of the Chi Lin Nunnery are the only ones in Hong Kong that are built using the system.

The nunnery is also informed by *feng shui*. 'From a *feng shui* point of view, it's good having the temple hill as its support back mountain and the beautiful Nan Lian Garden as its far Bright Hall. The nunnery also faces the southwest which is a very prosperous position, maintaining its prosperity for at least 60 years after its renovation,' says Albert Cheung, a local *feng shui* master.

In keeping with this tradition, the nunnery's northernmost building is raised slightly higher than the others, and is considered to be the most important, while the buildings to the east and west balance each other. The roofs are covered with grey tiles and bear decorative carvings, while the main temple hall has what looks like two golden-hued whale tails atop it, to represent the element of water, and to protect the building from fire. Wind bells, long a feature of Indian pagodas, hang from the

corners of the roofs; their purpose to scare away evil spirits and birds.

Within the complex of 16 timber halls there are two halls of 'celestial kings'. The kings are demonic-looking creatures, also known as 'world protectors'. According to legend, they live on Mountain Meru, a sacred mountain in Buddhist cosmology that is considered to be the centre of the physical, metaphysical and spiritual universes, and are the guardians of Buddhist teaching and the four quarters of the world; they fight against evil and protect places where goodness is taught. They have been venerated in their present form since the Tang dynasty. There is also the Hall of Avolokitesvara, also known as Kwan Yin, the goddess of compassion, and the Hall of Bhaisajyaguru, the Buddha of healing and medicine. The figurative statues, many of which were made in Japan, are fashioned from bronze, coated with materials such as gold leaf, clay, wood, and stone.

Between the buildings on the north-south axis are courtyards with immaculately kept *bonsai* plants, and ponds with Indian lilies. Though popularly regarded to be Japanese, the Chinese claim they invented the art. Its equivalent names are *penzai* or *penjing* and there are held to be three categories: tree; landscape; and water and land.

Meanwhile, the lilies bear a strong resemblance to lotus plants, but have been planted instead because their blossoms last longer, says the insider. When visitors to the nunnery are scarce, workmen and volunteers can be seen removing snails from the lilies in the ponds, preening foliage, and treating the wooden columns of the halls. The nunnery closes at 4 p.m. for the nuns to say their prayers. A rare exception is Chinese New Year.

To the south of the nunnery is the Nan Lian Garden, which is also designed to engender contemplation. Visitors enter under a highway where squatter houses once were – noise barriers have been put up to shield the garden. Meanwhile, the peaks of Kowloon form a more natural backdrop. The 38,000 sq ft garden was jointly developed by the LCSD and the Chi Lin Nunnery, and the latter was entrusted in 2003 with the planning, design and construction of the garden. 'The cost of the park is an estimated HK$245 million,' says an LCSD spokesman.

LCSD parks have received criticism for their abundance of regulations. Listed on a board at the entrance of the properties, as well as more conventional 'don'ts' such as riding a bicycle, the Pleasure Grounds Regulation also includes antique rules carried over from British law, for instance, "A

person shall not bring or cause to be brought into a pleasure ground any cattle, equines, sheep, goats, pigs or poultry or any beast of draught or burden."

Though the LCSD does not manage the Nan Lian Garden, if anything, there are even more regulations there. For example, there is to be no eating or drinking, except of water, in the garden, since scraps of food or drips from drinks attract ants, flies, and cockroaches. There is a prohibition on tripods for photography and on sketching; and there's to be no filming or live interviews, because obstructions will negatively affect other visitors' enjoyment of the garden – and no group photos for the same reason.

At the Nan Lian Garden, you can't walk a metre without being instructed on what next to do or not to do. The results are often comical. 'No climbing' says one sign on an ever-so-gently-rising mound of grass; 'Forward' reads another pointing to the right and where walking forward would be, in any case, impossible. 'Sitting area' marks what is obviously so.

Even the koi fish, symbols of love and friendship, are 'well trained' according to garden literature. For those considering not taking heed, surveillance cameras are ready to capture misdemeanours. Does the abundance of regulations encourage the mindfulness and discipline needed for meditation and vegetarianism? A balance needs to be found between freedom and control.

The design of the garden is based on the Jiangshouju Garden in Shanxi province. According to Nan Lian Garden literature, the four major elements of such Tang gardens are artificial hillocks and ornamental rocks, water features, timber structures and old trees. The garden includes species of Buddhist pine, Japanese black pine, cypress, and common crapemyrtle trees. The structures in the garden include pavilions, terraces, towers, verandas, halls, a thatch-roofed cottage, and a watermill.

Feng shui master Cheung explains that 'more than 80 per cent of *feng shui* energy comes from nature: the external landscape, the compass bearing, the trigram, the interaction between the *yin* and *yang*, the sun and the moon, heaven and earth. The art of *feng shui* is about how to live in harmony with nature.'

The golden Perfection Pavilion on the Lotus Pond Middle Island and the brightly coloured Zi and Wu bridges at the northern and southern shores of the pond are the apex of the garden. Typically, visitors take one to three hours to travel a circular route with its 'borrowing scenes', 'concealing scenes', 'sheltering scenes', and 'penetrating scenes'

along the way. The rules, signage and colours raise a suspicion that spirituality has become Disneyfied here.

That Hong Kong's parks are over-designed has been another criticism levied at them, while another is that they include too many facilities. The garden includes a restaurant, a souvenir shop, a facilities room and the Pine Teahouse or *Song Cha Xie*, where tea from Mount Wuyi is served. The mountain in northwestern Fujian has a long history of producing tea.

During the Song dynasty (960–1279), the compressed tea from Mount Wuyi was so sought after that it was worth more than its weight in gold, but the arrival of the Ming dynasty (1368–1644 AD) saw the craftsmen of Wuyi alter their production from compressed to loose-leaf tea in an attempt to copy the successful tea producers of Anhui province.

Another facility in the garden, and another vehicle for the nuns' message, is the Chi Lin restaurant, one of Hong Kong's most famous Buddhist vegetarian restaurants.

'Although Buddhists are mindful about what and how they eat, adherents follow various levels of strictness,' says Gordon Li, deputy chief executive at the Yuen Yuen Institute, adding that there are three Buddhist communities in Hong Kong. He says that first are the monks and nuns who are totally vegetarian according to religious dictates, though fine dining does play a part when entertaining important guests. 'The main difference between "high end" and "low end" food are the ingredients used, such as truffles, which are far more expensive than other mushrooms.'

The second Buddhist community, says Li, is made up of devoted lay believers. Some in this group are totally vegetarian, and eat simple fare comparable to that eaten by the monks, but some enjoy better food such as that sold by vegetarian restaurants.

He says the third group is comprised of lay believers, who are not totally vegetarian. They practise vegetarianism on certain occasions such as the first and fifteenth of the lunar month, and on the birthday of Buddha on the eighth day of the fourth moon in the Chinese calendar – usually sometime in May – and the day before going to the temple.

Today, an increasing number of people around the world are eating less meat or opting for vegetarianism of varying degrees. There are various reasons behind the trend, such as weight control and the idea that vegetarian food is healthier. While this may be true of the vegetarian food offerings of certain cultures, the healthiness of much Buddhist

vegetarian food in Hong Kong is a misconception, says Howard Ling, director of Vegetarian Business and founder of BIJAS, Harvester and Happy Veggies. 'Organic produce is not mandatory, and while ingredients may be healthy, deep frying is common and the use of large amounts of peanut and vegetable oil negates the health benefits.'

Offerings at no frills eateries are categorised into 'old style' vegetarian dishes and 'new style', otherwise known as 'new technology', with further menu categories typically being vegetables, mushrooms and fungus, pan-fried and deep-fried dishes, sweet soups and desserts. '"Old style" means the old cooking style which is oily and thick in sauce. "New style" refers to raw food, slow cooking, and less oily dishes,' says Ling.

In 'new technology' vegetarian food, gluten, a wheat protein, is used. The dough is repeatedly washed to remove the starch, and the end result is something which looks and tastes exactly like its non-vegetarian counterpart. Some examples include sweet and sour 'pork', steamed 'chicken', roast 'pork' and *char siu*, meaning barbecued pork with honey, 'duck', and 'abalone'. These are popularly served in one dish as a snack. Smoked duck, steamed chicken, even shark fin and steak are imitated and served in the restaurants.

Restaurants like the Chi Lin Vegetarian Restaurant are not catering to monks and nuns. The meat and seafood-like flavour of the dishes is a way to attract non-vegetarians. It's just business, say some. This commercialisation has been gradual. In fact, vegetarian fare and food in Hong Kong as a whole has also undergone changes in portion size which may be interpreted as such. For example, the large-size *dim sum* commonly served outside Hong Kong is regarded as inauthentic, but in 1950s and 1960s Hong Kong, portions of *dim sum* were as large. This was mostly because most people were employed in hard labour and needed to eat a lot.

As the level of economic prosperity of Hong Kong and its residents has risen, smaller portions of food, which are regarded as being more elegant, are now served. Also, higher earners deem slimmer figures more desirable which is another reason behind maintaining the current portion-size status quo. Even portion sizes at high brow-Buddhist vegetarian restaurants such as the Chi Lin Vegetarian Restaurant are smaller and the presentation of food is of great importance, to justify the price of a meal. Ironically, given the Buddhist emphasis on mindfulness, staying aware of your responsibilities, appearance above all else can mean that a huge amount of food is wasted. At blue-collar

eateries, portions are larger and food presentation bears more of the hallmarks of that which is served at home. This new technology vegetarian food can also be found in the restaurants located at the larger Buddhist temples like Po Lin Monastery in Lantau Island, says Li.

References

Chi Lin Nunnery/ Nan Lian Garden, 60 Fung Tak Road, Diamond Hill; Tel: 2354 1888/ 3658 9313; Web: www.chilin.org and www.nanlian.org; Open: daily, 9 a.m. to 4.30 p.m., free. Nan Lian Garden is open daily, 7 a.m. to 9 p.m.

Kowloon City

Little Bangkok

Thai gathering place in the shadow of Lion Rock strengthens their sense of community

Given its numerous Thai restaurants and groceries, the 'Little Bangkok' moniker bestowed on Kowloon City is deserved. The district has plenty of Thai eateries, shops, supermarkets, specialty stores; and Thai people from housewives and business people to domestic helpers who live there or visit. When Thais or non-Thais want to buy Thai products or eat Thai food, it's the obvious place to go

Many of the Thai establishments are gathered on and around South Wall Road, one of eight parallel streets topped by Carpenter Road, to the south of the former Kowloon Walled City. The streets are intercepted by Nga Tsin Wai Road and tailed by Prince Edward Road West. Walk past and

there's a distinct atmosphere in the combination of fish sauce, vibrantly hued narcissus, and still smoking satay from a street side grill served on a stick in a brown paper bag, dipped in one of a choice of sauces. Also in the frame are delicate orchid cuttings, bloated plastic bags of curry pastes, piles of limes, bundles of sticks of lemon grass, knobby growths of galangal, and rows of jars and packets of seasonings.

On weekend mornings, Southwall Road is also one of the places that orange-robed Theravada Buddhist monks go to collect alms. Three monks from the Makthumvanaram temple in Tai Wo in the New Territories and their volunteer helpers walk the streets on the weekend mornings collecting rice, noodles, moon cakes, *lai see* and other offerings and chant mantra blessings in return to the Thais who have come to see them. Some of them are shopkeepers from the neighbourhood, while others come from across Hong Kong like Banart, an employee of the MTRC who lives in Mei Foo but goes to Kowloon City on Sundays from 8 a.m. to 11 a.m. to pray, and Usa Sriubol with her Swiss husband Charles Grossreider, manager of catering services at Cathay Pacific, who go to Kowloon City on special religious festivals from their home in Pokfulam.

Meanwhile, the Tak Ku Ling Road Rest Garden is a gathering place for domestic helpers. 'Parks are the lungs of a dynamic, crowded city. They're places where people can breathe, and in the case of Hong Kong, this is no less the case,' says Bert Bulthuis, a Dutch architect on secondment in Hong Kong, and founder of the SITEC Studio for Architecture and Design, adding that public spaces offer opportunities for less formal interactions than do buildings, and that parks are especially necessary in a place where the population is growing.

According to him, another reason why Hong Kong needs its parks is that people typically live in small spaces in Hong Kong. Parks function as a kind of extended living room to meet friends and that in a climate where you can be outside almost every day, public space is an important getaway. 'An important effect of the Thais meeting at the Tak Ku Ling Road Rest Garden on the weekends is the preservation of their cultural identity as a group,' Bulthuis says.

According to the Royal Thai Consulate-General in Hong Kong, there are 14,086 Thai people living in the SAR. Of these, 2,106 have lived here less than seven years and 11,980 have lived here more than seven years. According to the Hong Kong 2011 Population Census, there are 4,371 Thais living in Kowloon, of which 1,263 live in Kowloon City.

The Thais arrived relatively late in Hong Kong, from the 1960s on. But, the Thais of Hong Kong are linked to their Chiu Chow Chinese predecessors. Many Chiuchownese had moved to Thailand, a diaspora that initiated import and export trade relations between Chiu Chow and Thailand, and between Hong Kong and Thailand as well, says Tamasorn Bungon, chairperson of the Thai Association, a small organisation based in Kowloon City that depends on donations from members and some funding from the Thai Consulate. She says that trade relations paved the way for personal relationships, namely the intermarriage of Chiu Chow coolies with Thai women. These coolies in 1970s Hong Kong were not wealthy enough to attract Hong Kong Chinese women. Instead, they took wives from Thailand who were willing to marry whoever was financially viable. Bungon says this is why lots of people in Chiu Chow have family in Thailand and why the dialect is so popular there that you can get by in some Thai settlements by only speaking the Chiu Chow dialect, Teochew. Most of these settlements are in the north and northeast of Thailand, though there are parts of Bangkok where Chiu Chow is spoken as well.

According to Bungon, the wives of the coolies who returned from Thailand to Hong Kong after marrying were probably housewives. But, later some started their own businesses, many of these being Thai restaurants in Kowloon City. The district was an obvious place for these Chiu Chow coolies and their Thai wives to live due to the existing Chiu Chow connection, she says.

Like Chiu Chow, Thailand has a strong food culture and this is reflected in the many Thai eateries of the district that range from the street stall serving hawker food such as barbecued chicken wings or traditional satay, to the sit-down restaurant and stalls at the food court of the Kowloon City Municipal Services Building. With the existing Chiu Chow restaurants, and places serving other foods, the Thai eateries catered to the needs of both aircraft crew and travellers who were staying in or transiting through the nearby Kai Tak International Airport. The restaurant business of Kowloon City was booming pre-1998 when Hong Kong's airport was relocated to Chek Lap Kok by Lantau Island, and, unsurprisingly, many of Kowloon City's restaurateurs were unhappy about the move. In the first year after the airport closure, many restaurants suffered and shut down; while the stock disasters in 2000 and 2003 and SARS in 2003 also affected businesses.

'Kowloon City was a very famous food spot. The airport brought a lot of business. It has taken more than 10 years for the food spot to recover after the airport moved to Chek Lap Kok and it is really great to see Kowloon City reborn again. Hopefully, this little area can still maintain its old-style characteristics and big chain restaurants will stay away and let the small, unique restaurants survive,' says foodie broadcaster Mak Kit-wee, who adds that she has been eating at the Gold Orchid Thai restaurant since she was at college. She says that there is more choice and a greater concentration of Thai food in Kowloon City at a cheaper price than anywhere else in Hong Kong, but that eateries serving other types of cuisines such as hot pot, dessert and cake shops have become popular in Kowloon City in recent years.

Ben Ho Man-fung, a council member of the Hong Kong Federation of Restaurants & Related Trades, an NGO representing restaurant operators across Hong Kong, says that more and more restaurants and shops are opening in Kowloon City because rents are cheap compared to nearby areas. 'A few years ago, you could open a store in Kowloon City with only HK$20,000 to $30,000 a month; but this has now risen to $50,000 to $60,000.

However, this is still far cheaper than other areas,' he says.

As domestic helpers from Thailand began arriving in the 1990s, the Thai community in Hong Kong has grown. According to the Thai Association, the majority of Thais in Hong Kong now are female domestic helpers. The Thai Association and the Thai Regional Alliance in Hong Kong offer optional training, the former for Thais and the latter, a government funded operation, for ethnic minorities in Hong Kong as a whole despite its name, including those from the Philippines, Thailand, Indonesia, Nepal, and Sri Lanka.

'In August 2012, there were 3,248 Thai domestic helpers in the territory,' says Bungon, adding that 90 per cent of these come from Isaan, northeast Thailand, where the weather is very dry and where farmers are particularly vulnerable. Isaan was also where yesteryear's Chiu Chow labourers went to trade, and to find brides.

'The Thai government places the responsibility for training up prospective domestic helpers on employment agencies in Bangkok,' says Bungon, adding that candidates supposedly learn language and housekeeping skills there for up to six months, but usually a great deal less because candidates must travel to the capital to sign with an agency, but

normally return immediately to their home villages to avoid accommodation and food costs. She says another contributing factor is that the Immigration Department of Hong Kong works faster nowadays. In just six weeks from the date of application, a Thai can fly to the territory to begin work in a household. This means that the language, housekeeping, and other courses such as computing, cooking, and facial and massage courses offered in Hong Kong are popular. In addition to providing these classes, the Thai Association and the Thai Regional Alliance also advise the immigrants on their rights, and offer counselling services.

'Thai domestic helpers have little effect on Thailand's economy because the numbers involved are relatively few, unlike the numbers of domestic helpers from the Philippines and Indonesia. The relationship between Thailand and Hong Kong is strong: Thailand is the number-one rice exporter to the territory, and some say that because of this, Thailand and Hong Kong cooperate more in other economic matters as well,' says Bungon.

She adds that the number of Thai domestic helpers varies, due to, for example, greater demand for workers in Thailand, especially during harvesting seasons, and Thai government policies. The 2010 number of 3,200 Thai domestic helpers in Hong Kong compares to 2009's about 4,000, down 20 per cent year on year. Thais are working everywhere in the territory, with Kowloon City and Wan Chai main focal points. While the former district is known for its Thai eateries, the area around Wan Chai Market is comprised mostly of Thai grocery shops rather than places for a sit-down meal.

'Kowloon City is a gathering place among Thai nationals, but few Thai domestic helpers are employed there. In Kowloon, where residents are generally less well off than those on Hong Kong Island, residents prefer to employ Indonesians who are sometimes willing to accept less than the minimum wage and forego their weekly day off,' says Bungon, adding that in places such as Wan Chai district which includes Causeway Bay, Happy Valley, Tai Hang and Wan Chai or the Peak, there are quite a few Thais because foreigners like their cooking. On the outlying Islands, such as Lamma Island and Discovery Bay, Thai domestic helpers are employed to take care of the elderly.

Somchit Chimvimol is a Thai who has been working as a domestic helper for 18 years, including postings in Saudi Arabia and Cyprus. At 66 years of age, she was a late entrant to the work, after being a hairdresser in Thailand. Every Sunday, she goes

from her employers' home in Sai Kung to meet friends working across Hong Kong at the Tak Ku Ling Road Rest Garden in Kowloon City. Her Sai Kung employers are her fourth employer in Hong Kong.

'There is no real consensus among the Thai domestic helpers about working in Hong Kong – some like working here and others don't. Pros include their comparatively high salary of HK$3,750 per month versus what they would earn at home, and the fact that Hong Kong is relatively close to Thailand,' says Bungon.

'I like Hong Kong. There's a chance to make big money here, but a housemaid's job is very tiring,' says Chimvimol. She plans to stay in Hong Kong for another two years and then go back to Thailand, during which time she says she will continue to meet friends at Kowloon City to eat and talk and play cards in the park.

In addition to housewives, restaurateurs and domestic helpers, Thais in Hong Kong include business people and service industry professionals including masseuses and sex workers. Most of the Thai sex workers arrived in Hong Kong in the 1990s at the same time as the domestic helpers, and are concentrated in Wan Chai, though there is also some activity in Sham Shui Po district. Usually, the sex workers are not residents. They arrive on visitor visas that allow them to stay for one month at a time and require them to travel back and forth between Thailand and Hong Kong. But some, if they apply for visas from the Chinese embassy in Thailand, receive three-month visas, which makes their coming and going less noticeable to the authorities. But, irrespective of their profession, the Thais need a gathering place which Kowloon City provides.

Like food, religion also sustains a community. Songkran – the Thai New Year – and Loy Kra Thong on the evening of the full moon of the 12th month in the traditional Thai lunar calendar, usually in November – and the King's and Queen's birthdays on the 5th of December and 12th of August respectively, are special times of year for the Thais in Hong Kong to celebrate and reassert their identity.

Despite the closure of Kai Tak airport and the credit crunch, an increasing number of Thais are setting up businesses in Kowloon City. A popular saying among locals in the area is 'When a shop closes down in Kowloon City, another Thai enters the market'.

References

Tak Ku Ling Road Rest Garden, Tak Ku Ling
Road, Kowloon City

Thai street food, 26 G/F South Wall Road,
Kowloon City

Thai snacks, kebabs, grilled fish, desserts, drinks,
7–8 G/F, No 20 South Wall Road, Kowloon City;
Tel: 2718 0096

2: CONSUMERISM

Kwun Tong

Trading places

Critics say malls are killing street life but, for now, business continues at Shui Wo street market

Drilling, boring, barrel rumbling; a cacophony of the sounds of construction fills the air underlining the changing face of Kwun Tong, yet another district in which Hong Kong property developer Sun Hung Kai (SHKP) is active. Upon completion, its massive Millennium City will be the largest shopping and commercial complex in the territory. The contrast with the traditional Shui Wo street market is a stark one. This gently curving road five minutes from Fu Yan Street on the northwest side of Kwun Tong is lined with small shops and outdoor stalls. It's long been the place where Kwun Tong locals have shopped.

So far, Millennium City consists of six skyscrapers built along the southern side of Kwun Tong Road between Kwun Tong and Ngau Tau Kok MTR stations. When completed, the site of the 'city' will cover an estimated area of over 215,000 sq ft and contain over 3.3 million sq ft of office space. The Bank of East Asia, the third largest bank in Hong Kong, will use 740,000 sq ft of this as a back-up operations centre. The skyscrapers are numbered 1, 2, 3, 5, 6 and 7. Number 4 has been bypassed because being a homophone for death in both Chinese and Japanese it's considered to be unlucky. Millennium 8 is still on the drawing board. SHKP plans to erect them in the Kwun Tong Industrial Area also along Kwun Tong Road towards the Kwun Tong MTR station. The generic appearance of the Millennium City buildings suggests they could just as easily be situated in the heart of Central.

The buildings have no apparent connection with historical Kwun Tong.

With the towering vertical design of the Millennium City buildings, Sun Hung Kai is 'borrowing from the sky' – a Chinese saying which describes multi-storey structures. There are many skyscrapers in Hong Kong – the skyline is what Hong Kong is famous for – though Chinese architecture traditionally places emphasis on the horizontal axis stressing the visual impact of the width of buildings. Western architecture, on the other hand, tends to grow vertically. Some say that Hong Kong has the most skyscrapers in the world, if one counts individually the multiple towers that rise from a common multi-storey podium. This is not surprising. Early skyscrapers emerged in land-restricted areas such as Chicago, New York City, and London, as well as Melbourne, Australia. In Hong Kong where land is scarce, it follows that many districts feature them.

In big-is-best terms, the skyscraper has connotations of worldly achievement and is considered a symbol of economic power. Like other forms of architecture, it plays a role in sculpting the identity of a district or city and the mindset of the people. While skyscrapers may reflect the culture in which they are situated, the Millennium City towers bear no such distinguishing features, either British or Chinese. In a district where one of the main challenges is poverty, they seem to be very much a foreign implant.

The advent of the office block skyscraper signals great change in the urban landscape of Kwun Tong from a specialised industrial hub and is an indicator that the society of that district, its surrounding areas, and Hong Kong at large is heading towards being just another city in China. Kwun Tong has actually had high-rise buildings in the form of housing estates from as early as the 1960s – Hong Kong's earliest public housing, the Shek Kip Mei Estate in Sham Shui Po district, dates from 1953. These structures of typically 30-something floors are located in the north of Kwun Tong, though the most southern of these are just opposite the Millennium City buildings. In a Hong Kong context where the centre of the universe is shifting increasingly towards the Mainland border, Kwun Tong and the Kowloon area at large is becoming increasingly important – although the financial hub of Central overlooking Victoria Harbour still commands the most expensive rents in the territory. Today, Kowloon is less of an industrial backwater, with more office space and a new type of tenant and new recreational facilities to serve them such as the

APM shopping mall. Companies are tempted to rent in Kwun Tong by the much cheaper rates than on Hong Kong Island.

Millennium 1 and 2 share a mall and a lobby at ground floor level. With shiny blue and grey striped glass façades, their style is in keeping with other commercially developed districts, but in stark contrast with the old industrial buildings that surround them. Millennium 3 is separated from them by the 1970s-style Meyer building. Like its sisters, 3 houses mostly offices and shares a similar architectural design. But it's Millennium 5, with the APM mall, that's the most frequented of the Millennium City family.

At 630,000 sq ft, this is easily the largest mall in the district and equal or greater in size to the malls of many world capitals. In Hong Kong, it's one of many including Pacific Place and Times Square on Hong Kong Island and Harbour City, Festival Walk, and Elements in Kowloon. Many of these malls were developed by the Mass Transit Railway Corporation and are located in the immediate vicinity to MTR stations. On entering the mall and looking out of the entrance walkway windows, visitors get a poignant sense of the disparate nature of Kwun Tong. Outwards, the ramshackle character of the district's industrial past is evident: leaking air conditioners on the outsides of matt-surfaced 1970s buildings, handwritten signage, and stalls with corrugated iron roofs. Inwards, APM is a world unto itself; a city of bright, white, shiny perfection. The seven floors of the mall boast restaurants, clothing stores, cosmetic shops, and even a six-screen cineplex.

According to the APM website, 'APM' represents 'a.m.' and 'p.m.' and reflects the late-night shopping concept that the shopping mall initially promoted; an expansion on Hong Kong's 'shop till you drop' and 'city that doesn't sleep' reputation if ever there was one. The intention was that retailers at the mall would remain open until midnight, restaurants would serve food until 2 a.m., and partiers at the various entertainment spots would be able to drink and dance until dawn. Though such plans have failed to come to fruition, the slogans of the mall aimed specifically at the 15 to 35-year-old market include 'play more, sleep less' and 'play more, shop more', which is an anthem being sung across Hong Kong. Special events featuring local Cantopop stars are the perfect drawcard for this audience. With their carefully managed images, they too promote a new concept of 'role model'.

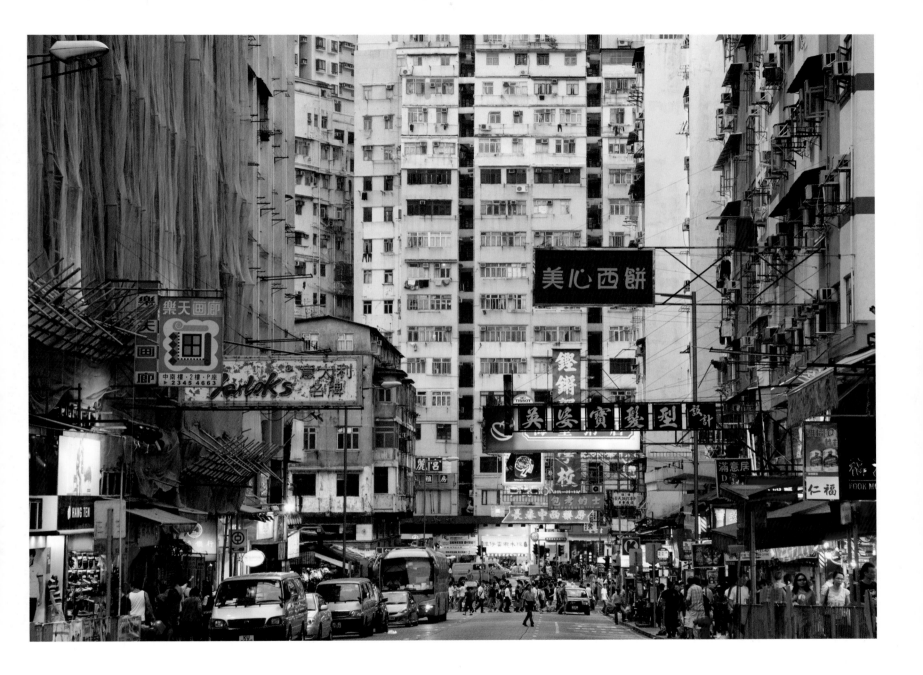

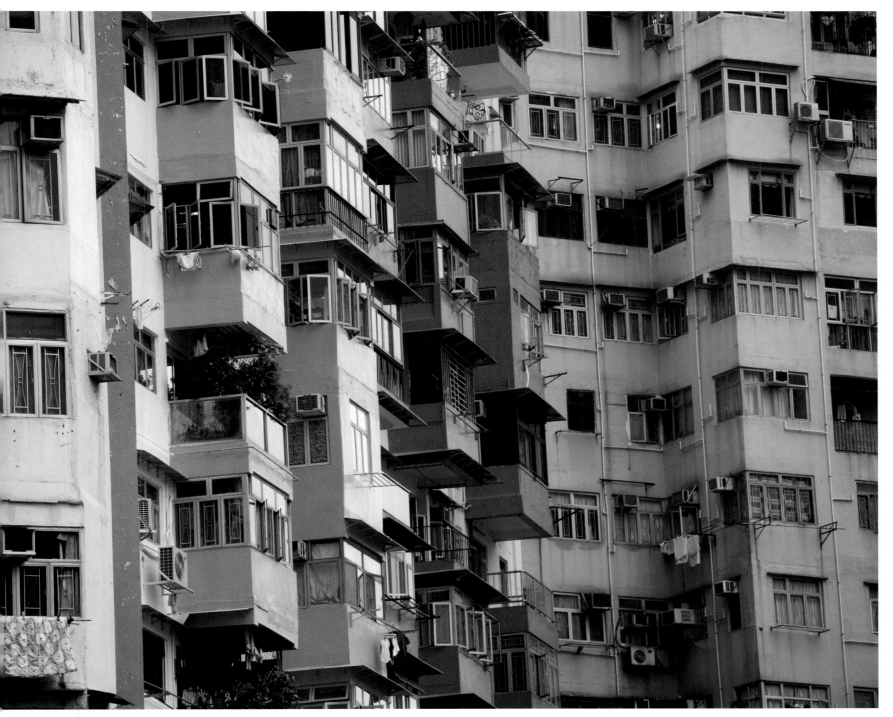

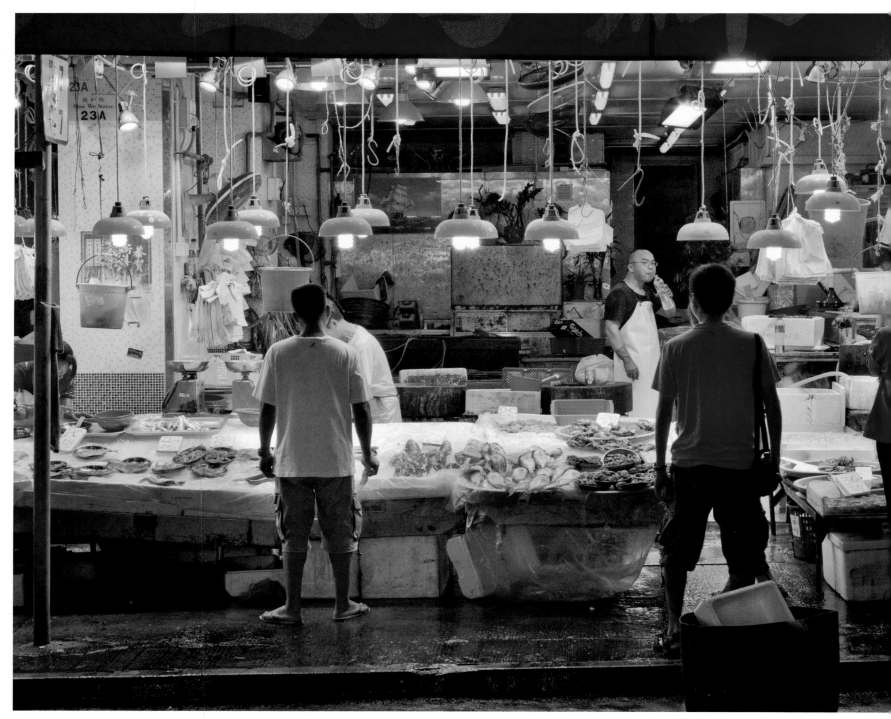

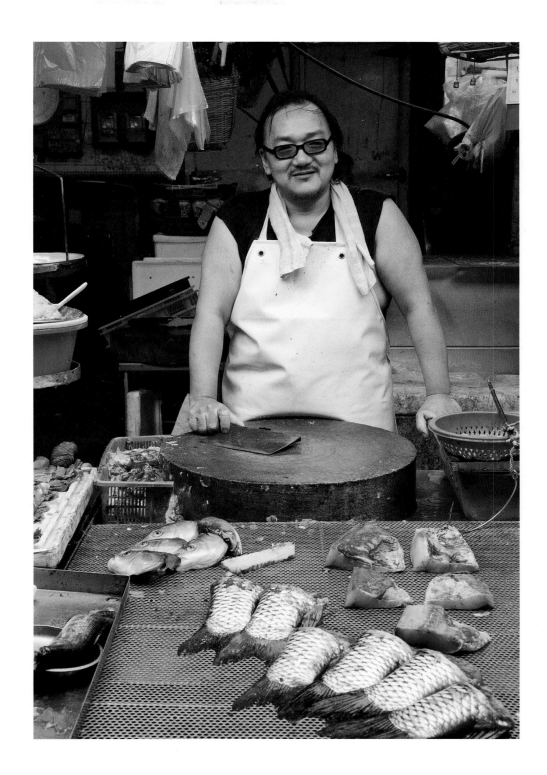

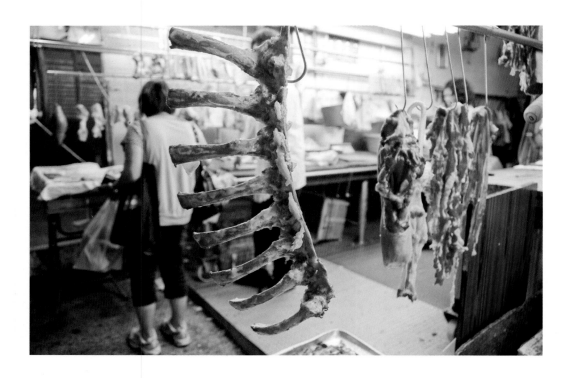

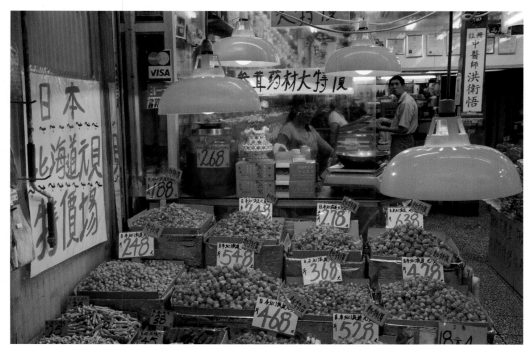

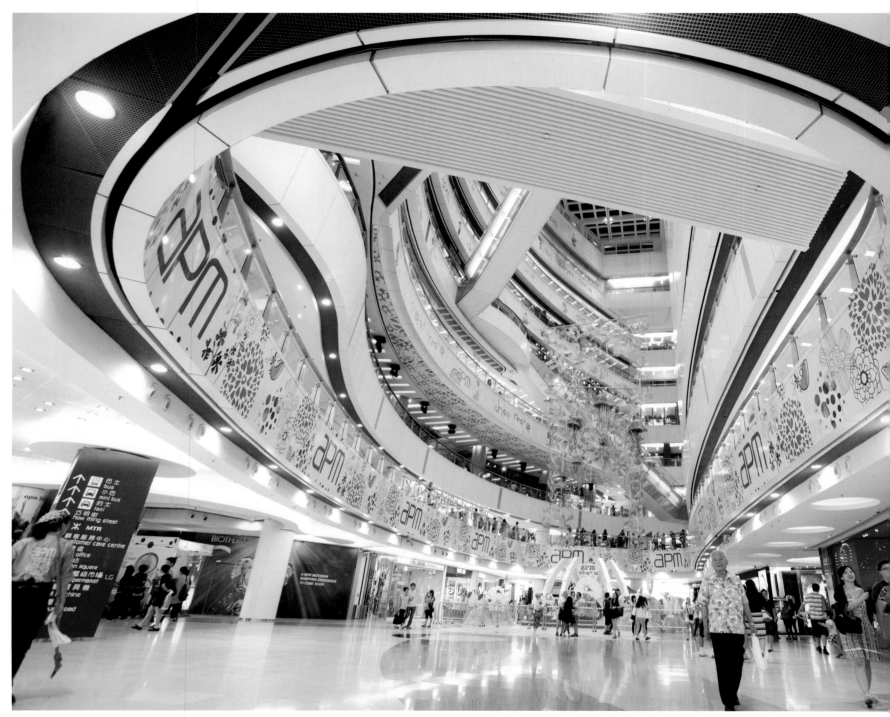

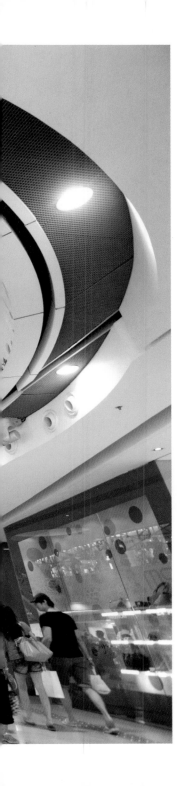

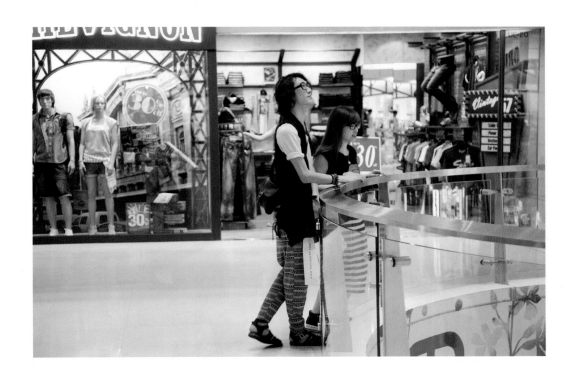

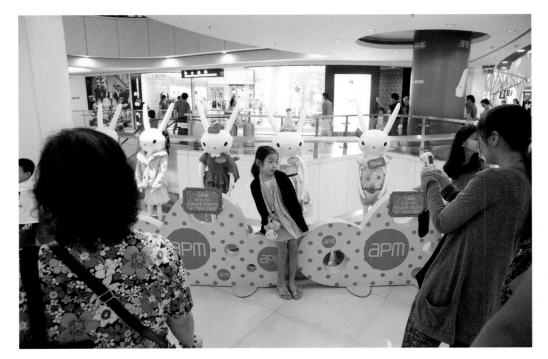

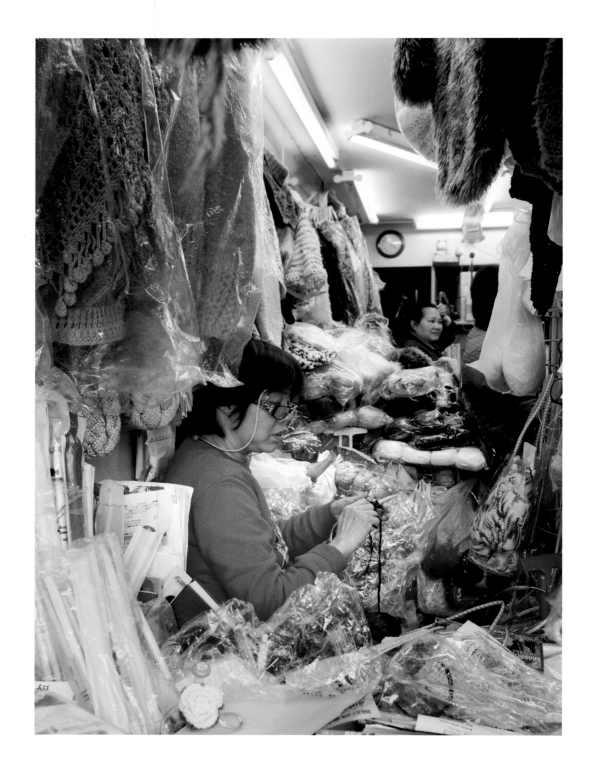

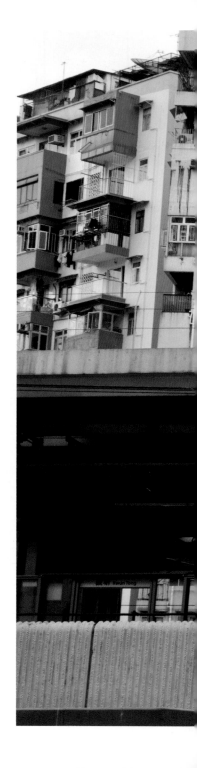

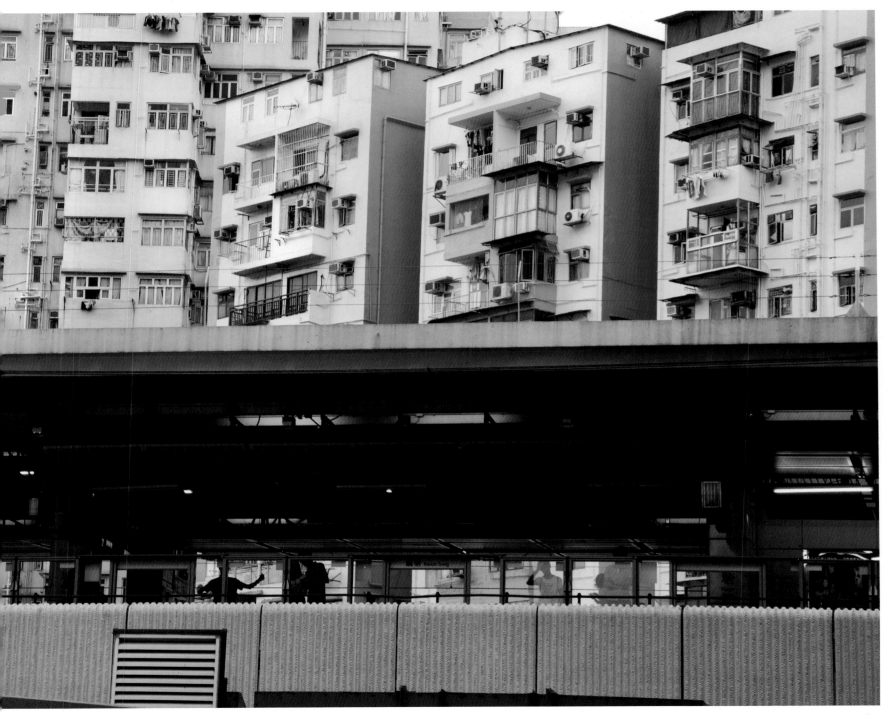

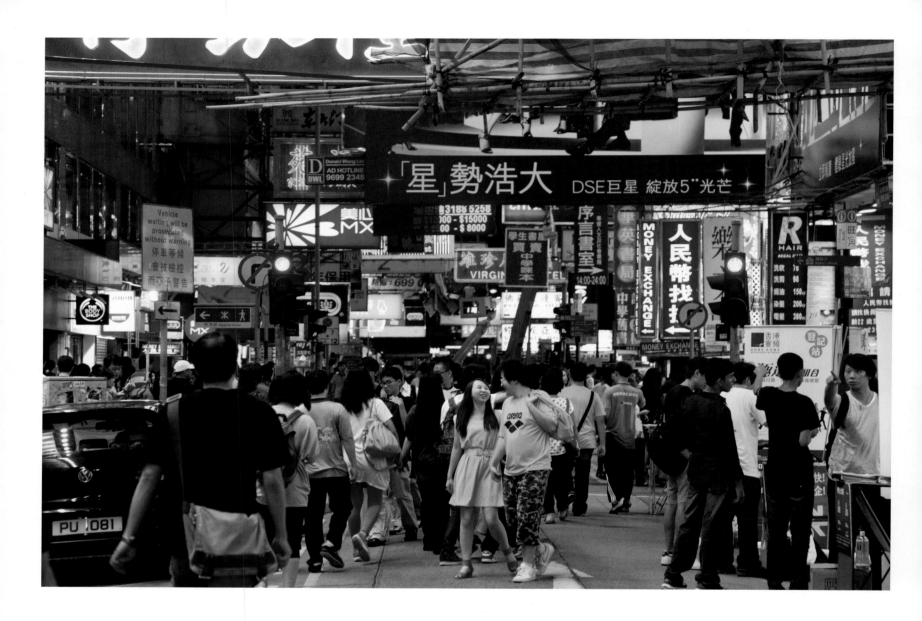

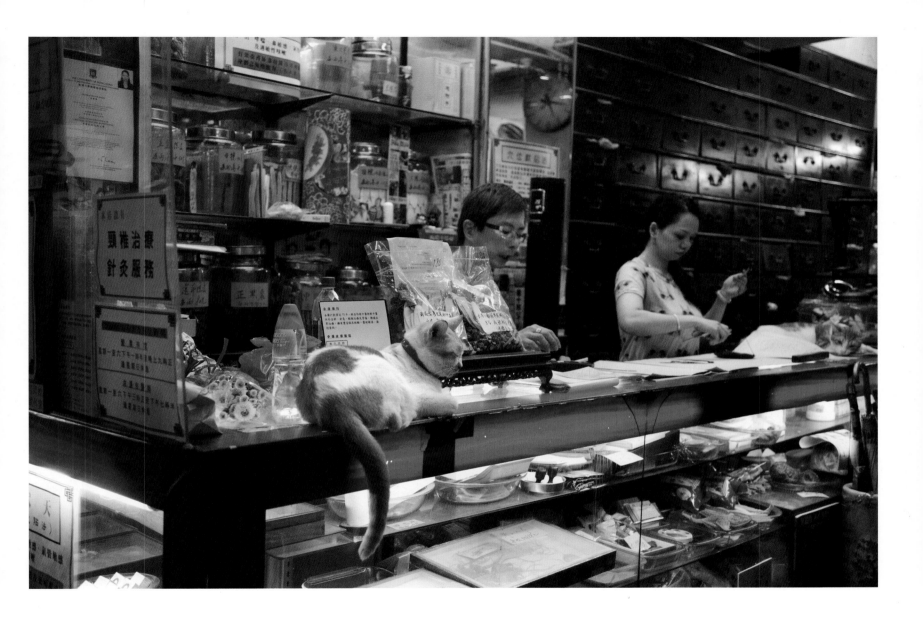

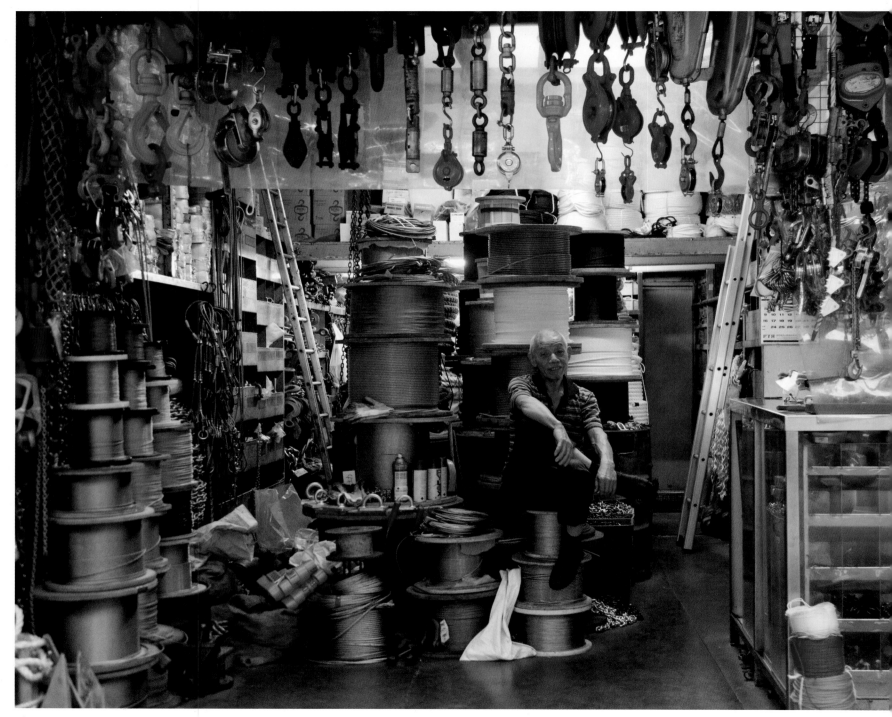

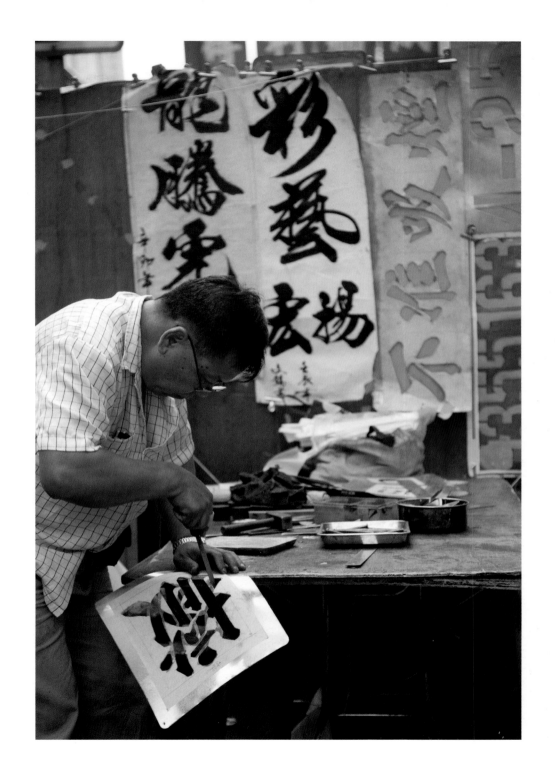

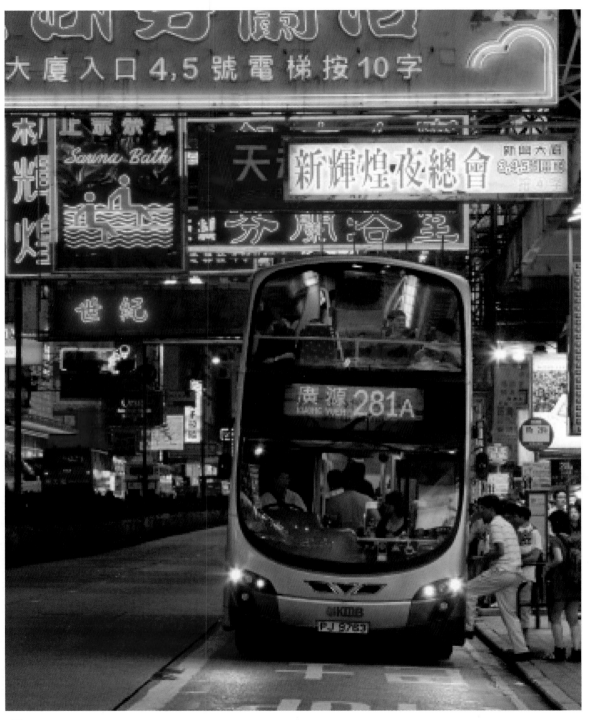

48

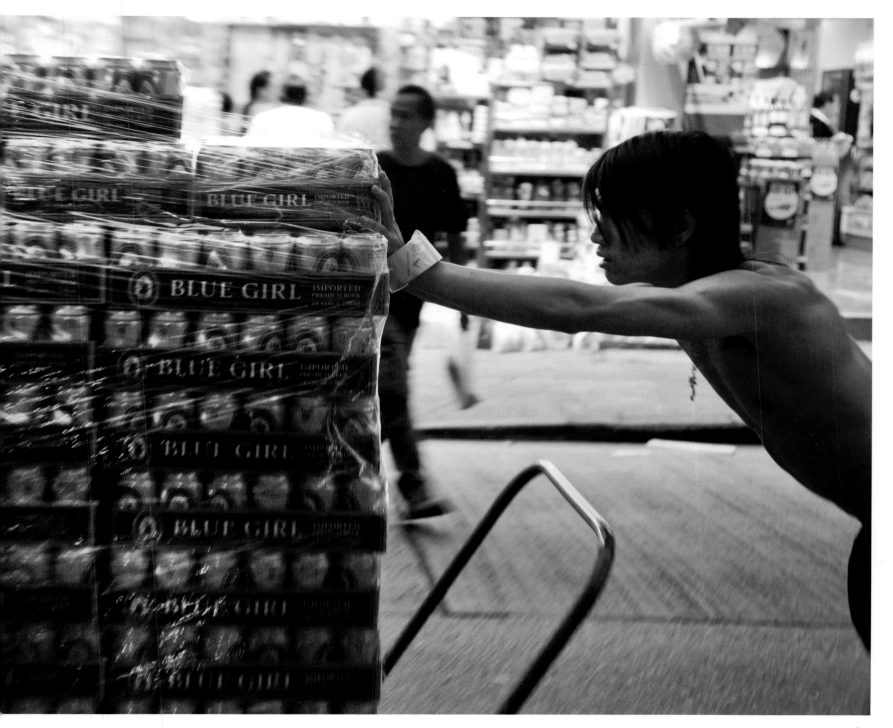

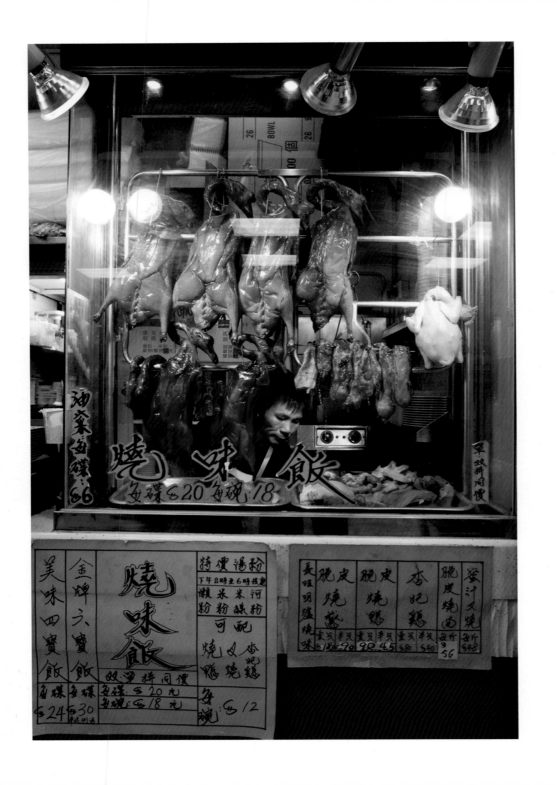

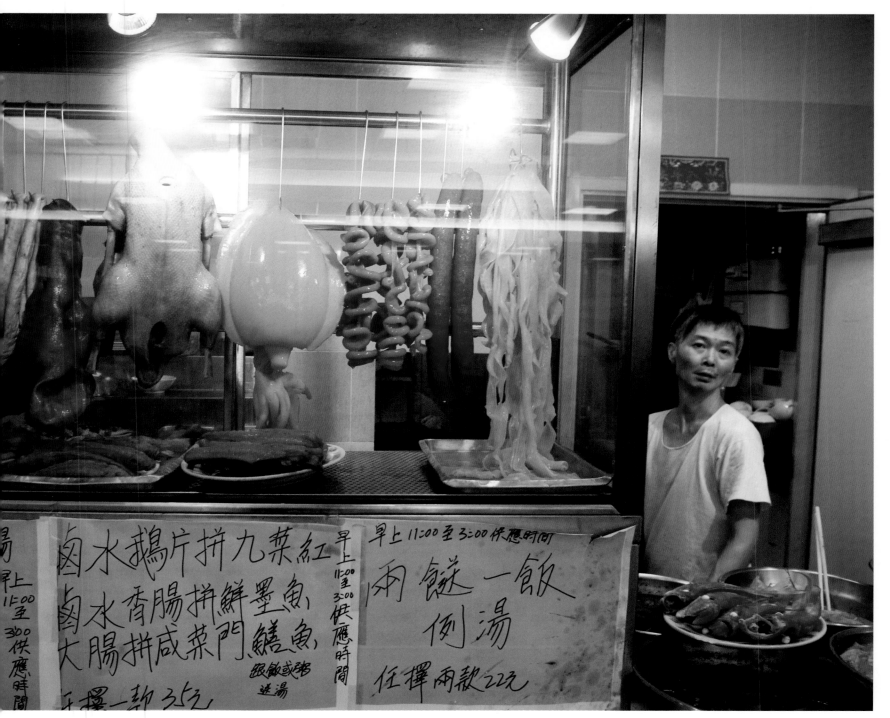

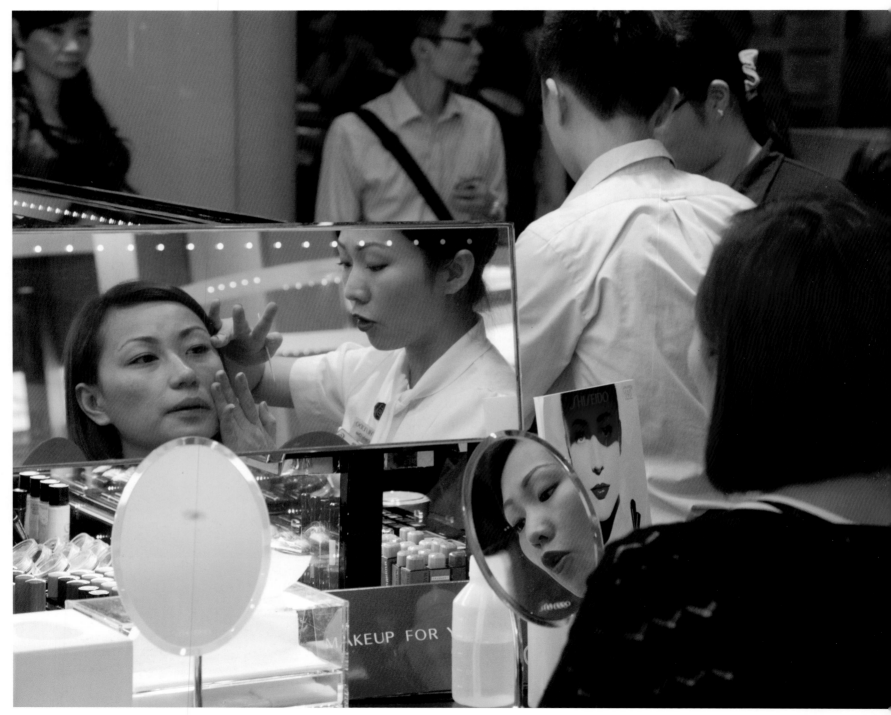

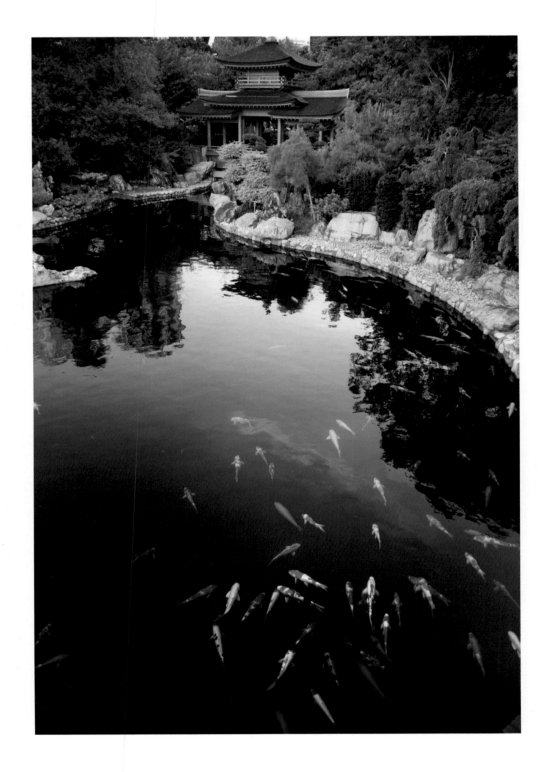

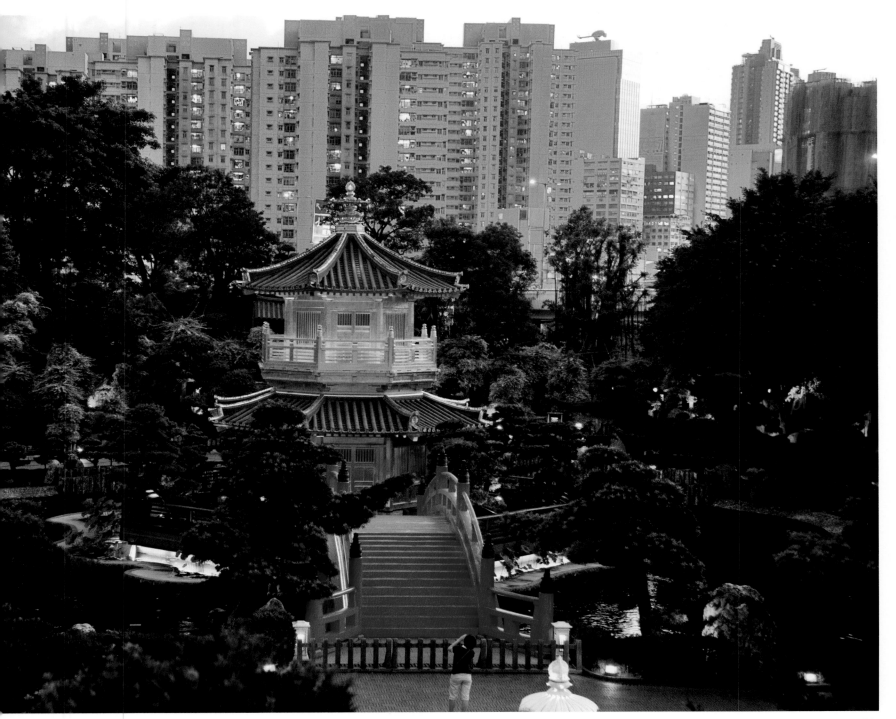

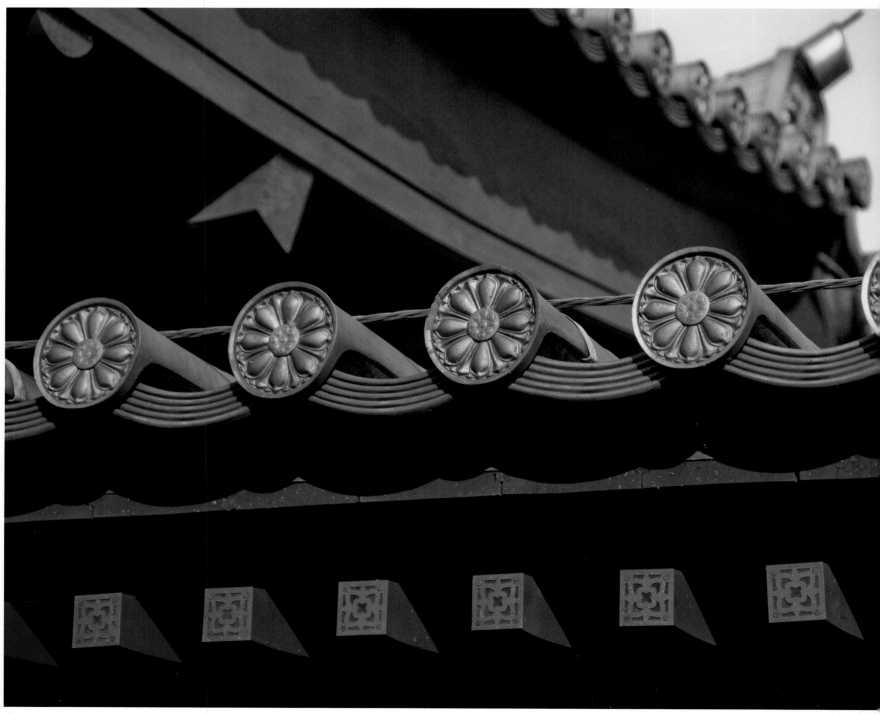

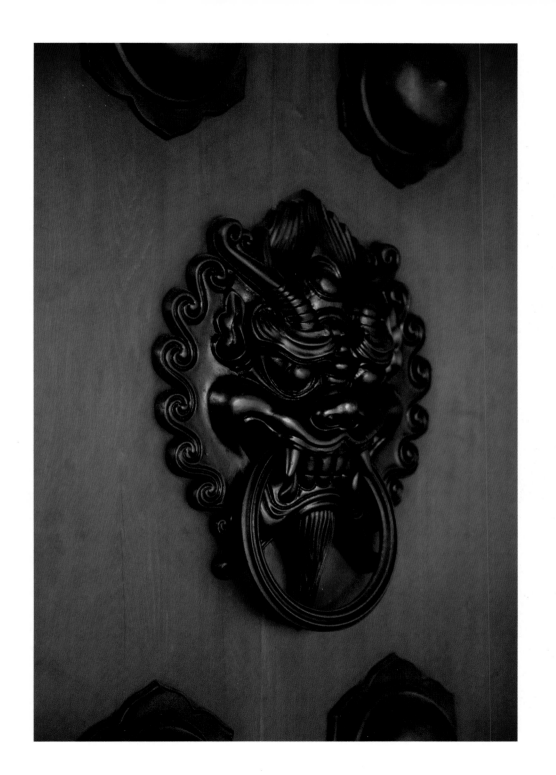

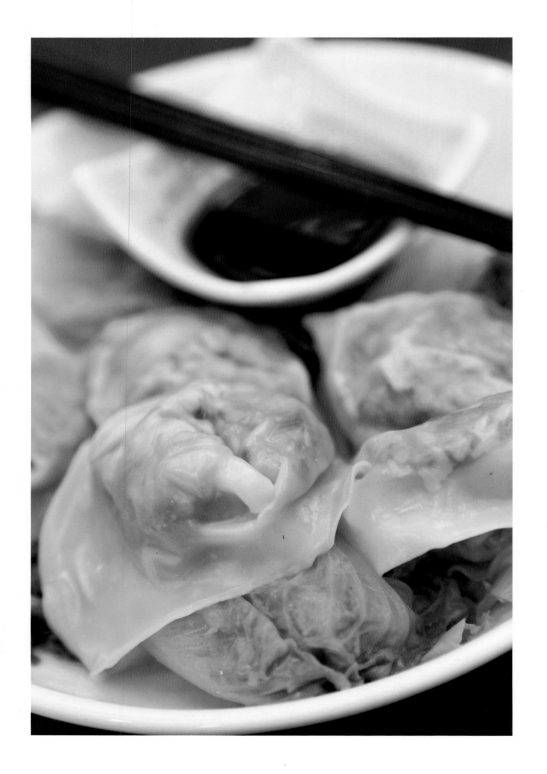

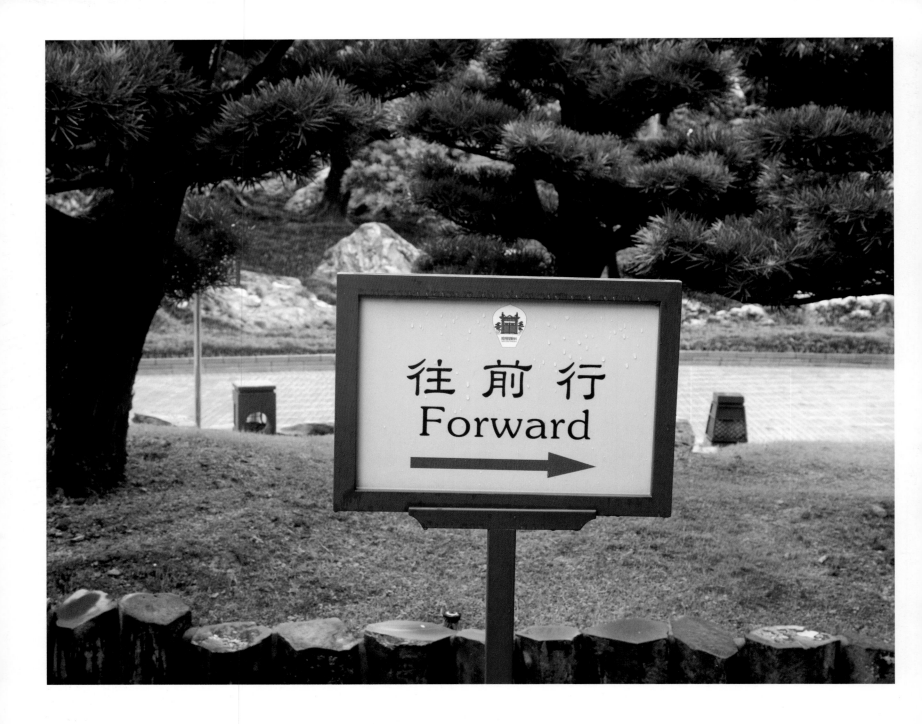

The mall has about 100 shops, which the APM directory organises into fashion, fashion accessories, beauty, gifts and books, lifestyle, audio visual retailers, and personal care and convenience stores. Some shops have been scored off the directory, which suggests that business has not been equally kind to all retailers. As well as shops there are places to eat located on the lower levels of the mall. These include specialty restaurants serving foreign food including popular chain eateries such as Genki Sushi, Oliver's Super Sandwiches, and the Spaghetti House. There is also fast food, a Starbucks Coffee shop, and a food court. JUSCO supermarket is on the lower ground, first, second, third, and fifth floors. All whims appear to be catered for.

As if this weren't enough, APM boasts almost 100 plasma TVs and LCD screens that display local news, movies, information of the latest trends, music, and celebrity gossip further reinforcing the APM experience. At big sporting events, fans crowd into the mall to watch the sporting dramas being enacted. According to the APM website, the digital facilities also 'help to communicate APM's image of stylish living to shoppers'. The latest trends are carefully selected to match 'the distinctive demands of both genders'. The screens create a perceived need in the shopper's mind for a particular product which the mall then 'solves'. They also reassert gender stereotypes.

In order to hold on to its visitors, APM has incorporated such facilities as a parents' room for baby care, numerous waiting areas and lockers in which shoppers can place bags before continuing to shop. Their flow is ensured by two express escalators in the middle of the complex which convey shoppers between the first and third floors and the third and fifth floors. Transport and accessibility has also been made easy. APM (an MTRC developed property) is situated right above the Kwun Tong MTR station, which makes it especially popular with people in close proximity to an MTR station; and with over 50 bus routes and 20 mini bus routes, APM is in easy reach of Central, Causeway Bay, Sha Tin, and Chek Lap Kok Airport

Shui Wo Street, 15 minutes walk north of APM, represents a completely different shopping experience from that of the mall – it bustles with local character. That local residents frequent the street is not surprising given its proximity to the many housing estates of the area, including Wo Lok Estate, the north and south Tsui Ping Estates, Wan Hon Estate, and Garden Estate. Though each high-rise estate has its own shops and market, shopping at Shui Wo Street is cheaper for certain items, such

as vegetables and other similarly less expensive items like stationery and slippers, say Kwun Tong locals. Though critics say malls are killing street life business continues there for now.

You name it, you can find it at Shui Wo Street. Shops and open-air stalls nestle along both sides of the street and there's a wet market housed within a building at the corner of Fu Yan Street where Shui Wo Street begins. Its first three floors are a market given over to the sale of items similar to those sold on the street outside, while its upper storeys house a sports complex with badminton and basketball courts and an activity room. Some say that the environment inside the indoor market is better; that the floors in some parts of the building are cleaner than the street outdoors.

But Shui Wo Street has also been transformed. In the 1980s, the street had about 300 illegal street hawkers before many were rehoused into a government-regulated space in 1984. Other street hawkers banded together to rent the street's present-day shops.

Today, some of these at Shui Wo Street include butchers where visitors buy live clucking chickens and their dismembered feet, pork parts, and roasted and barbecued meats. Under the glare of red lamps glimmering cleavers are wielded. People

point, prices are haggled, before cash is exchanged. Visitors can also purchase freshly made meat and vegetable stuffing for fish, meat balls, or dumplings. Smiling, the man mixing it raises it high in the air to demonstrate its consistency.

Grocery stalls boast high-piled mounds of vegetables that are weighed on ancient sets of scales that have seen better afternoons; tofu from a bucket and pickled vegetables. There are numerous fruit stalls bursting with all the colours of the rainbow. Golden hued mangoes fragrant and heavy with sunshine, the similarly coloured star fruit, and the fuchsia and green-hued dragon fruit are just some of the fruity juiciness that is purchased for a small sum. Going to the market is a fun and arresting experience; an adventure akin to a trip to a tropical orchard. There's nothing to separate the visitor from the produce: no plastic wrap or containers and whatever's within arm's reach can be picked up, smelt, and squeezed for ripeness.

Other shops are more reminiscent of old China, selling herbs for medicinal mixtures, tea, or fresh egg noodles wound in multi-coloured strands. Elsewhere, at seafood stalls, fish flip, their patchwork-quilt like skins shimmering prettily, while shrimp perform back flips as if on command. Men and women demonstrate products in a live

version of the plasma TV transmissions at the APM mall. Voices booming over microphone headsets, they offer passersby free food and drink samples in the hope of selling more. It's a heady mix in which there are no dull moments.

The Park'n'Shop supermarket on Shui Wo Street represents a sort of midway point in cost terms between the local shops and stalls and the APM mall. Its prices are generally 40 per cent higher than those offered at the stalls, say Kwun Tong locals. But, locals go there to purchase rice which is otherwise unavailable on the street itself or to take advantage of promotions which occur periodically and make items in the supermarket the cheapest option. In terms of atmosphere the supermarket can also be seen as a midway point between the glossy confines of APM and the liveliness of Shui Wo Street.

In addition to Park'n'Shop, today's supermarkets include: Great, Taste, and Gourmet (all upper-crust arms of Park'n'Shop and catering to Hong Kong's middle classes), and its main competitor, Wellcome, Hong Kong's first supermarket, established in 1945. Marketplace by Jason's is its classier division.

With the advent of Millennium City the composition of Kwun Tong is changing and its individual character is being lost. Local scenes of bamboo scaffolding and stalls selling ladders, wheelbarrows, and baskets underline this reconstruction. However, transition is gradual, and still some remnants of former times remain: makeshift and dilapidated bus stops, spray-painted text on walls, 1970s industrial buildings, and alleyways which host a multitude of stalls selling items such as clothing, mobile phone accessories, and goldfish, as well as fruit, fruit juices, and time piece accessories. Contrasting sights abound reminiscent of haphazard urban development and redevelopment or 'Brussellisation': those of old industrial buildings in front of which gleaming MTR trains whoosh by; shiny skyscrapers reaching heavenwards juxtaposed with a hand-painted rice wine advertisement on the nearby wall of an industrial building. How long before such distinguishing local features are razed and steamrolled into bland uniformity is anyone's guess.

While some say small retailers have lost local residents' trade to APM, this seems not to be so. The difference in clientele between that of APM and Shui Wo Street is striking. The APM audience is younger, single, unmarried or young couples who are typically from beyond Kwun Tong, while those who shop on the street are older local people. The

lifestyle propagated by APM is completely foreign to them and they have no need for the more gimmicky and expensive products sold at APM.

Some Kwun Tong locals say that if action isn't taken the market on Shui Wo Street will cease to exist within 15 years. This probable disappearance follows a pattern typical to Hong Kong; that of the city turning its back on native ways of life in favour of a more generic globalised lifestyle. Some say that in modern urban life shopping outdoors has become a perverse dialogue with nature, because in the world of modern man and the mythology surrounding him nature has no place because it threatens the superiority that man has adopted. But for now at least, Shui Wo street market lives on.

References

APM, 418 Kwun Tong Road, Kwun Tong

Shui Wo Street Market, Shui Wo Street, Kwun Tong

Yau Tsim Mong

A place to go

Comparisons between Mong Kok's Langham Place and Tokyo's Roppongi Hills reveal the mindset of Hong Kong developers

They say that imitation is the best form of flattery and some would say that there's a lot of it going on between Tokyo's Roppongi Hills and Mong Kok's recently built Langham Place. There should be – both share the same design principles and architect, were conceived as urban renewal projects, are mixed-use lots and are conceptually similar on the face of it at least. Others say that there's less imitation than might first appear, and that the developments are different and reflect very different mindsets.

'In many ways [the projects] are similar but Langham Place is definitely more compact than Roppongi Hills. They reflect the density of the cities they belong to,' says Dr Benjamin Yiu, assistant professor of architecture at HKU SPACE.

Roppongi Hills is one of Japan's largest property developments. Situated in Toyko, it incorporates the Mori Tower a 238 m, 54-storey tower block, several smaller buildings of shops and restaurants, and the nearby four Roppongi Hills residences. The first six levels of the tower contain retail stores and restaurants. The tower also contains a cinema and offices on the 8th to 48th floors with approximately 48,000 sq ft of rental space per floor. Tenants include Goldman Sachs, the Lehman Brothers, Google Japan and Yahoo! Japan. Meanwhile, the rooftop Sky Deck is open to the general public and there are cultural and educational facilities on the upper floors including the Mori Art Museum named after its developer, Minoru Mori; Tokyo City View, an observation deck; Roppongi Hills Club, a members-only club serving gourmet cuisine; and Academyhills, whose functional facilities include a learning institute and a library. The Grand Hyatt Tokyo is also located

there. The tower is served by an exit from Roppongi Station subway station.

Around Mori Tower are several smaller buildings of shops and restaurants, as well as a Virgin cinema. There are nearby shopping streets and four Roppongi Hills residences. Large open spaces have been built into the development featuring gardens and pavilions. The Mori Garden that's located there was part of a mansion that housed members of the feudal Mori clan which ruled in Japan for 71 generations during the feudal period.

But, what's this to do with Hong Kong? Langham Place comprises a 42-storey hotel, a 15-level shopping and entertainment centre with over 300 shops, restaurants, and a cinema complex, and a 59-storey office tower of over 1.8 million sq ft. The office tower was the first large skyscraper to be erected in Mong Kok after height restrictions were lifted following the closing of Kai Tak airport. What Langham Place doesn't have compared to Roppongi Hills is the scale, and missing elements include cultural space, permanent residences, or extensive green space.

Yiu says differences are due to more than just space. The developer of Roppongi Hills aimed to restore the area to its pre-war glory days as a cosmopolitan destination for academics, artists, and the global business community; and to create a truly 'global city' within the larger metropolis. His vision was 'to challenge the concept of city by creating an integrated development where high-rise inner urban communities allow people to live, work, play, and shop in close proximity to decrease or completely eliminate commuting time' – according to developer Mori's website, which claims the Hills has had over 40 million visits a year since it opened in 2003.

Meanwhile, according to the Urban Renewal Authority (URA), the building of Langham Place was supposed to 'cleanse and modernise a dilapidated part of Kowloon', and provide a modern commercial space in Mong Kok. The project was intended to be an economic catalyst, drawing more tourists into the area and providing locals with higher end-retail choices and night-time entertainment spots. According to Brian Honda, Jerde's senior vice president and architect of both Langham Place and Roppongi Hills, the aim was '[to] borrow from the district's phenomenal street market DNA and [rework] it into a vertical form to create a place unique to Mong Kok'.

The Langham Place project was completed in November 2004 and was a HK$10 billion project, a 50:50 joint development by the Great Eagle Group

and the URA. The URA, or Land Development Corporation as it was then known, spent about HK$4.4 billion to acquire the 129,120 sq ft site. An estimated HK$300 million was then paid by the developers to the government as a land premium.

'During its launch, the West Kowloon site was not developed, nor were Elements or Olympian City. So Langham Place was an alternative for premium shopping in Kowloon,' says Jenny Leung, a veteran advertising executive and marketer, and now freelance writer, adding that Langham Place redefined the shopping experience in Mong Kok by offering branded products at a higher cost, and sponsored a TVB drama which used the mall as a backdrop which quickly established awareness of the mall.

Langham Place is 'a typical Urban Renewal Authority project to make big money by big destruction,' says Dr Yiu. 'The project is not a success because we lost half of the real Mong Kok.'

Langham Place opened in 2004. Demarcated by Argyle Street, Portland Street, Shantung Street, and Reclamation Street, the 600,000 sq ft of retail space is spread over 15 levels, with 60,000 sq ft of space per floor, from the second basement level to the third floor. From the fourth floor upwards, the area is 40,000 sq ft.

Leung says that Langham Place has consolidated its position by 'ensuring the right mix of tenants in the mall, and by introducing young and hot brands which aggressively organise programmes, such as Adidas featuring celebrity Eason Chan, to bring excitement to the mall.' She adds that the mall also holds exhibitions in its open area as joint promotions, such as the Halloween Party with Ocean Park of 2010 or Knit-fitti in 2012.

But, for all of their similarities, there are many differences between Roppongi Hills and Langham Place. One is that Roppongi's Mori Tower has features of mixed use within the building, while the Langham Place shopping centre and cinemaplex is separated by Shanghai Street from the office tower and hotel. The shopping centre attracts shoppers into a 60 m high grand atrium, and ushers them into the multi-storey retail area from the ground level via the largest unsupported escalators in Hong Kong. The escalators were designed to reduce the horizontal drift of shoppers and keep them inside. From the top, shoppers walk down 'The Spiral', a gently graded corkscrew ramp that's lined with shops and which provides a transition between the 9th to the 13th floors – or can take the lifts. Some say this aims to address the imperfection of vertical shopping centres as retail spaces, and the difficulty

of attracting shoppers to the top. Horizontal shopping centres suffer a similar disadvantage at their peripheries or middle sections depending on where their exits are situated.

The office tower is at the intersection of Argyle and Shanghai streets, two of the busiest streets in Mong Kok. The 59-storey tower, built between 1999 and 2004, contains 770,000 sq ft of office space. Each of the floors above ground level provides about 17,000 sq ft. Gimmicks include the tower's dome which changes colour on Friday, Saturday, and Sunday nights. Meanwhile, the 42-storey Langham Place Hotel at Shanghai Street, is the only five-star hotel in Mong Kok, which is otherwise known for its cheap hotels. The hotel is directly connected to both the Langham Place shopping centre and the Mong Kok MTR station.

Another difference between the Roppongi Hills and Langham Place developments is the comparatively smaller number of buildings at the latter. What the visitor to Langham Place sees is actually just a portion of the original architectural plan, which included multi-storey residences. Today, apart from the Langham Place hotel which caters to visitors, there are no residences for locals included at the Mong Kok site.

'It has nothing to do with the neighbourhood except that it tries to tap a maximum of visitors from entrances strategically open to the surrounding areas,' says Yiu.

This contrasts with Roppongi Hills where Japanese domain law enabled residents of former residences on the site to be re-housed within the development. The reasons for the scale-down of the Hong Kong plan are uncertain, but some say it may have been due to the difficulty of acquiring plots from owners on which to build, although the building of Langham Place on Hong Lok Street, formerly home to about 6,000 people, has involved the displacement of former residents. The scale-down might also have been due to the lack of perceived benefit of building multi-storey residences there. The fact is that a shopping mall can generate profit whether the district is an enclave or not.

At Roppongi Hills, culture and education is provided at the Mori Tower, with the Mori Art Museum situated at the top. Prominence to the cultural heart is given via the Museum Cone – a 100 ft-high elliptical entrance structure at the ground level – compared to Langham Place's pride-of-place escalators which lead to its buying and spending opportunities.

But, perhaps the greatest deficiency of Langham Place is its organisation of public space. At Roppongi Hills, nature or greening of the city is even evident on the roof level – where the design team created traditional Japanese gardens – of the TV Asahi broadcast centre. Meanwhile, Roppongi Hills' pedestrian-level uses were connected into a new around-the-clock district. The man-made and nature were integrated as were the traditional and the modern, without diminishing the Buddhist Temple, Edo-style garden, and parks and plazas among the dense mixed-use buildings.

According to the Mori Building Company, by assembling land into a large block and then consolidating building needs in high-rise structures while exploiting underground space, a 'compact city' is created that enhances the efficiency of urban infrastructure such as rail transportation and road systems, while integrating functions of work, residence and living, entertainment, education, and commercial and retail.

There are clear ecological benefits to the vertical building approach as open space at ground level is freed up, resulting in 'vertical garden cities' that, according to the Mori website, 'provide a place of safety and relaxation'. Vertical garden cities also serve the practical purpose of reducing emissions and energy consumption. The open spaces and rooftop greening mitigate heat; and the mixed-use urban model brings the workplace closer to the residence reducing energy expenditure.

But, at Langham Place, greening is limited. 'Greening is a concept that has appeared in many artist impressions, but which has not been implemented in Hong Kong to my knowledge,' says John Herbert, managing director of Kelcroft E&M, which provides cost-saving built environment solutions for corporates. 'Greening is good, under BEAM and other rating tools, and soft landscaping of a site is promoted because it creates an advantageous micro-climate compared with the type concrete-scape,' says Herbert.

'If designed right, this lowers the temperature of the air, entering the building by several degrees,' he says. 'If the building intake air is drawn from a greening area, such as a green roof, then the annual savings resulting from the lower intake temperatures are significant – worth big savings. Building intakes are typically at roof level. However, a ground floor garden means people around the building, and the building enjoy lower temperatures. Greening means not your typical LCSD "garden". Frankly it is pretty useless to create a garden with more than 75 per cent concrete areas,

because it does little to defeat the effects of the heat island effect.'

Yiu says the lack of greening at Langham Place reflects the objectives of major developers. 'In their eyes, the key to success is not anything other than retail alone or the retail-plus-hotel formula.'

Other public facilities such as the cooked food centre and offices of community organisations are hidden under the Langham Hotel. Contrary to numerous food outlets which 'made the cut' in the shopping mall and hotel – the majority of which serve foreign cuisines – the cooked food centre is linked by just a corridor to the shopping mall. No signage for it is visible inside the mall. Leung says that, as was the intention with shopping, the Langham Place aimed to 'offer extensive dining choices in the area elevating the offer from mass to premium dining.'

The consequence of this arrangement of facilities is a reinforcement of a gap between worlds. These worlds may be deemed 'local' and 'foreign', though this may be a facile approximation of 'rich' and 'poor'. After all, Hongkongers would not consider Langham Place a foreign implant if it was located in the affluent area of Central.

The lack of social inclusivity in the design of the Langham Place complex: in what was scrapped and what made the cut, in what is positioned where, in what is visible versus invisible, has much to do with the values of Hong Kong society as decided by property developers, and majority societal values beyond the borders of the territory. Using Langham Place as an example, it would seem that when varying things compete for space, those that aren't money generating take second place. Society steers us to be competitive and the relationships between people are becoming ever-increasingly one-dimensional: that of competitors and, ultimately, winners and losers.

Some like Yiu suggest that a reappraisal of priorities might work out to be commercially beneficial, that if Langham Place, like Roppongi Hills, were to provide more public spaces with tables, chairs, greenery, and so forth, or champion local cuisine, that the added attractiveness might enhance the value and rental asking price of shops.

'If you look at the Sands' complex in Singapore's Marina Bay, local elements such as the cooked food centre take a great place in the development. It is quite successful. I feel that the Singapore government promotes their local eatery culture very well. It has become a brand of the Lion City,' he says, adding that the cooked food centre of Langham Place could be presented as 'specialty

local cuisine' which might be an equally, if not more, attractive option to tourists rather than the much pricier international foods inside the mall that they don't need to be in Hong Kong to consume.

Without its own culture, Hong Kong has no 'face', says Yiu, and 'no vision to identify our strengths for similar actions. Chain and brand names are considered more profitable. They kill the grass-level living environment. Giant shopping malls such as Langham Place immediately keep these elements away.' He says that street life is being taken away by malls and that's very sad to see.

References

Langham Place, 8 Argyle Street, Mong Kok; Tel: 3520 2888; Web: www.langhamplace.com;

Wong Tai Sin

Sin no more

*Spirituality appears to be on the rise at
Wong Tai Sin Temple*

In a consumer city such as Hong Kong, spirituality seems incongruous. 'Life is good in Hong Kong, who needs to be helped or saved?' an apt question might be. But, far from being on the demise, the consumption of spirituality in the territory seems to be on the rise.

'A few years ago, the local Chinese language *Apple Daily* newspaper reported that some 70,000 people had visited temples in the territory in a single day at the beginning of Chinese New Year. *The South China Morning Post* and *Standard* papers reported the same thing around 2005 to 2007 and used the term "revival" or "renaissance" of Chinese religious beliefs,' says Gordon Li, deputy chief executive of the Yuen Yuen Institute in Tsuen Wan.

The institute is the sole place in the territory that is dedicated to the study of Buddhism, Confucianism and Taoism.

According to Li, the rise in interest in spirituality in Hong Kong is related to the rapid development of China. 'Chinese culture was ignored by the new-era Chinese themselves after the Qing dynasty, or after the 1919 May Fourth Movement. But, in recent years, the Chinese have rethought and reclaimed many traditional things, not as relics but for usage,' he says. In addition, the local media has featured spiritual and religious practices on TV, online and in the press.

But, it's hard to estimate the numbers of religious followers. How can they be counted? Li says this is difficult. As an example, he cites academic research that provided a census reflecting the number of Taoists and Buddhists throughout China in the 18th century. He says that according to the document, there were only about 20,000 Taoists throughout the whole of China, which he calls 'unbelievable' for a traditional religion with a

history of development spanning over 2,000 years. Counting also raises the problem of definition: Only Taoist and Buddhist monks and nuns were counted in the census. People worshipping their ancestors, offering daily incense to the deities, and making offerings to the spirits are merely regarded as 'traditional Chinese'.

Hong Kong has a long history of spirituality and superstition or traditional Chinese practices. Some say that the territory's name, meaning 'Fragrant Harbour', refers to the incense factories that used to line the coast. There are an estimated 400 temples in the territory which reflect Buddhism and Taoism as the most widely practised religions in Hong Kong, and there are numerous temples dedicated to Tin Hau, the Goddess of the Sea; and Man Tai or Man Cheong and Mo Tai, the Gods of Literature; and Kuan Ti, the God of War.

In addition, Hong Kong has many other places of worship from Christian fellowships in traditional churches or commercial buildings, monasteries, Hindu and Sikh temples, synagogues, and mosques; and traces of spirituality are everywhere. Monks beg for alms in affluent areas; and across the territory, shops feature narrow red altars on their thresholds and restaurants bear kitchen gods on their premises. Even the spaces underneath the territory's flyovers are used to harness fortune, such as the Canal Road flyover between Causeway Bay and Wan Chai which is a popular place for *da siu yan,* or villain hitting. This involves the usually elderly 'villain hitters' beating human-shaped paper cut-outs with shoes or other heavy items to curse their customers' enemies. The smell of joss sticks, real and metaphorical, is never far.

Among Hong Kong's about 600 places of worship is the 200,000 sq ft Wong Tai Sin Temple, which is also known as Sik Sik Yuen to locals – Sik Sik Yuen is the name of the religious charity that owns and manages it. The temple has a long history. Its foundations were laid in 1915 when a Taoist priest named Leung Renyan spread the influence of the deity to Hong Kong by setting up a portrait of him and an altar to him in his Wan Chai home.

Wong Tai Sin Temple is successful now as it was in the past. Some say the temple's past success was due to the timing of Leung Renyan's revival of Wong Tai Sin; that before 1911, the emperor served as the divine religious symbol often stretching the mandate of heaven into religion, but that after the Chinese Revolution, a replacement symbol of faith was needed.

According to the copy of *Self-Description of Chisongzi* text located at the temple, Wong Tai Sin,

sometimes known as 'Immortal Chisong', in other words 'Immortal Red Pine' after the mountain in his birthplace, was born Wong Cho Ping in AD 338 in today's Lanxi city, Zhejiang province. A shepherd who began to practise Taoism at 15 years of age, he was later revered for his powers of healing.

Leung's home also functioned as a herbal medicine shop, and customers would pray to the deity and seek advice for their ailments, after which Leung would then write out prescriptions. In 1921, three years after a fire destroyed his shop, Leung is said to have received a message from Wong Tai Sin instructing him to build him a new shrine to be called 'Sik Sik Yuen' and be situated '3,600 paces from a pier'. Other instructions specified the orientation of the temple and its dimensions.

As at other temples across Hong Kong, the devotees at Wong Tai Sin Temple light incense which they wave or raise above their heads while bowing to statues or plaques of a deity or ancestor. The sticks of incense are then placed vertically in receptacles in front of the statues or plaques, either singularly or in threes depending on the status of the deity or the sentiment of the worshipper. Thicker joss sticks are used for special ceremonies such as funerals. Another feature of the temple are the divination sticks.

Fortune telling is very popular in Hong Kong. This type of fortune telling also known as *kau cim* requires that the worshipper shakes a receptacle containing 100 numbered sticks, until one dislodges itself from the others and falls out. Each number corresponds to a poem, which in turn, answers the worshipper's question. Sticks are classified into six different grades from 'very good plus', to 'very bad minus'. To confirm the answer given, the worshipper picks up and tosses two kidney-shaped blocks, *jiao*, which are round on one side and flat on the other. A successful answer requires one flat side and one round side to be shown; a failed answer means that two round sides are shown. When both sides come up flat it is said that the deities are laughing at the worshipper, who then has the option of repeating his or her question until a conclusion is reached. The prediction covers one Chinese calendar year.

The early architectural structure of Wong Tai Sin Temple was simple, with only certain structures built such as the main altar – which houses the portrait of Wong Tai Sin – the Three Saints Hall where Taoist and Buddhist deities Lui Tung Bun, Kwan Yin and Kwan Tai are worshipped, Confucian Hall where Confucius is worshipped, and the Yue

Heung Shrine, general office, quarters, front gate, and a well.

'Before the temple became world famous, not many people knew about Wong Tai Sin except those from Zhejiang province, where Wong Tai Sin originated,' says the Yuen Yuen Institute's Li. He says that Wong Tai Sin temple is Hong Kong's most popular temple, with the largest number of visitors from around the world visiting.

Wong Tai Sin Temple has worked hard for its success. According to temple literature, it was decided in 1937 that 'to remain prosperous, the temple be constructed according to the five elements of Chinese *feng shui*'. Metal, wood, water, fire, and earth are represented by the Bronze Pavilion, Archives Hall, Yuk Yik Fountain, Yue Heung Shrine, and Earth Wall.

Li says that there are three kinds of temples in the territory: 'In Hong Kong, there are Taoist temples, which are owned by organisations or by a single Taoist or group. Some of these are large-scale temples such as Wong Tai Sin, the Yuen Yuen Institute and Ching Chung Kwan in Tuen Mun district. Some are small scale, located, in Mong Kok's older residential buildings where there might be just 300 sq ft to accommodate the altars of the deities.'

Like their Taoist counterparts, Buddhist temples in Hong Kong are owned by organisations or single or groups of Buddhists. Li says these could be lay Buddhists, not necessarily monks or nuns, adding that most are small-scale.

'Local temples', says Li, is an academic term which includes the temples of local cults, most of which were for worship of specific deities such as Tin Hau. He says that some are owned by the Chinese Temples Committee (CTC) which manages about 24 temples in Hong Kong, others are owned by local cults, and the rest are owned by the local people and elites of native villages. Wong Tai Sin Temple is a Taoist temple which is run by a well established Taoist organisation.

Temples are further categorised into local religious temples, private temples, and public temples. Some are owned by the Hong Kong government, but are managed by the Tung Wah Group of Hospitals (TWGH) or CTC. Other private temples are owned by communities such as the people of Yuen Long, Tai Po, and Sheung Shui in the New Territories. Other Taoist and Buddhist temples are owned by religious organisations, as Wong Tai Sin Temple is owned by Sik Sik Yuen.

Almost all of the territory's larger temples have been built on land designated for religious

construction, while some local temples are graded buildings, which means it is unlikely that they will be redeveloped. This is rare in a city where everything is up for grabs, and even corridors and rooftops are fair game for property investors. That said, Hong Kong has many small Taoist and Buddhist 'temples' and 'altars' situated inside old mixed-use buildings which may not be exempt from redevelopment.

'By promoting religious teachings and religious virtues, the Chinese religions want to elevate the moral standard of society. This is why some Chinese religious organisations run so many schools in Hong Kong. Through religious practices such as rituals and providing services and counselling, they want to help society to become more stable and harmonious. This is also the reason why some people call the Chinese religions 'moral religions,' says Li.

But some say that spirituality is being commoditised, for example through spiritual tourism. Li says that there are a few explanations for the apparent commoditisation and commercialism. 'Chinese religions are different from religions like Judaism or Islam. No donation to the temples or organisation behind them is obligatory – people donate at will. When the organisations or temples need resources for further development or just to survive, they need to do more than just wait for donations. For example, they might promote their paid religious services or sell religious totems and so on,' he says.

The introduction of online praying on the website of Wong Tai Sin temple has been seen as evidence that spirituality is becoming more about superstition, and the quick appeasing of the gods, than the intellectual contemplation and devoted practice of true religious adherents. But, according to Li, Wong Tai Sin Temple provides its online prayer and fortune telling because, apart from wanting to promote faith, the temple management is trying to reduce the number of visitors to the temple, who can instead make requests for Taoist priests to pray for them on the website.

At its inception in the 1920s, Wong Tai Sin was a closed-door temple – a private abbey to which only members of Sik Sik Yuen were allowed access. The temple opened to the public in 1956. A few years later, in the 1960s, the government planned to revoke the land for public housing, but some of the worshippers disagreed and formed an organisation for the temple. Some say that in exchange they agreed for part of the donations to be streamed to the CTC and TWGH for charity. As a result, the land was granted to the Sik Sik Yuen who have since

managed the temple. Other temples, almost all of which are local religious temples not belonging to either the Taoist or Buddhist tradition and mostly in the New Territories, are managed by the TWGH. Since the Chinese Temples Ordinance was enacted in the 1920s, all donations to CTC temples –about 20 of more than 450 temples in Hong Kong and all 20 local religious temples – must be used for charitable purposes. The ordinance was supposed to prevent religions from being sources of private gain, but was not supposed to interfere with the management of temples. It manages temple income and allocates it to social, recreational, and charitable uses.

Unlike Western churches which have long held gatherings for specific religious or preaching purposes organised by the churches, social gatherings in temples are mainly organised by adherents, lay people or tourists, but not the temples themselves. According to tradition, Taoist and Buddhist temples are supposed to be places for monks, nuns, and practitioners to get deeper into religious practice or be a place where adherents go to worship rather than being gathering places for the community. Exceptions to this are the local temples owned by villages and lineages which are a centre for family and lineage issues such as the Tin Hau Temple in Lam Tsuen in Tai Po district.

The reality is though that Wong Tai Sin temple has become a gathering place. Visitors were attracted to the temple when Sik Sik Yuen began its charitable works in medicinal services, child care and elderly services, and education. In fact, as early as 1924, Sik Sik Yuen established a herbal clinic to offer free herbal medicines and consultations to the poor, and, today, Wong Tai Sin Temple literature says that practitioners serve more than 200 patients there each day. In 1980, a Western medical clinic was set up at the temple to provide medical services at subsidised rates. Due to demand, it had to be moved to more spacious premises within the temple compound. The temple also hosts a 4,000 sq ft physiotherapy centre and a dental clinic.

Worshippers also gather at the temple on the birthday of Wong Tai Sin on the 23rd day of the eighth lunar month – it is said that the portrait of Wong Tai Sin revealed the birth date. The deity's upheld left hand with thumb and forefinger pointing upwards is held to resemble the Chinese character for '8', (八), and the other three fingers are folded inwards and with the thumb and forefinger are said to resemble a '2' and '3', (二 and 三).

The first day of the new lunar year, when the first incense is burnt at the stroke of midnight, is also a noteworthy date in the calendars of Wong Tai Sin adherents. This tradition dates from 1934. Back then, people worshipped outside the temple, and later the temple would open its doors on the first day of the new lunar year. As this was the only day that the public could enter the temple for worship, the burning of incense became a special event, and later a Chinese New Year ritual.

While online praying is unlikely to stave away locals on these days, it's also unlikely to affect the huge amounts of tourists, for whom the temple is a stop on a tourist itinerary. Li says that there are still many visitors to the temple.

'In my opinion, more and more people have been going to Taoist temples in the last 10 years. There is an increasing number of people between the ages of 20 and 40, who, like the elderly, are going to the temple to worship their ancestors, to pray for luck, and seek to be blessed by the deities,' says Li, adding that the most obvious periods to observe this phenomenon is at the beginning and end of the lunar year and the Ghost festival around the fifteenth of the seventh month.

Other features at Wong Tai Sin Temple including the Good Wish Garden, Wall of Nine Dragons – a replica of the one in the Imperial Palace in Beijing – and the Fortune Telling and Oblation Arcade, the latter which is managed by the TWGH all provide incentives for visitors.

The arcade features 161 fortune telling booths, and according to one practitioner, 'Destiny leads a person to a particular fortune teller'. *Bazi* is one of the most popular Chinese fortune telling method there. It involves the interpretation of a person's hour of birth, day, month and year to reveal the life destiny of that person, their current situation, and most suitable area of employment. Face and palm reading are also popular at the arcade. The former is the interpretation of facial features into predictions for the future, while the latter analyses the lines on the palm for love, personality and other traits. Many people visit the fortune tellers early in the New Year, and you needn't be an adherent to visit the temple or speak Cantonese to hear your fortune told as some of the practitioners speak English well – which also doesn't help contain the numbers of visitors.

For locals and tourists, a visit to the temple is to harness good fortune – a fact played upon by the shopkeepers outside the temple. They sell all sorts of luck inducing-trinkets, such as the ornaments sporting multiple pinwheel fans which spin when the wind blows through them. Meanwhile, fish

charms bearing Chinese characters are supposed to bring riches as well as luck. Some Hong Kong taxi drivers hang these from their rearview mirrors to protect them from accidents.

Li says that people are affected by social trends and seek better luck and a better life via traditional religious means. 'Only some of the worshippers are spiritual, who are not so much praying to "get", but exploring the philosophical side of the Chinese religions. This type of person wants to find answers to their philosophical questions,' he says.

References

Sik Sik Yuen Temple, Wong Tai Sin Road, Wong Tai Sin; Tel: 2327 8141; Web: www.siksikyuen. org.hk; Open: daily 7 a.m. to 5.30 p.m.

3: ART

Kwun Tong

For art's sake

Recycling buildings in former industrial hubs could give creativity a break

Like former industrial districts TriBeCa in New York City and the area around Old Spitalfields market and Brick Lane in London's East End, the southern part of Kwun Tong has everything it takes to be an art hub: large-scale empty industrial spaces, and the rental prices. But Kwun Tong's 'art hub' is in its infancy, and who knows if it will develop organically.

Hong Kong has long been labelled as a 'cultural desert', a reputation which took hold in the 1960s and which is only recently loosening. This being so,

the mere potential of Kwun Tong as an art hub is progress for the territory, and it's also hard to see a negative side to the recycling of buildings in Kwun Tong for art space.

Australian street artist James Cochran says that the draw for artists is 'the cheaper rent and the ability to find decent sized studios in these areas. Street art is another thing, and has always had an attraction to the marginalised parts or what could be considered the abject areas of society, be it industrial zones, abandoned warehouses or drains or canals.'

Spearheading the Kwun Tong art movement is the Osage Foundation and gallery group which was established at the end of 2004. The non-profit foundation's aim is to build creative communities and to promote cultural cooperation.

'The arts help us to understand who we are, where we come from, where we are going, and what we want to be. They are an essential part of describing new information, new ideas, and new values. We believe that the arts play an important

part in the life of every member of the community. The foundation believes that every society should strive to become a creative community, that the aesthetic appreciation of art is vital to the wellbeing of any society and should be accessible to all,' says Eugene Tan, director of Exhibitions at Osage, adding that 'the foundation works through three principles: early arts education, cultural expressionism, and experimental art forms. Osage has a particular interest in early childhood art education as it provides the building blocks of all art education and the foundation of skills necessary for contemporary life.'

Since its inception, Osage has developed exhibition spaces in Hong Kong, Beijing, Singapore and Shanghai. Tan says that one of the weakest links in arts infrastructure in Asia is the lack of commercial galleries, and so Osage has tried to develop commercial platforms through galleries. The works of artists are discussed and selected for representation by a panel, the members of which all have art backgrounds. Artists are handled on a case-by-case basis; some Osage handles exclusively, but the group also works with artists for who they represent just one or two pieces of work. Most of the art works exhibited are for sale in exhibitions that typically run for a month or two.

'We work with artists throughout Asia. Osage's mission is exploring artists work throughout Asia, not just China,' says Tan. He adds that due to the fall in the Chinese art market, people are looking at art from other markets, though many still seek an art work that reflects 'the modernisation of China'. But, 'Southeast Asian sales are getting better. Sotheby's and Christies have started to include more Hong Kong artists in their auctions – Wilson Shee and Chow Chun Fai have been active since about 2005,' he says.

Osage Kwun Tong is a 15,000 sq ft warehouse-style space in a former industrial building. Between its opening in December 2006 and June 2008, Osage Kwun Tong had 10,000 visitors, a figure that represents an average of 500 visitors per month. According to Osage research, of these art enthusiasts 52 per cent were from the academic sector, 37 per cent from the private sector, and 8 per cent from art and culture-related industries; 2 per cent were press and 1 per cent from the government. How many Kwun Tong locals were among these groups is not known. Off the cavernous functional lobby giving you a hint of space to come, an industrial lift takes you to the exhibition space on the fifth floor. A bilingual 'No Spitting and No Smoking sign' is the last unorchestrated symbol of

present-day Hong Kong that visitors' eyes will spy for a while. The roomy dimensions include 4.2 m beam-free ceilings and low profile columns, with the longest run of unrestricted wall space at over 47 metres. It's a first for cramped Hong Kong, and equals the contemporary art venues of any world city. The size of the area allows for the simultaneous showing of multiple exhibitions, and the space is re-configured for every show.

Located in a street parallel to the north of Osage Kwun Tong, Osage Atelier Kwun Tong measures a more diminutive 900 sq ft. It hosts exhibitions of creative industries and visual art in all media, including painting, drawing, textiles, jewellery, and home furnishings. While Atelier is an indoor art space, Osage Open at the same location takes art outwards. It is comprised of two sizeable outdoor spaces: a north space which measures 2,000 sq ft, and a south space which is about double the size. Surrounding the raw concrete open space are tower blocks, the façades of which blend together, one reflecting in the glass panelling of another and forming something altogether new. The two outdoor areas are concrete canvases upon which art in its myriad forms can take place. The wear and tear on the structures that includes the stains from dripping air conditioning units is plain to see and is a reflection of the passage of time, and the passage of the lives of those who have toiled within their corners.

In Kwun Tong, the arrival of the Osage gallery is not surprising. In the past decade, industrial restructuring to the Chinese Mainland has left many former factory units in the district empty. Due to their size, the spaces are really suited to the new artistic lease of life being given to them – like industrial spaces in Kwai Chung, Ap Lei Chau, Chai Wan, and Fo Tan. Tan says that the largeness of the space and the lack of columns were major reasons why the gallery took up space there. He says that Kwun Tong is accessible, and there wasn't a big enough space in art hub Fo Tan which is also further afield.

The conversion of industrial space in Kwun Tong follows a pattern familiar in other world cities. During the 1960s and 1970s, lofts in TriBeCa in New York City became residences for young artists and their families, due to the seclusion of Lower Manhattan and its vast living spaces. Today, TriBeCa is one of the most fashionable districts in the city and home to numerous alternative exhibition spaces such as the Clocktower, Artists Space, the Franklin Furnace Archive, and the Alternative Museum. It's also now one of New York

City's most expensive addresses. Many of New York City's most successful bright young things and creatives call it home.

Meanwhile, in London's East End, where today's art hubs of Spitalfields market and Brick Lane are found, industry was historically associated with the sea and included ship building and rope making. Today, these two parts of the East End are known for a proliferation of art galleries including the Whitechapel Gallery, and the workshop of performance artists and photo-montagists Gilbert & George. The neighbourhood around Hoxton Square is home to the White Cube gallery and many artists of the so-called Young British Artists movement, which refers to a group of British artists which began to exhibit their work together in London in 1988.

Artist Cochran says that industrial zones are usually placed on the fringes of the city, but as the city expands the gentrification process comes in, when what was once a cheaper and less desirable place to live becomes populated and gentrified.

'Art galleries in gentrified areas generally continue to do business, but may benefit from new money or clients coming into their area. Certain art galleries also take the risk to start up in an outer area where the clients have to come to them, but if they are lucky enough, the area may become more vibrant or gentrified in future years,' he says, adding that if the area starts to change then there is the risk of the rawness and energy of the art that was created there being lost. 'So, it is important to maintain some of the art and culture that helped form the identity of the area.'

Back in Kwun Tong, though some film production companies and photographic studios are located in the district, few local businesses are involved in art, but instead, are in trading, logistics and sales. 'There are some design studios in Kwun Tong... the Kwun Tong art scene is scattered, but increases in rent will put a stop to that,' says Tan.

As in the Big Apple, where many former residents and artists have been pushed out by spiraling property prices, the same may occur in Hong Kong. Amid talk about the importance of art and culture in the context of the West Kowloon Cultural District, the government has, nonetheless, introduced an industrial building revitalisation policy that makes it easier for the owners of old industrial buildings to convert them to other uses, meaning that it will be harder for artists to afford the rent of the former industrial buildings of Kwun Tong or elsewhere.

Cochran says that if a government genuinely wants to spur on art, it would need to keep areas for artists with a decent rent for their studio spaces. While there are various studio residences that exist with government support, these places are limited. Art communities or collectives are formed, but of course these are usually in the industrial or outer areas. 'Perhaps there needs to be a kind of displacement compensation to assist these communities to continue or reinstall themselves elsewhere when the gentrification process forces them out. Or, even better, if they could be allowed to stay in the area without being hit by the rising rents,' he says.

According to Alec Cham, market analyst for Centaline Property Consultants, Kowloon East is the focus of the industrial property market in Kowloon. 'In July 2012, of all the districts in Kowloon, Kwun Tong accounted for the highest amount and the highest volume of transactions of industrial buildings. Total consideration reached HK$1.316 billion and the number of transactions reached 106, accounting for 57.5 per cent and 43.3 per cent of the whole Kowloon district. Kowloon Bay is the second highest, recording $347 million in total consideration, and 41 transactions, accounting for 16.3 per cent and 15.2 per cent of Kowloon,' he says.

According to the Hong Kong Institute of Architects, the government policy seeks to 'promote revitalisation of old industrial buildings through encouraging development and conversion of vacant or underutilised industrial buildings'. The aim is to offer premises 'to meet the territory's economic and social needs including the development of higher value-added economic activities', such as the six economic areas identified by the Task Force on Economic Challenges. The six areas include: testing and certification, medical services, innovation and technology, environmental industry, educational services, and cultural and creative industries. But, one knock-on effect is that the policy has encouraged property investors to speculate on the rising value of industrial space, which has driven up rents leaving artists and other members of the territory's creative industries with nowhere to go.

'Osage doesn't own space. All areas are coming under redevelopment and this makes it expensive for art spaces. We are already seeing rental around us increasing at the end of the lease period. But the gallery is hoping to negotiate a good price,' says Tan. In 2008, the gallery moved out of their Singapore premises because the lease expired. They had wanted to negotiate a cheaper rent with the

landlord. In Shanghai, Osage moved to the French Concession.

According to him, the value of Hong Kong art is much lower than its Chinese Mainland counterpart and so it needs support. Hong Kong art is not circulating globally, though certain local artists in their 30s such as Pak Sheung Chuen, Tsang Kin Wah, Lee Kit are well known internationally. 'A lot has to do with education and how a government presents the importance of art. For example, there are few art history courses in Hong Kong. It's about striking the right balance between government resources and taking a step back,' Tan says.

According to the Education Bureau, the purposes of art education in the schools of the territory are: to introduce a broad based art curriculum which includes different art forms for the nine-year basic education; to emphasise the unique contribution of a balanced art education to the development of students' creativity, imagination and aesthetic perception; and to make good use of cross-curricular links to promote the use of artistic senses, for example, musical activities for the learning of languages and drama for simulating life situations. But some say that this is a posture, and that the arts in education don't really count because art is not a subject in the Open Examination, the HKCEE in which students are required to take eight or nine subjects, at most 10. These include: Chinese – reading, writing, listening; English – reading, writing, listening; and Mathematics which are compulsory, and which determine the future of students.

Others go further, saying that art has never been a priority of the Hong Kong government; and that with everything else they seem to be efficient, but when it comes to art they don't seem to know what to do. Tan says that this may be because the results and goals of art as not as tangible as other things. 'Because of the lack of fixed goals, the government may feel uncertain and that it needs to consult a lot of people. There is a perceived lack of direction when it comes to arts policies,' he adds.

According to Tan, development of the art scene in Hong Kong is vital, because, economically, the territory is becoming less competitive and, therefore, needs to establish a more distinctive identity and culture.

References

Osage Kwun Tong, 5/F Kian Dai Industrial Building, 73–75 Hung To Road, Kwun Tong; Tel: 2793-4817; Web: www.osagegallery.com, Open: Tue-Sun & Public holidays: 10 a.m.-7 p.m. Entrance to the galleries is free.

Sham Shui Po

Artful dodger

Mixed objectives continue to dog Shek Kip Mei's Jockey Club Creative Arts Centre

In a city known for its paltry art scene, some say a mini art revolution is taking place: There have been openings of art spaces in former industrial areas, ongoing discussions on the West Kowloon Cultural District, and other indicators that art is gaining a foothold, such as the 2009 opening of the K11 art mall in Tsim Sha Tsui. The joint venture between New World Development and the Urban Renewal Authority is the first in the world to integrate permanent art exhibitions with shopping experience, according to the mall's website.

Others say that a revolution is not genuinely taking place and what appears to be so, is not about art's artistic or cultural value, but a new way to profit from it. Yet other voices are saying that while Hong Kong lacks a world-class art museum and renowned local artists, the city has no need for a revolution because it already has a glut of 'low brow' art, from films and *manhua* comic books to designer toys, and ask for a broadening of the definition of 'art'.

The Jockey Club Creative Arts Centre (JCCAC) opened in September 2009 in Shek Kip Mei is a test of the respective views. The multi-disciplinary art studio centre was initiated by Hong Kong Baptist University. Partners of the JCCAC include the Hong Kong Arts Development Council and the Hong Kong Arts Centre. The project is sponsored by the Hong Kong Jockey Club Charities Trust, which is responsible for distributing donations to charities, and is supported by the government's Home Affairs Bureau. So, a lot of parties vouching for art.

'I think the JCCAC will continue to be more and more successful. I can foresee in 10 years time more industrial and residential buildings will be transformed into art hubs like the JCCAC,' says

Annie Tai, a Facebook applications developer who takes *erhu* lessons at the JCCAC.

But, the JCCAC has been dogged by criticism since it opened in 2008 for its location, staff appointments and management – Eddie Lui Fung-ngar, 62, a painter and sculptor, with a background in banking, was hired in 2005 as executive director of the JCCAC but later stepped down, and mixed objectives, all of which have impacted its success.

The JCCAC is housed in the former Shek Kip Mei Factory Estate, which is difficult to reach. The neighbourhood was the site of the 1953 fire which left 53,000 people homeless and was the first location to offer public housing in Hong Kong. Mei Ho House, the last of the extant original Shek Kip Mei Estate public housing blocks, was listed as a Grade I historic building in 2005 by former Chief Executive Donald Tsang and Antiquities Advisory Board. Grade I buildings are those selected by the Antiquities and Monuments Office (AMO) as having 'outstanding merits of which every effort should be made to preserve if possible'.

Unlike Mei Ho House, and despite an interesting history of its own, the JCCAC building has not been awarded any special status. Angela Siu, executive secretary of the AMO says that this is because when the AMO conducted a territory-wide survey on historic buildings between 1996 and 2000, the emphasis was mainly on those built before 1950.

The factory opened in 1977 and was built to re-house cottage industries, and then closed in 2001 because the Mainland's economic reforms had resulted in many proprietors moving their factories northwards. According to the JCCAC, the building was initially comprised of units involved in hardware, manufacturing, plastic-moulding, shoe making, printing, and watch making. There was a need for the factory as research showed that 30 per cent of such home businesses would dedicate half of their tiny 120 sq ft living space to machinery or the manufacture of goods which caused massive noise problems for residents, among other issues.

The redevelopment of the former factory is part of a new movement to revitalise old buildings – Lui Sang Chun, which is a Grade I historic building located in Mong Kok, has been revitalised into a Chinese medicine institute; Western Market, a 'declared monument' located in Sheung Wan, was refurbished in 2003 to accommodate varied shops; Woo Cheong Pawn Shop in Wan Chai, combining four pre-war residential blocks that date from 1888, was transformed into a restaurant called the Pawn in 2008. The JCCAC has retained some of the

factories' door signs and industrial machinery as a token nod to the building's past.

Some local examples regarding art include the Osage gallery in Kwun Tong and the Cattle Depot artists' village in Kowloon City, and then there is the art hub of Fo Tan in the New Territories. Fo Tan, at just five stops by MTR from the Chinese Mainland, is the longest established art depot in Hong Kong and is where the largest group of artists is based in the territory. Over 180 artists cluster in over 30 studios – mostly in blocks A and B of the Wah Luen Industrial Centre on Wong Chuk Yeung Street in the outskirts of Fo Tan. But, according to *Squarefoot* magazine in February 2010, prices have risen since the government announced a change to its policy on industrial space, allowing it to be repurposed. Studios that originally cost around HK$250,000 when the colony started a decade ago are now reportedly changing hands for HK$1.25 million. Many artists are worried that this policy will inadvertently push industrial space out of their reach.

Siu says that adaptive reuse of buildings is one means of conservation, and adds that after the chief executive announced a series of initiatives on heritage conservation in 2007, the Commissioner for Heritage's Office was set up on 25 April 2008 to implement the policy.

She says that the office has launched three rounds of the Revitalising Historic Buildings through Partnership Scheme, with 13 buildings open for non-profit organisations' submission for adaptive re-use. She cites two that have 'recently been under operation': Lui Seng Chun in Sham Shui Po which is now a Chinese medicine health care centre known as the Hong Kong Baptist University School of Chinese Medical – Lui Seng Chun; and the Lai Chi Kok Hospital which is now a cultural exhibition centre called the Jao Tsung-I Academy.

The lack of logic in the reuse of the JCCAC building from its original purpose is another reason for the centre's lack of success, say some. And the reality is that few Hong Kong residents have ever been there. On the other hand, the accessibility of places such as the K11 mall in Tsim Sha Tsui allows visitors to check the 'cultural box' without making much effort.

'When I started this I had a dream of artists collaborating with each other in a one-stop art-making centre, where people help each other build things, photographers take photos of the work, and the galleries downstairs promote it to the public. That's already starting to happen. The artists here

are starting to experience what it's like to be in an art hub. There's a nice atmosphere here now. People yell at each other across the atrium. We're getting back some of that old public housing feeling,' Lui said, in a 2010 interview with CNN Go. And though he said that artists are 'obligated to connect with the community. We can't afford to be detached and live in our own world. Art needs to reach the public.' Lui stepped down from his post in February 2010, after five years of service, and amid criticism of the JCCAC's low rate of attendance and lack of promotional events. The current executive director, Lillian Hau, was brought in in May 2010 to replace Lui. Hau is an arts administrator who previously served as grant manager of the Arts Development Council and executive director of the Robert H.N. Ho Family Foundation.

Insiders say that management issues have impeded the progress of art at the JCCAC. 'There are over 130 tenants at the JCCAC, mostly independent artists and small art groups, with a handful of arts and cultural institutions – Arts for the Disabled Association Hong Kong, Hong Kong Arts School – and some art students and recent graduates. JCCAC is multi-discipline but skewed on visual arts,' adds So. The costs of the studios varies. The three categories are: institutional tenants, artist or art group tenants, and student or graduate artist tenants. They pay HK$8, $5, and $3 per sq ft a month respectively. All groups are charged an additional $1.5 per sq ft management fee each month. So, 300 sq ft studios rent for $1,350 to $2,850 per month, while the biggest (1,300 sq ft) rent for $5,850 to $12,350 per month. Rates for new and renewal tenancies are reviewed and set annually, says So.

In addition, 'The JCCAC has quite restrictive terms. You have to rent for a year,' says the tenant, adding that although Fo Tan and Kwun Tong district rents are higher, it is the JCCAC of Shek Kip Mei, Sham Shui Po district that has been regarded as a failure. 'They are very strict. Originally, we weren't allowed to stay overnight. It's a bit more relaxed now,' says one tenant on condition of anonymity, adding that 'at 10 p.m. the management locked all the public washrooms [artists at the JCCAC don't have toilets in their spaces] and after 11 p.m. they locked the main gates.'

The tenant says that there is a Western café and a Chinese tea house, and on the second floor is a café run by G.O.D, but that these are just places for visitors and that there is no cooking space – artists must bring cooked food in. 'You have to be well

prepared. It doesn't allow for much spontaneity,' she says.

Rather than being the fault of location or any one individual or management policy, it seems more plausible that the problems are due to mixed objectives, whether JCCAC is for artists to produce work or for the public. Some of the creative tenants welcome visitors, while others want to be left alone.

According to So, the strategy of the centre is to be 'adaptive to changes in the environment and the needs and expectations of the public and the arts community'.

'Both objectives exist, but the objective of encouraging public art appreciation has greater emphasis, because there are so many exhibitions at the JCCAC. So, in terms of encouraging the public to appreciate art, I think the JCCAC is successful. It is an art hub with many free exhibitions and performances held regularly and open to all. But, for providing a private place for artists? I'm not sure because the rent there has been increasing,' says Tai.

Chau Chi-ho, a musician and Tai's *erhu* music teacher, said he came across the JCCAC's ads for artist space in 2004, and received confirmation after correspondence and an interview that his application for studio space had been successful;

he moved in in 2007. 'I don't think the JCCAC is an overall success. Many artists here are unsatisfied,' he says.

But, rental prices have attracted artists, and attempts on the JCCAC's part to gain visitors have included exhibitions, plays, guided tours, open studio days and art fairs. Students, ranging from pre-school to university, are targeted as visitors, but the JCCAC says it also receives visitors from non-governmental organisations and the general public.

So says that recent visitor statistics are estimated at around 280,000 per year, and are increasing as interest in art in Hong Kong increases, but the tenant says: 'I don't trust the JCCAC management. They are bluffing about the numbers to the public. On a Saturday and Sunday there are about 20 to 30 people at most,' adding that those visiting are not real art appreciators, but those who treat the JCCAC as a mall. She says she personally would welcome more genuine visitors, and for them to spend more time in her studio. The reality is that despite affordable rents, the JCCAC is often eerily quiet. One reason is that most artists have day jobs to support themselves. The bilingual JCCAC brochure warns visitors: 'Don't be disappointed if artists are not at work in their studios during your

visit – keep the brochure and meet them on your next visit.'

But, says Tai: 'The JCCAC is most popular when it holds local handicrafts fairs. These are very successful because they combine a commercial element with art, attracting a lot of young visitors to buy things and support local artists'.

Some say that behind the lack of visitors is an overestimation of the interest that the general public have in art. Although art is a compulsory subject in local primary and secondary schools (Forms 1 to 3), to many Hongkongers, the subject is not very important. 'There's only one art school in Hong Kong, the Chinese University. How they accept students at the university has contributed to the state of art – they look for students with high marks in other subjects, and have produced art students with no spirit for art,' says veteran Fo Tan-based artist Chris Ku, adding that even lecturers are disheartened because of policy, because they don't have much say over administrators. 'This has a profound effect on students, and is the root of the problem,' he says.

Though potentially well intentioned and successful in bringing art to debate, some say the likes of the JCCAC take something away from art, turning it into an event instead of simply letting it be 'art for art's sake'. In the words of the website of Hong Kong's art mall K11: 'Art events have found a new stage'.

However, others, like Tai, say that the JCCAC is a down-to-earth art centre, which is attractive in terms of its lack of arrogance. 'I am optimistic that arts' appreciation in Hong Kong will flourish but the artists certainly need more support, be it monetary or governmental,' she says, adding that according to her, Hong Kong people love art – they just need more space to develop it.

References

Jockey Club Creative Arts Centre (JCCAC), 30 Pak Tin Street, Shek Kip Mei; Tel: 2353 1311; Web: www.jccac.org.hk

Yau Tsim Mong

To be or not to be?

Outlook for culture at West Kowloon is still shaky despite the long presence of the Union Square development

To be or not to be? remains a fitting question regarding the West Kowloon Cultural District (WKCD), the 40-hectare reclaimed area in Yau Tsim Mong district, which is supposed to be all about the arts, but remains a construction site.

There have been various reasons given for the delay such as the mixed objectives of the district to meet local needs, on the one hand, and business needs on the other. Former Hong Kong chief executive, Donald Tsang, said the WKCD was aimed to be 'a major initiative to promote arts and cultural development to enrich Hong Kong people's cultural life', and also that governments around the world have become 'increasingly aware of the importance of arts and culture in terms of positioning a city ... in the premier league ... [and] in the minds of potential visitors, city workers, and of course inward investment'. The first objective is a Hong Kong-centric one for locals, while the second is one which some say will have little impact on the lives of most ordinary Hong Kong people.

There have been many justifications for the HK$21.6 billion expenditure from the Hong Kong government including that 'exposure to arts and culture fosters pluralistic and progressive thinking', as said at a forum in 2009 by Henry Tang Ying-yen, former chief secretary for administration and former chairman of the board of the West Kowloon Cultural District Authority. But, others say the money could be better spent.

'Foster + Partners was selected by the board of the the WKCD Authority taking into account the views collected from the Stage 2 public engagement exercise. Hong Kong is in the process of planning approval by the authority and on-site construction will start in 2013 given the right blessing by the

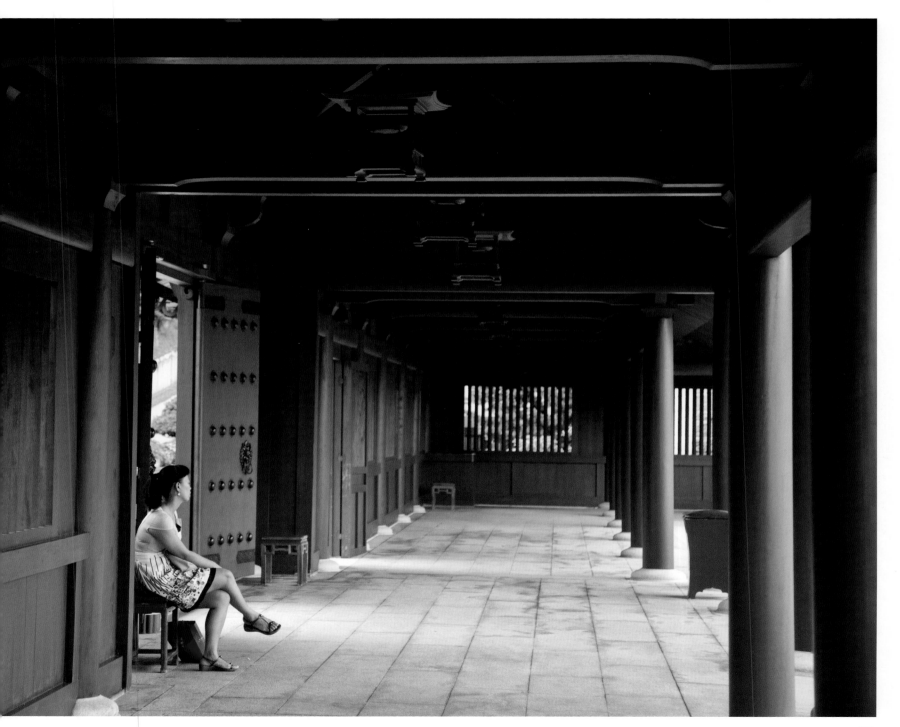

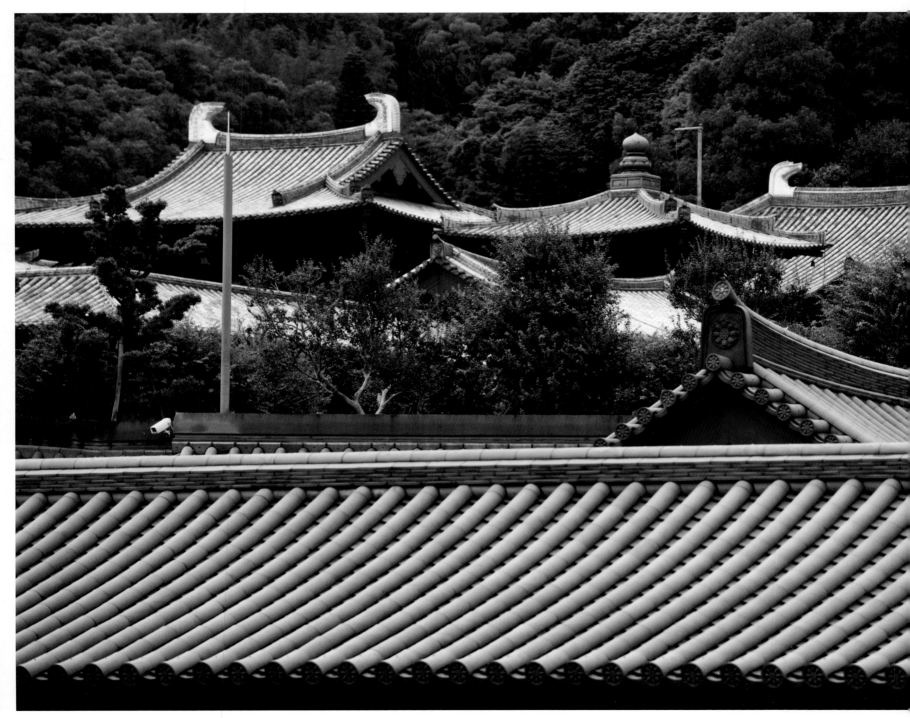

太歲祈福星燈

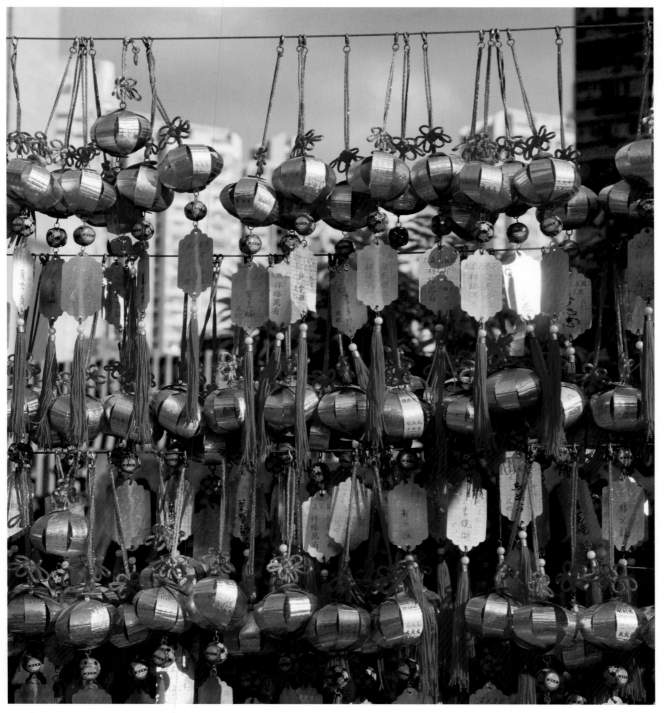

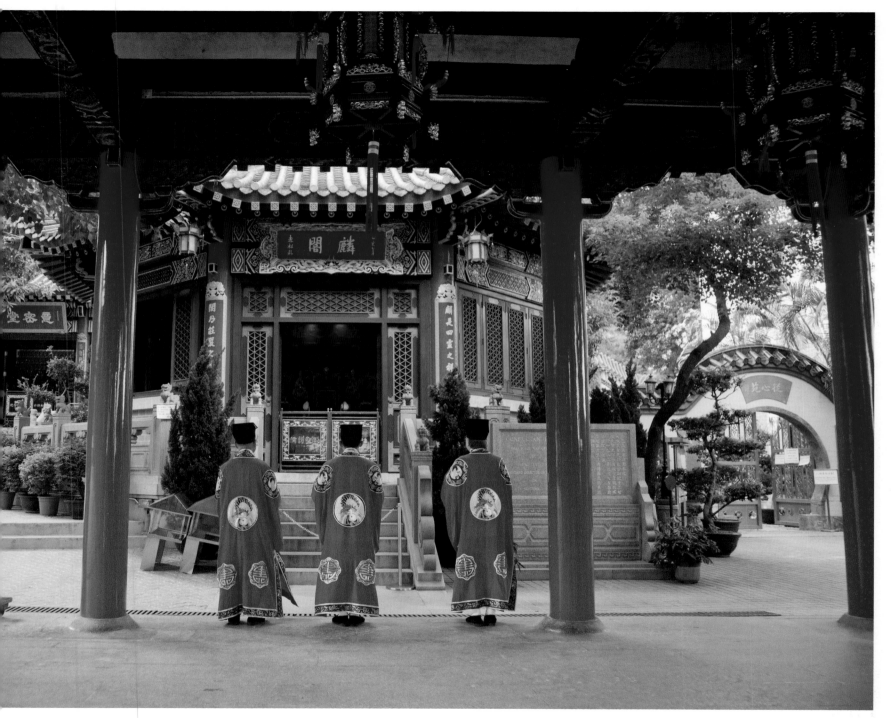

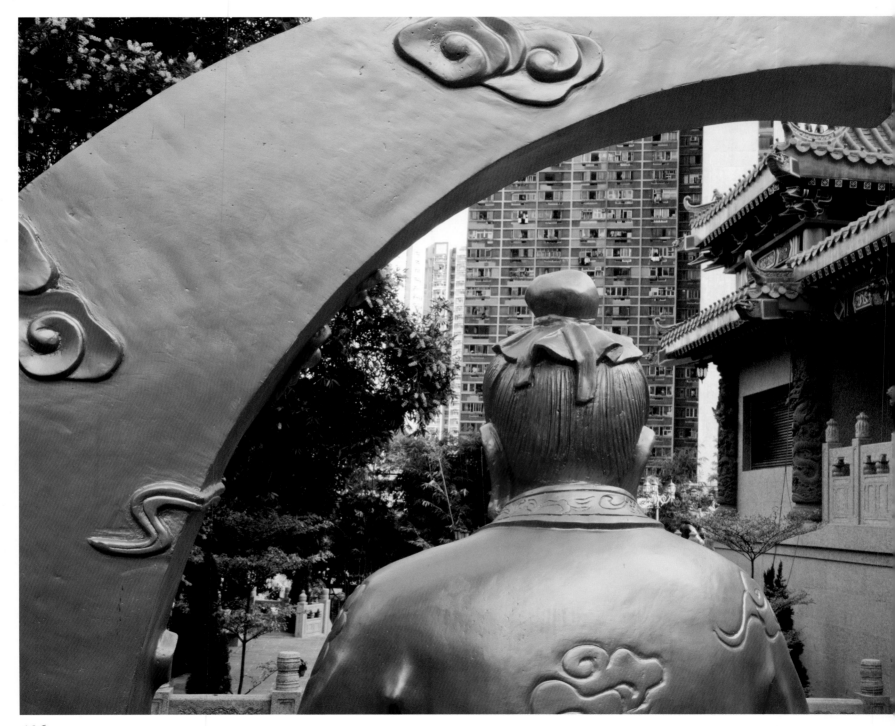

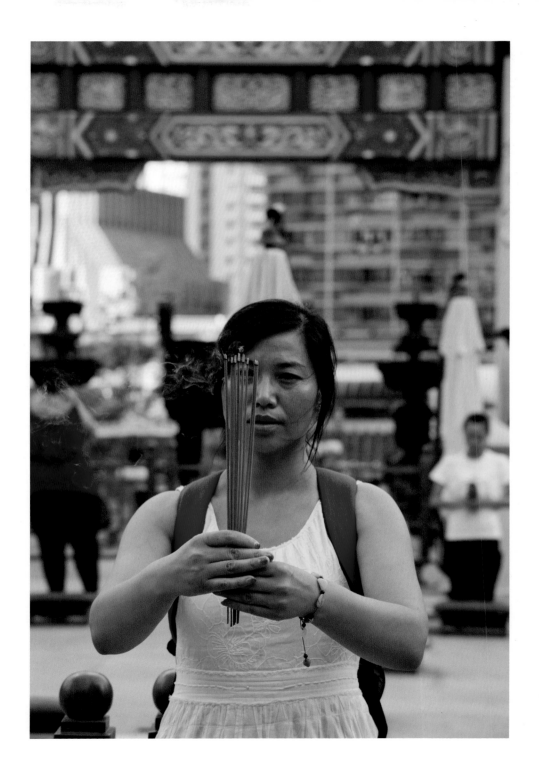

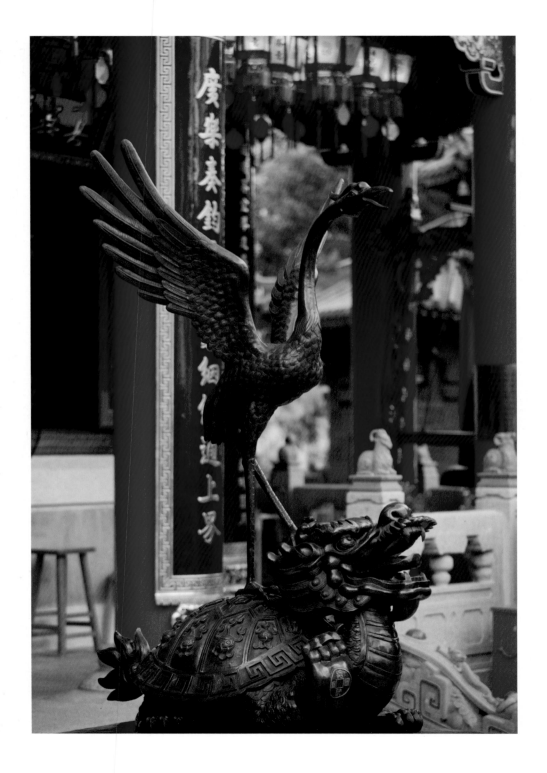

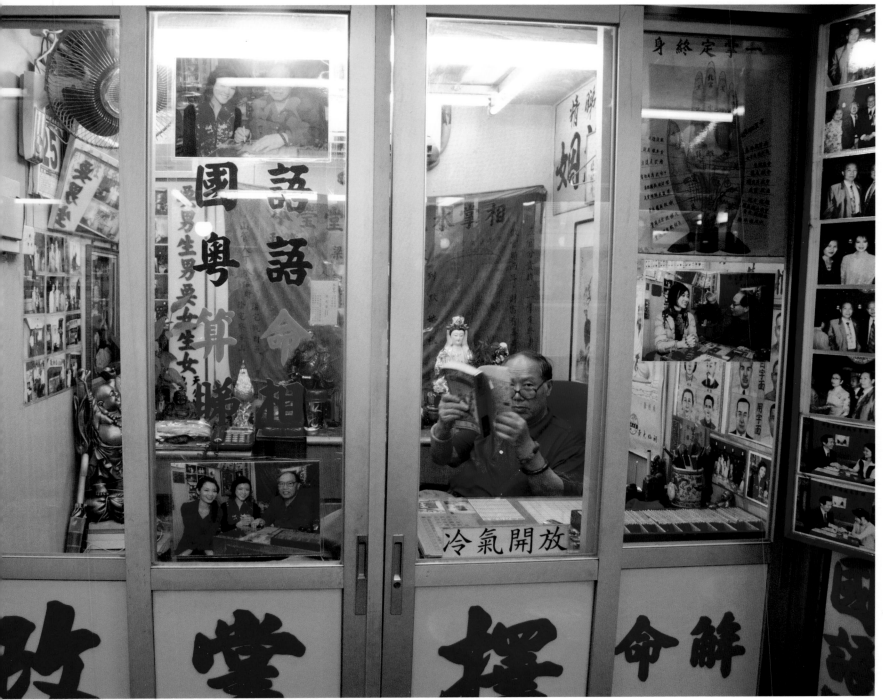

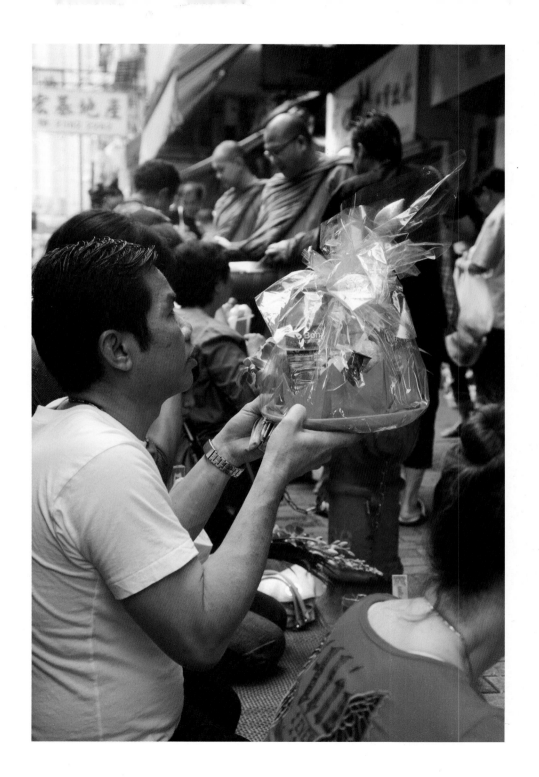

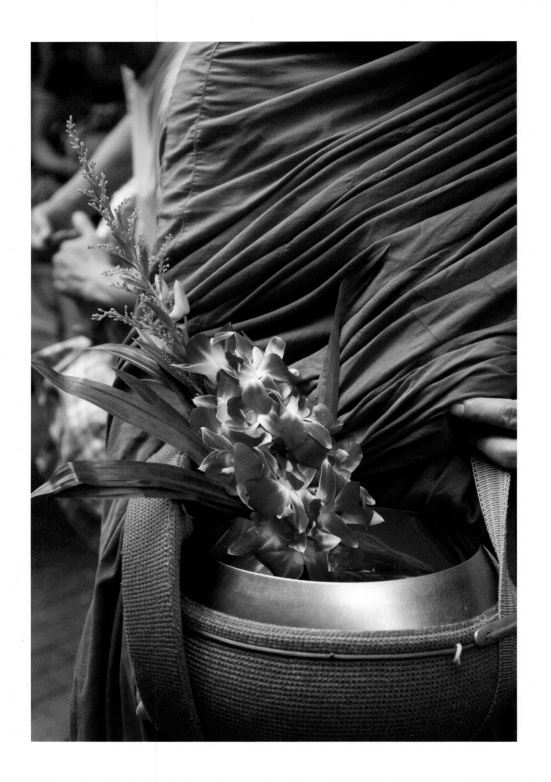

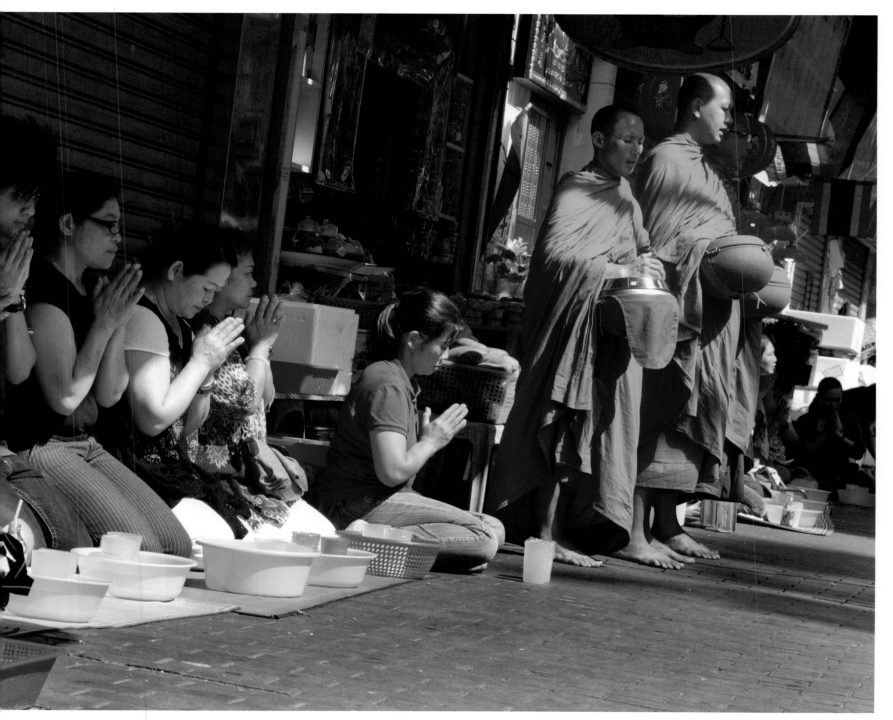

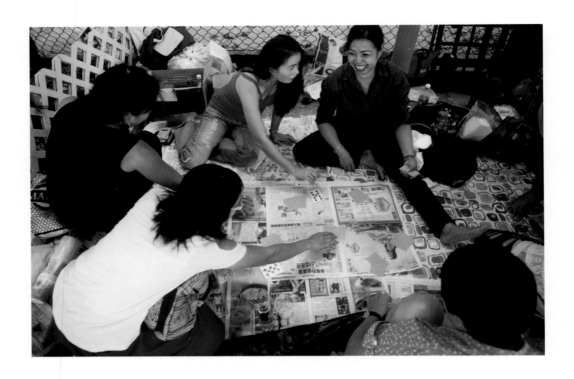

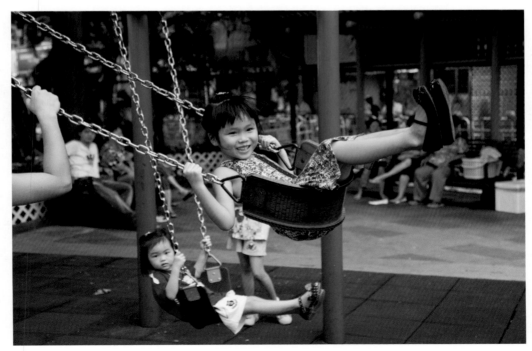

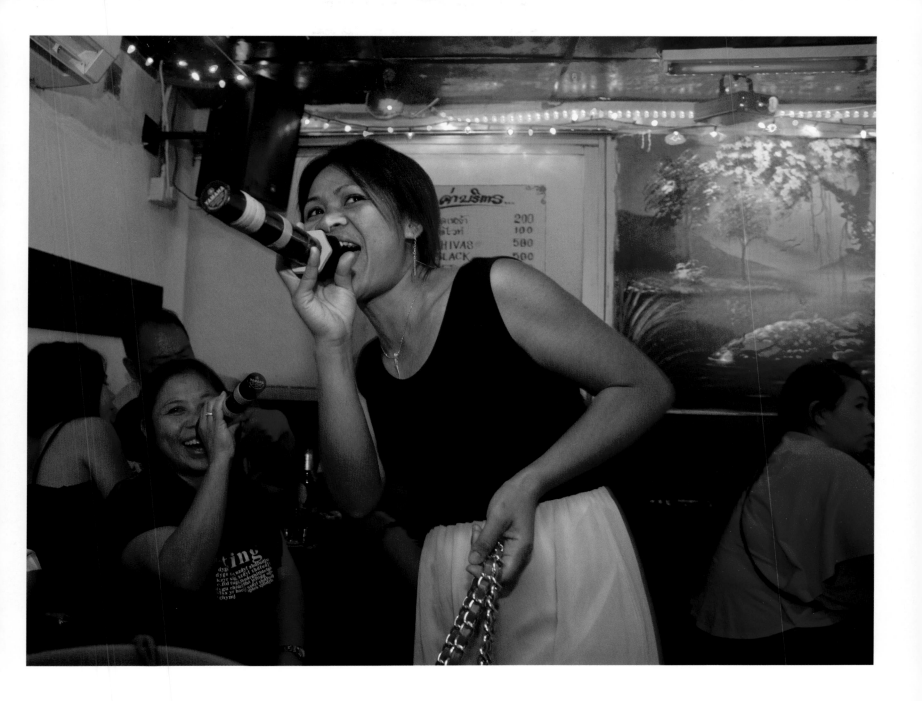

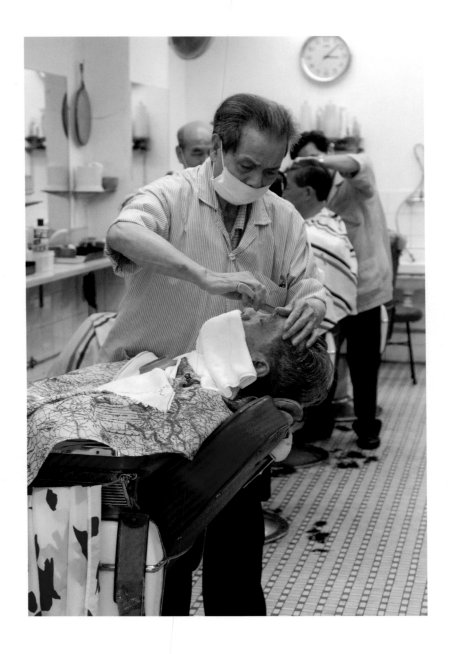

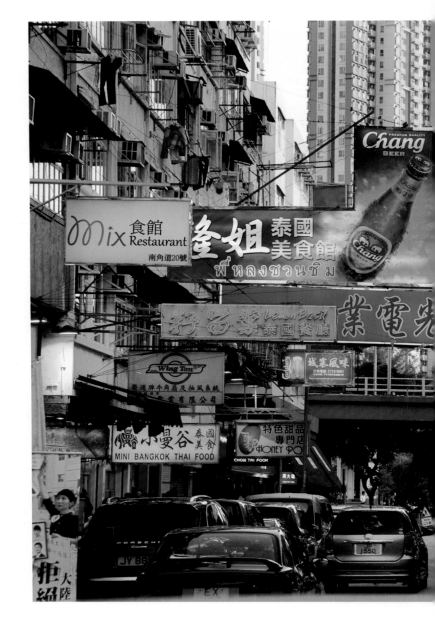

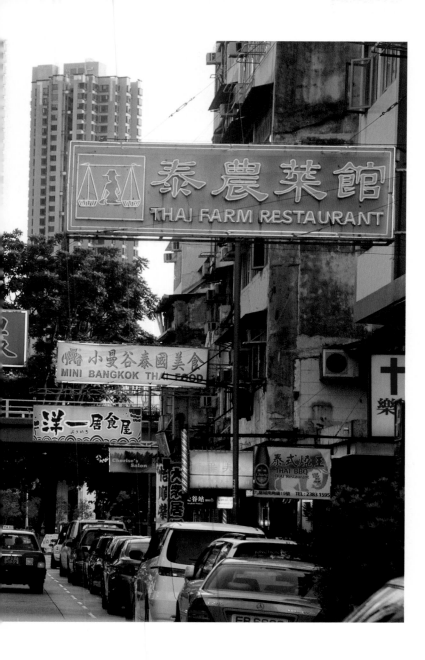

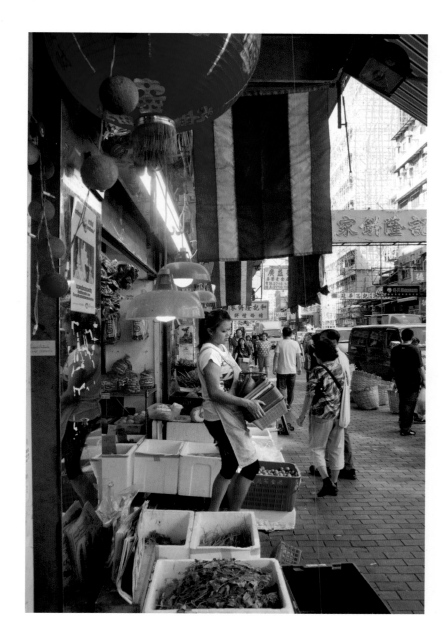

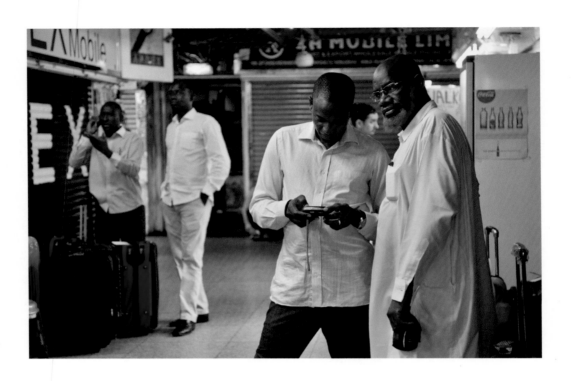

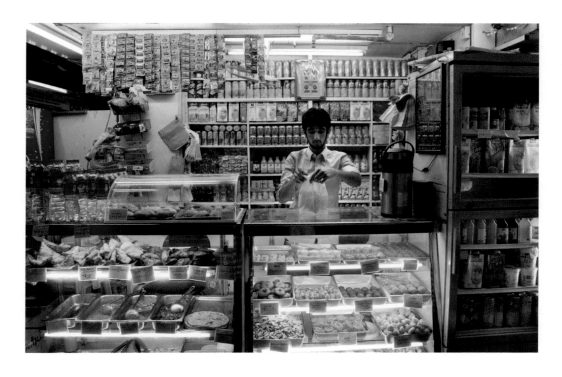

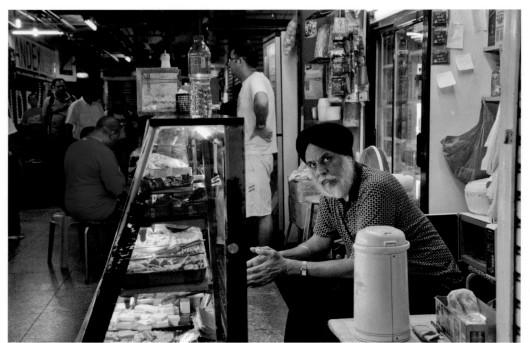

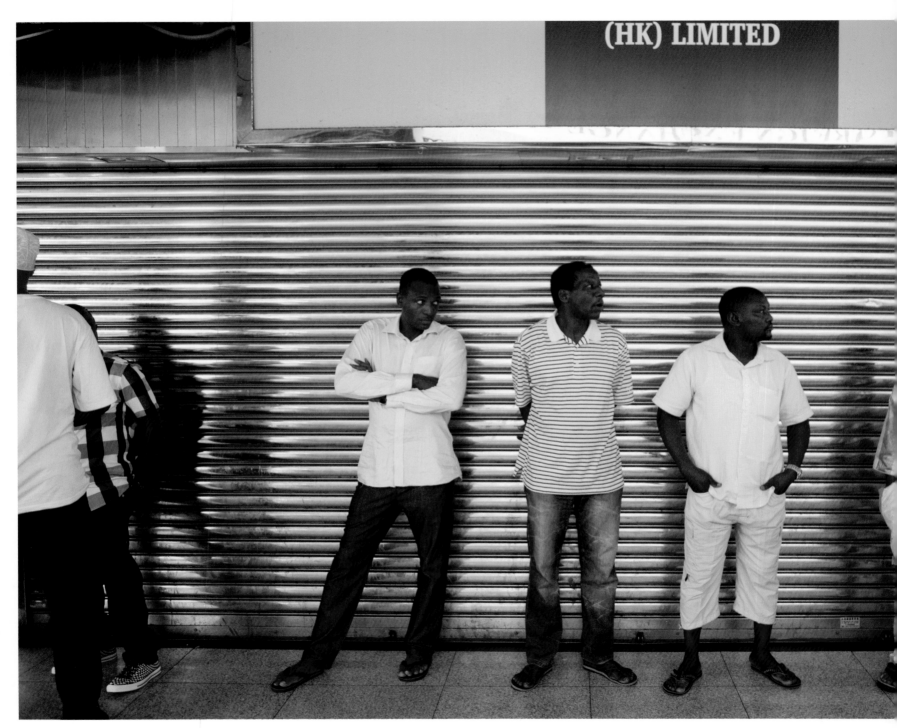

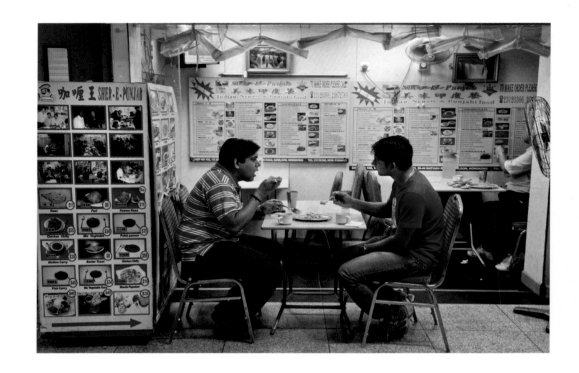

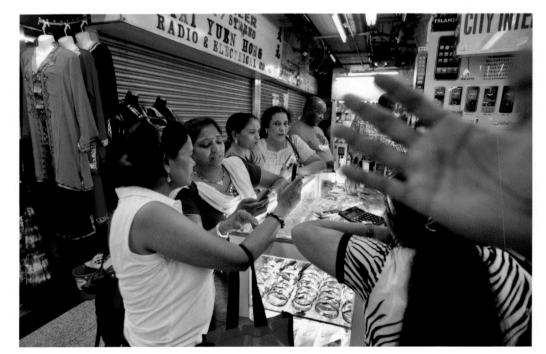

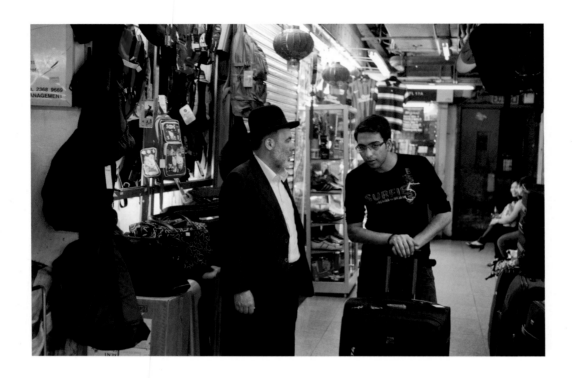

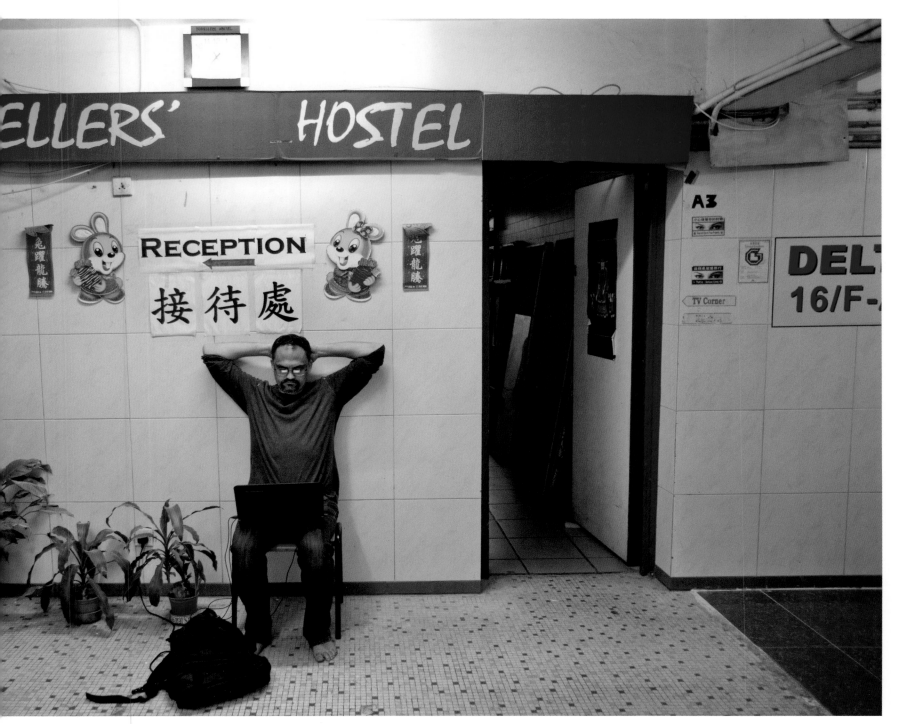

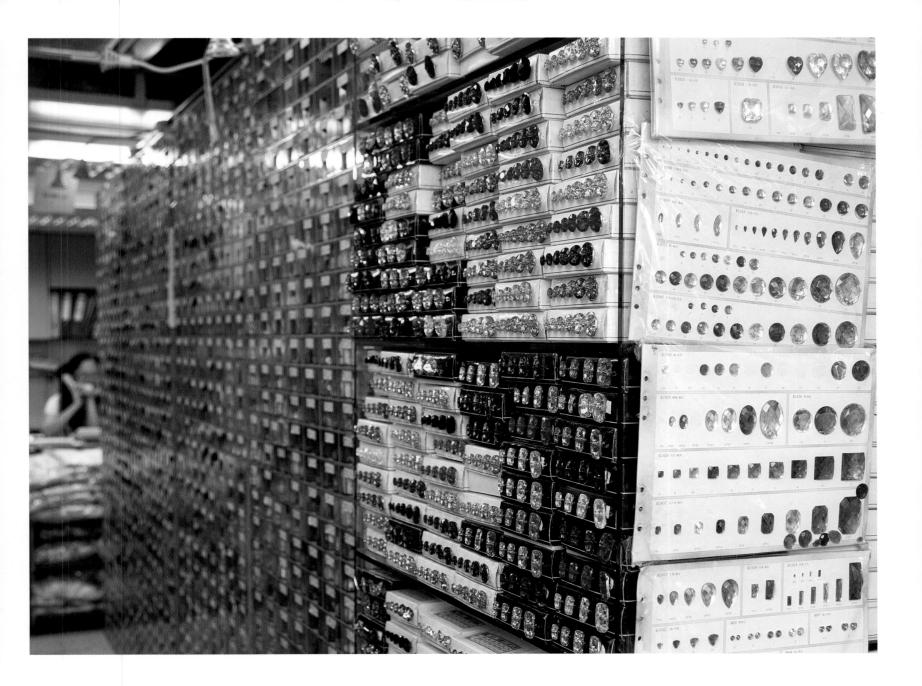

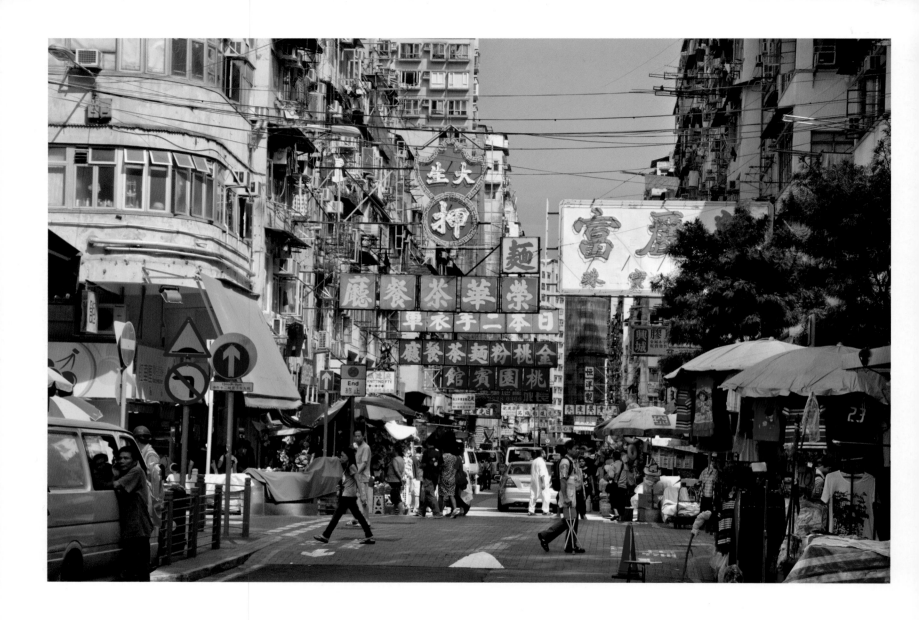

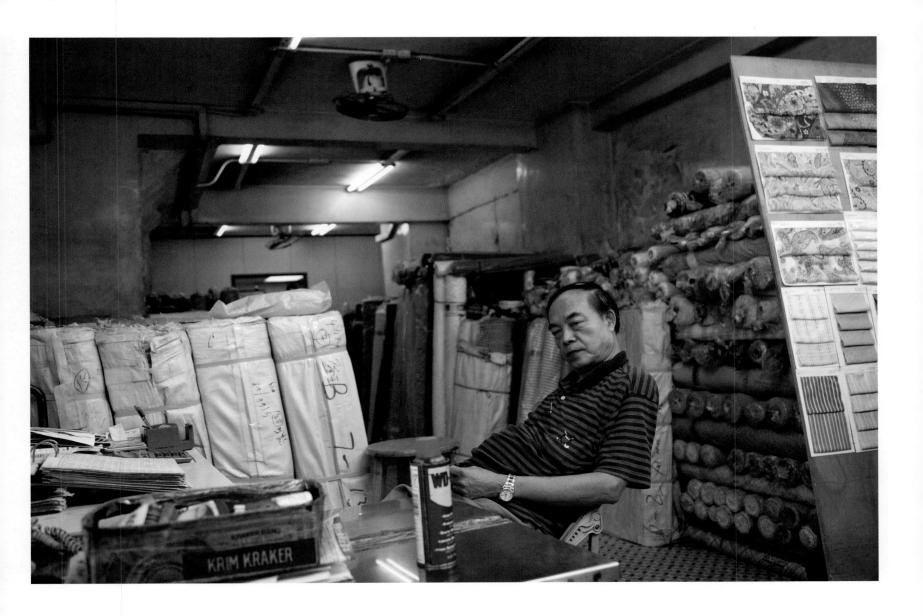

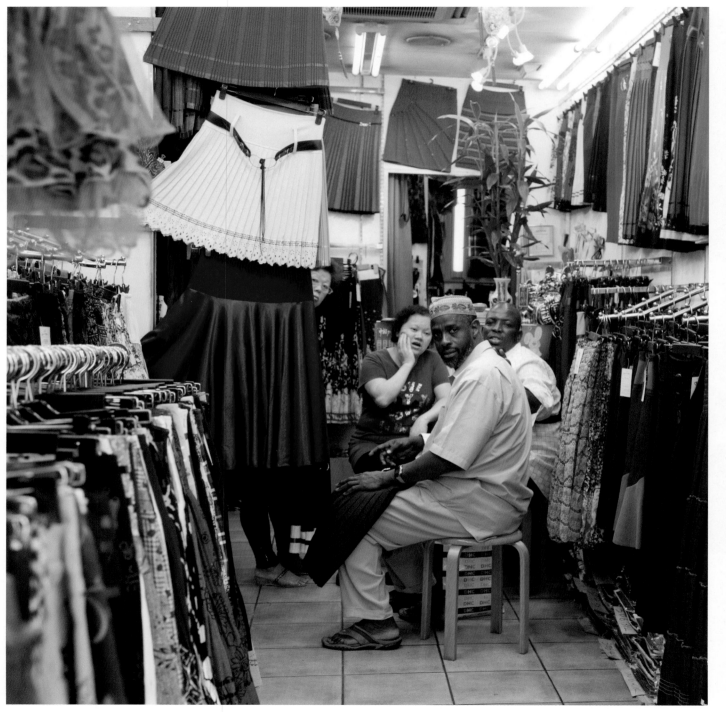

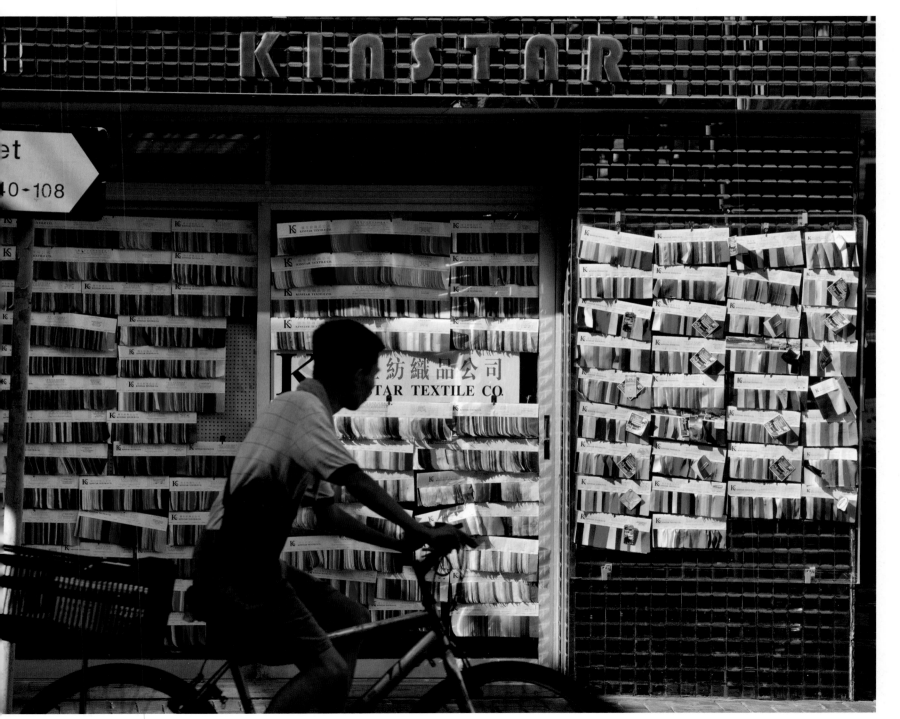

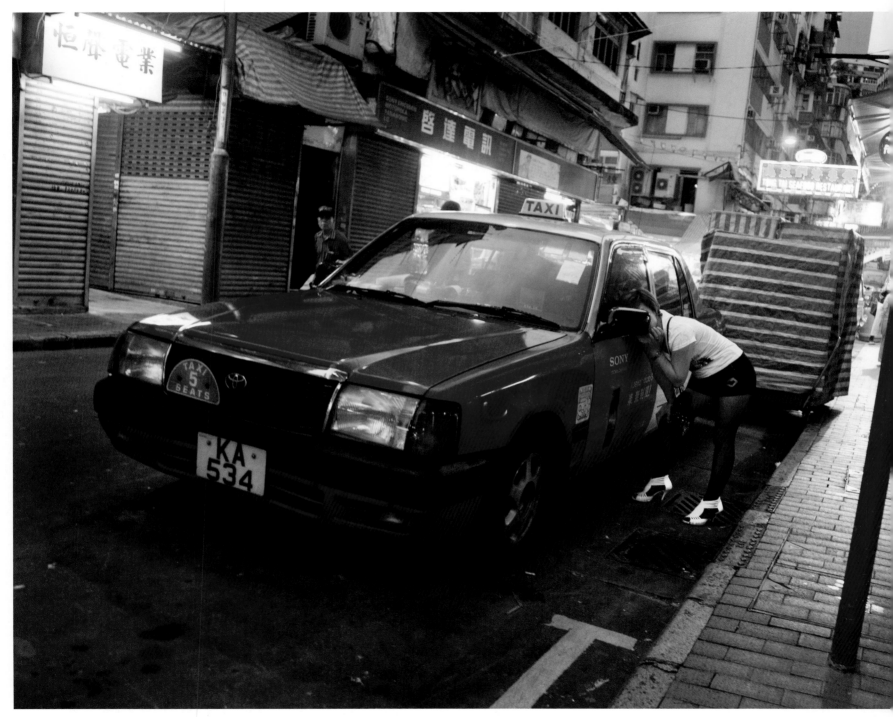

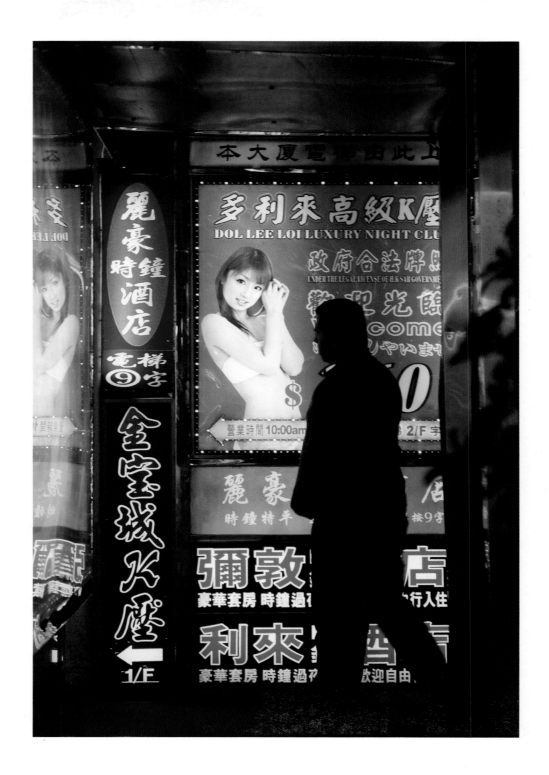

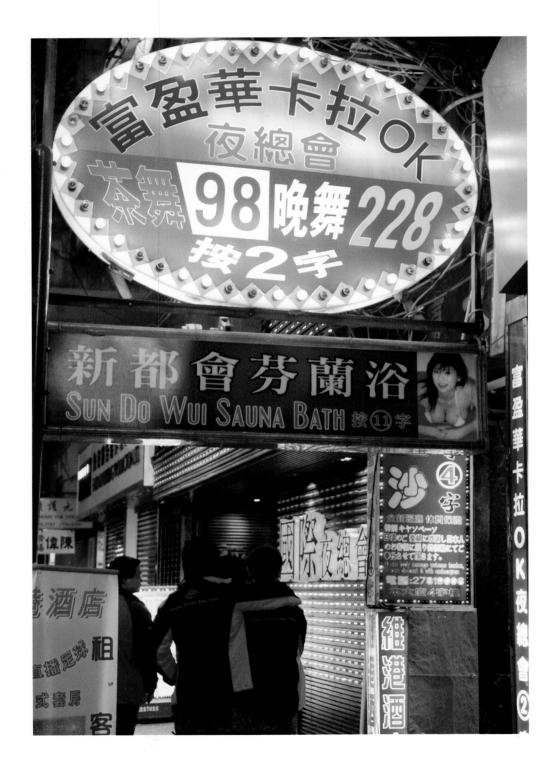

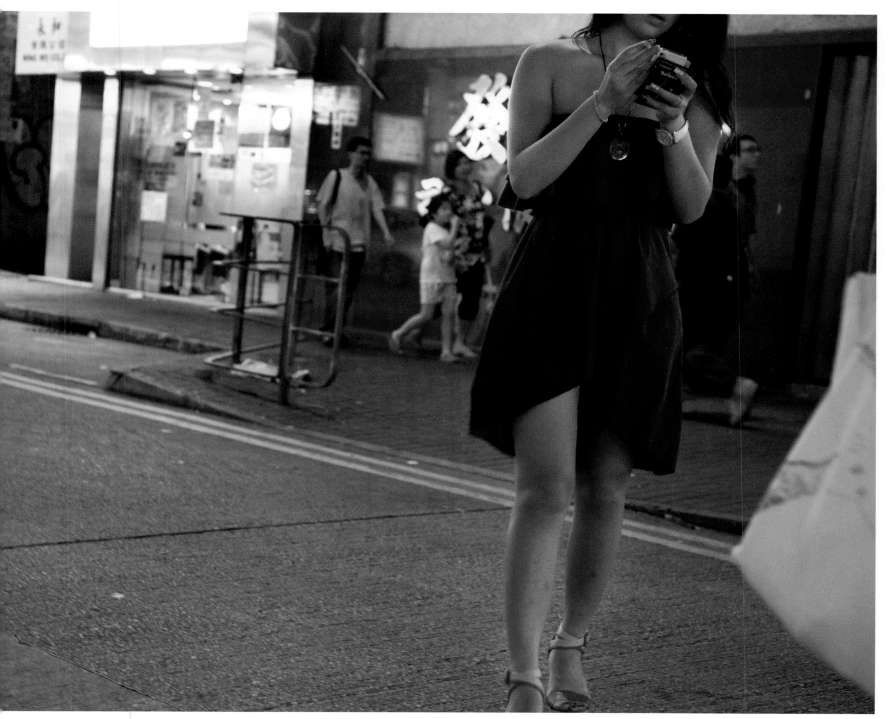

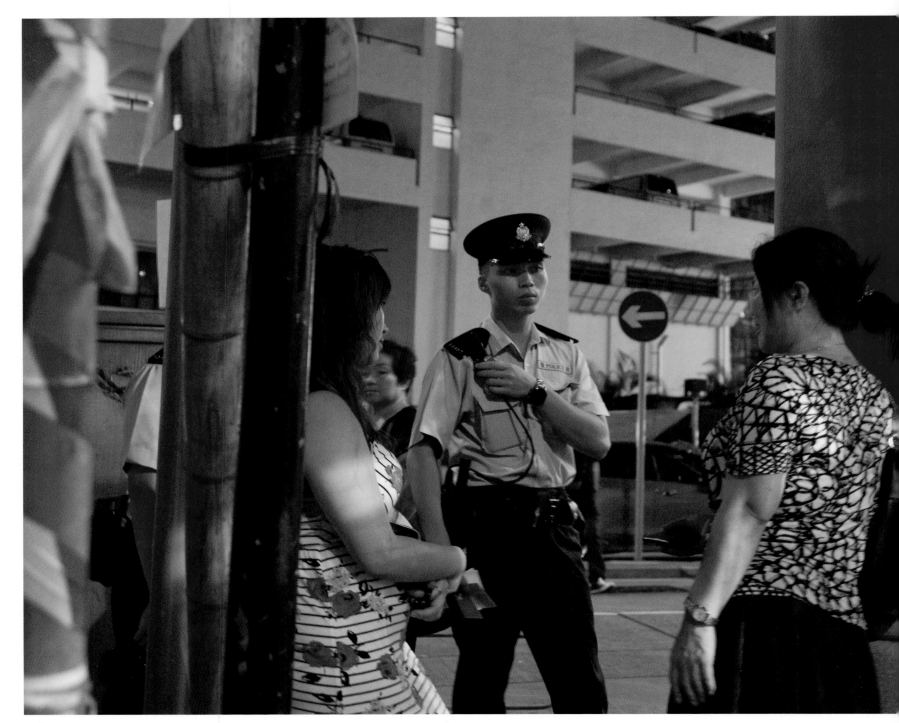

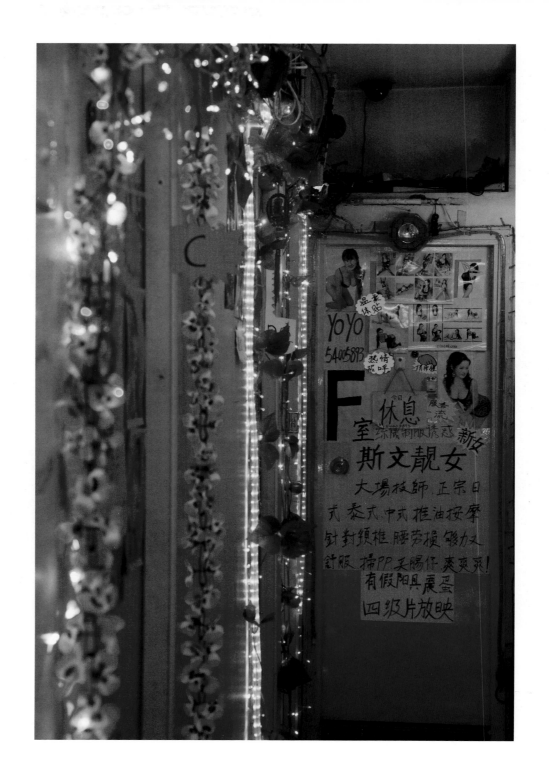

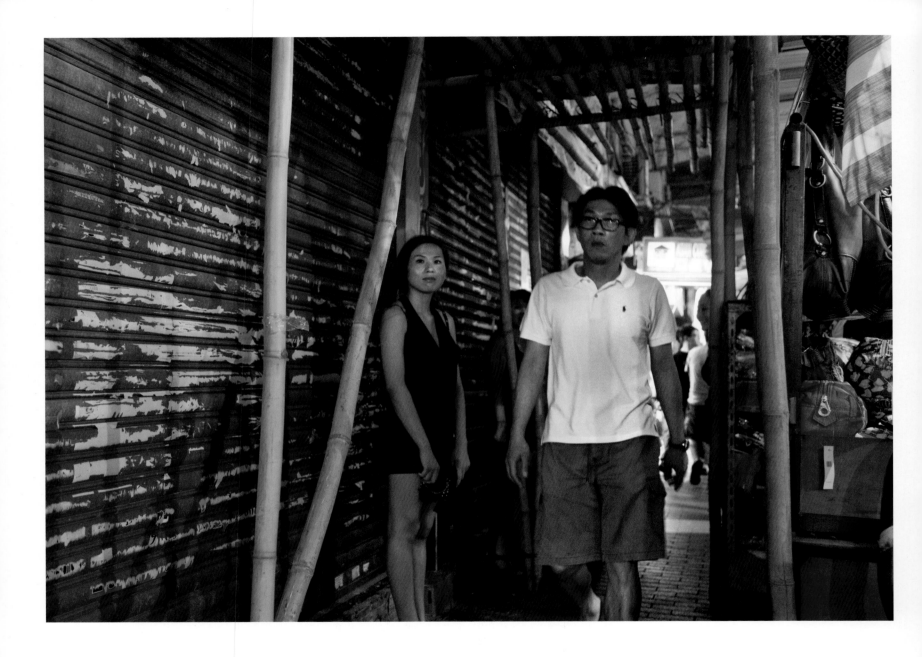

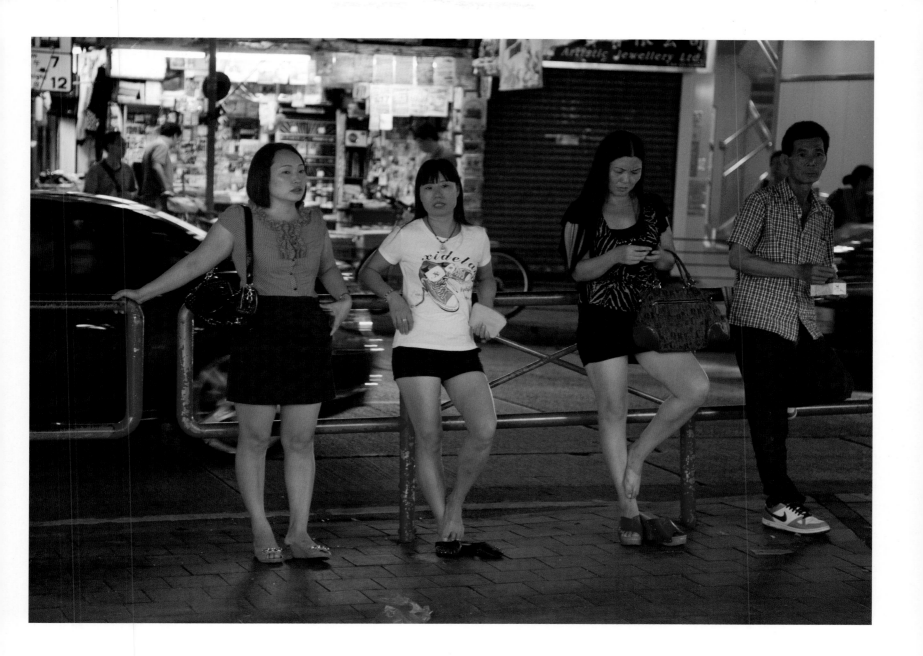

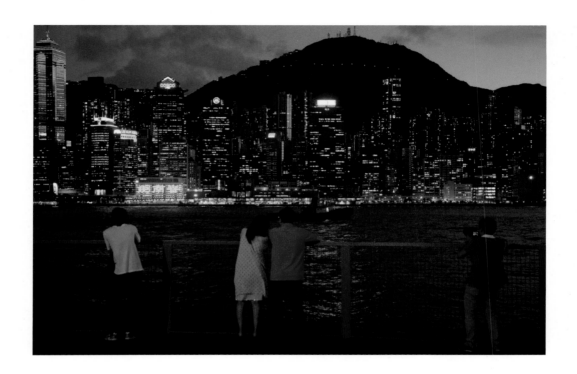

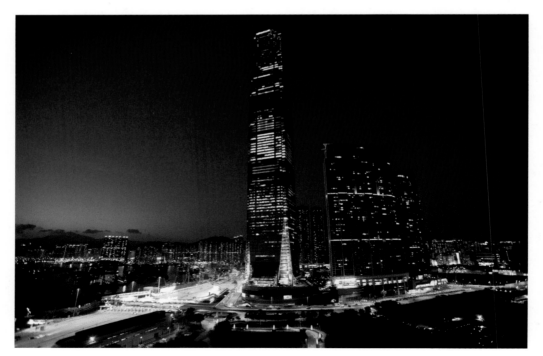

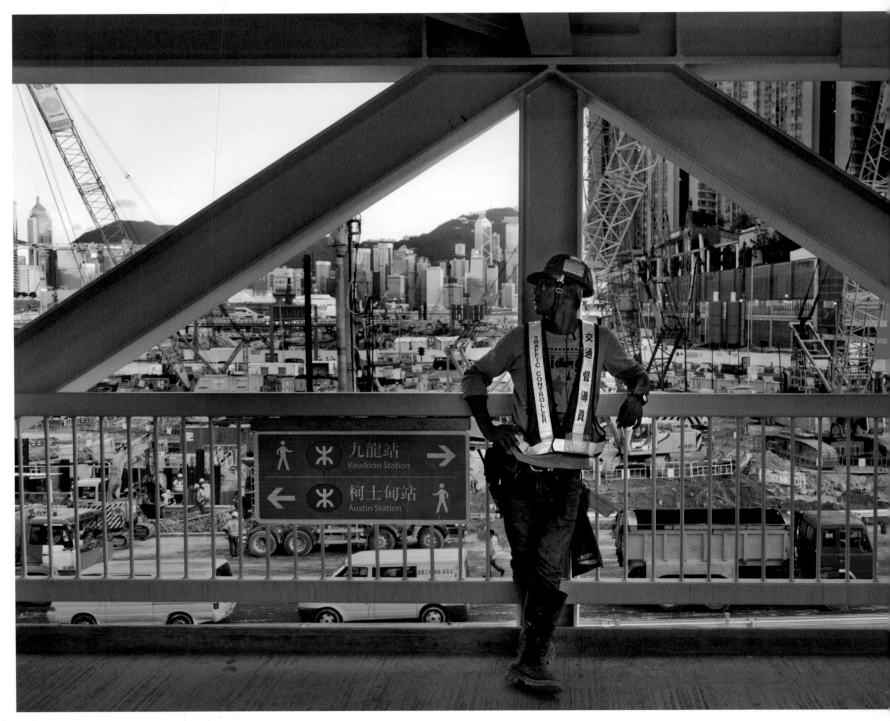

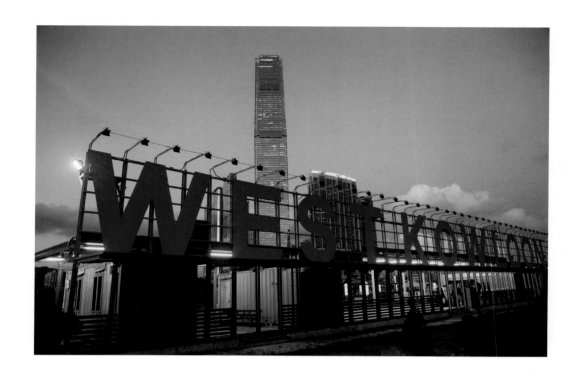

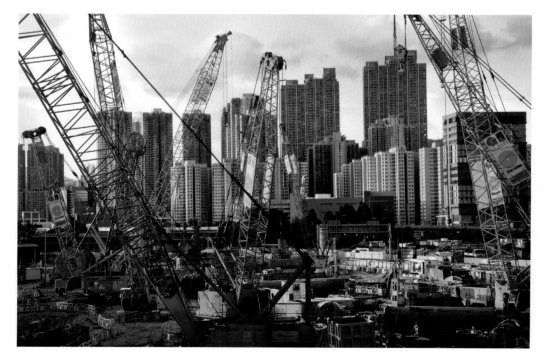

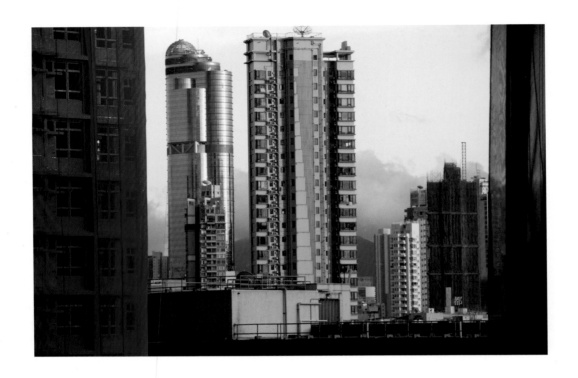

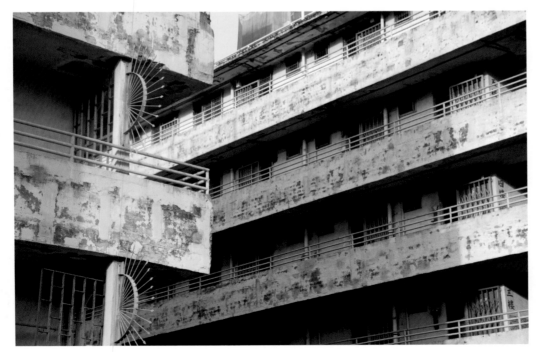

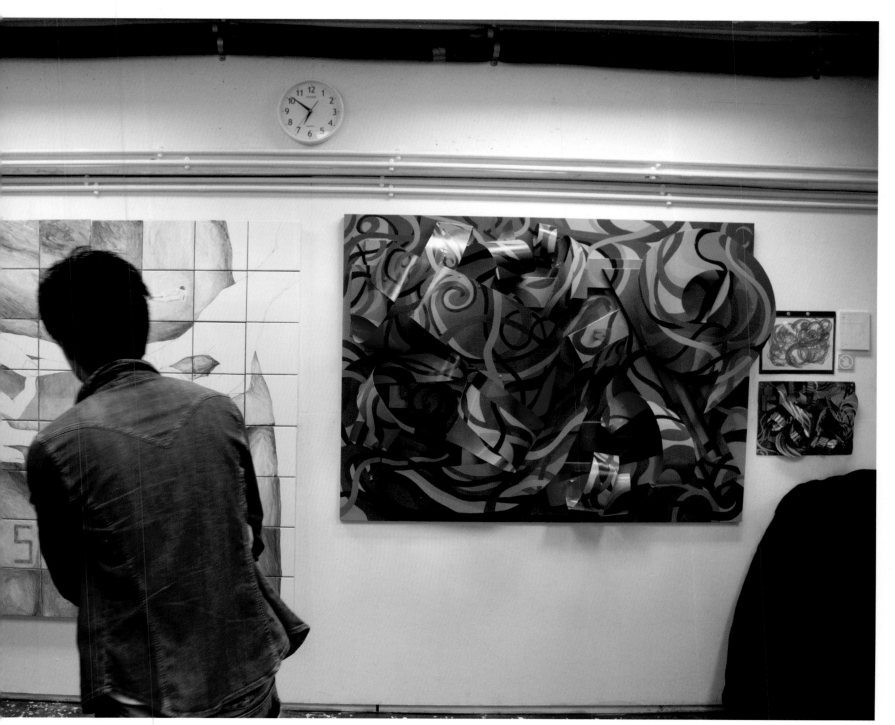

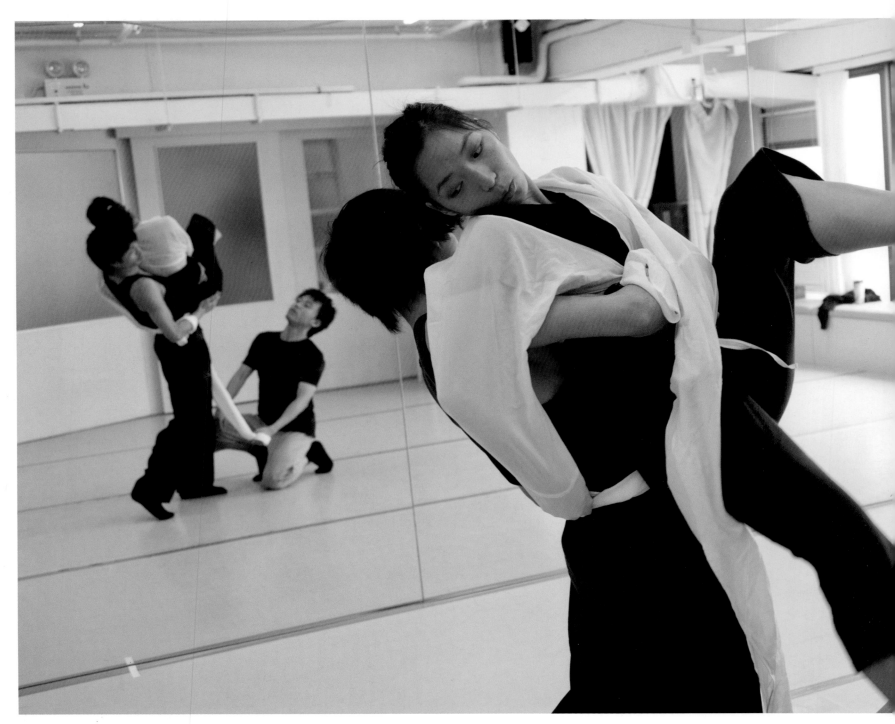

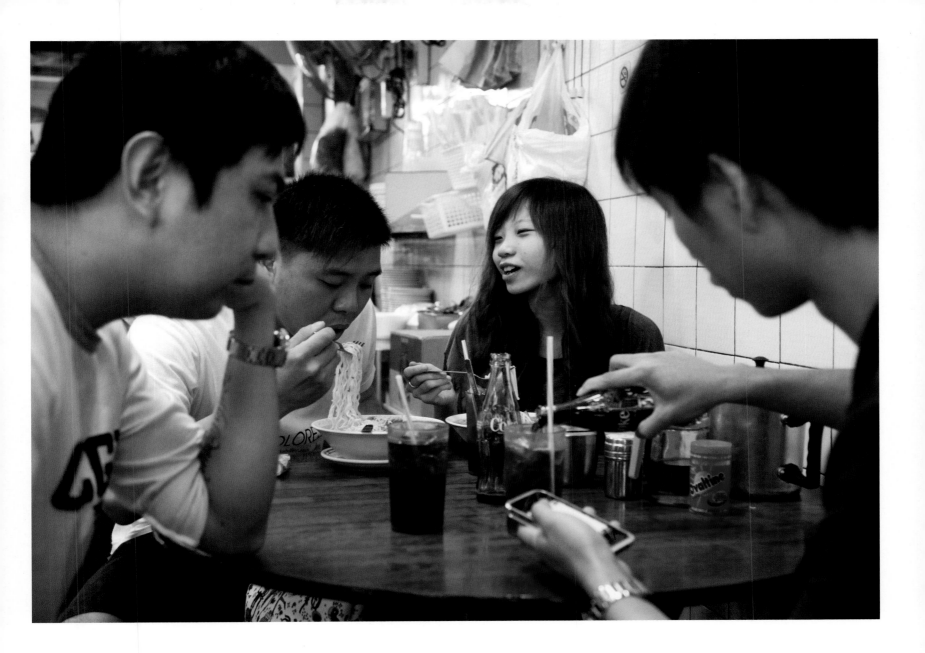

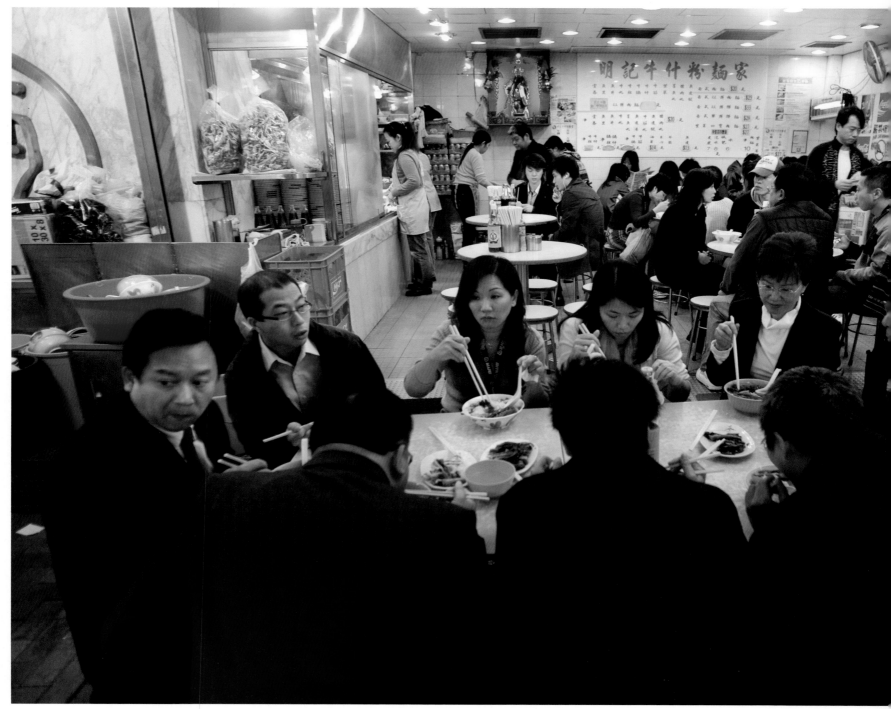

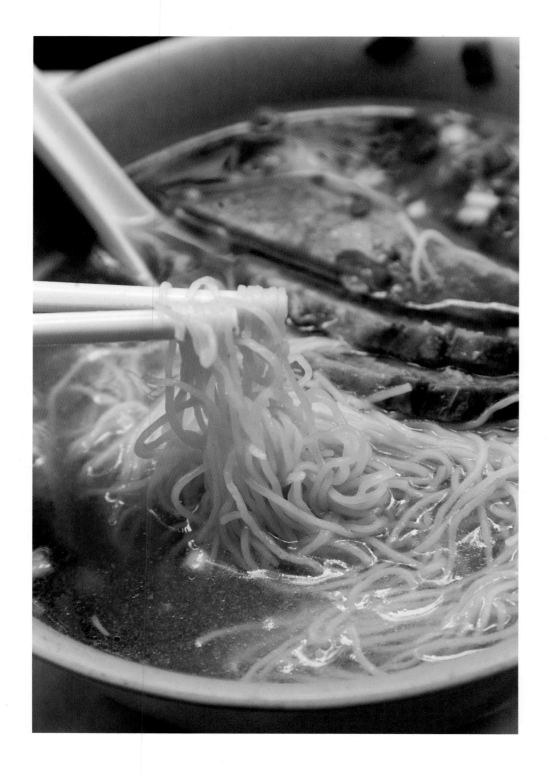

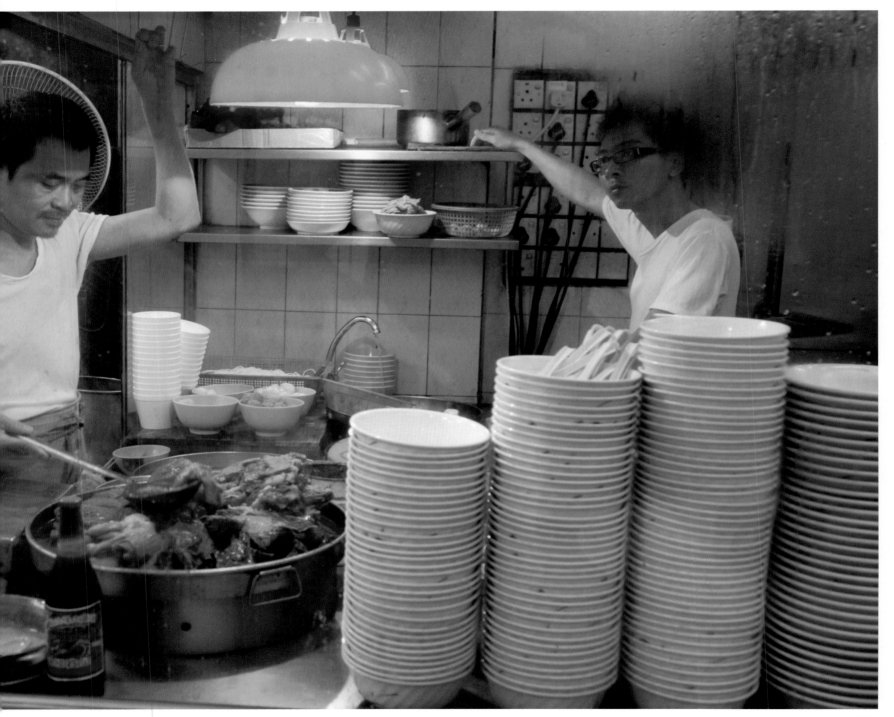

right authority,' says Martin Fung, consultancy team member on architectural sustainability under Rocco Design's team (a competitor of Foster + Partners) for the Conceptual Plan competition.

In 2001 an international competition was launched to develop a master plan for an arts, cultural and entertainment district on the West Kowloon waterfront. One hundred and sixty-one entries were studied, after which Lord Norman Foster of Thames Bank's Foster + Partners was named as the winner. The first of the new facilities was expected in 2008, but the signature feature, a canopy flowing over the various spaces contained within the development, said to be inspired by the local landscape and traditional Chinese art forms and calligraphy, failed to go down well with the Hong Kong public, and the plan was subsequently scrapped – some say in a contrived show of respect for locals following Cyberport, the HK$15.8 billion project in Southern district developed by Cheung Kong Holdings, a leading land developer in Hong Kong controlled by Asia's richest man Li Ka-shing, which critics say masqueraded as a proposition to commercialise creative digital ideas and start-ups, but which was really just another real estate project and an example of the inappropriately close relationship between the Hong Kong government and big land developers. Cyberport involved the construction of four grade-A office buildings, a five-star hotel, Le Méridien Cyberport, a retail entertainment complex and about 2,800 deluxe residences completed in phases between 2002 and 2004, but as reported in *The Standard* newspaper, in 2006, four years after the grand opening, the occupancy rate was merely 54 per cent, though the rent was cheap at HK$11 per sq ft.

'I think the time it has taken them to get to the point that they are now is unconscionable. To do God knows what? They have been going to endless meetings. If it is going to be run like a typical government development scheme, there will probably be more luxury housing in the vicinity and the planning process is going to be dragged out,' says Bonnie Engel, a veteran writer on Chinese and Asian art.

Perhaps owing to Cyberport, much was made of engaging the public, which was a long process. According to the WKCDA website, this involved a three-month Stage 1 public engagement exercise in 2007 to explain the Consultative Committee's recommendations and to gauge public views on the project.

According to the board of the WKCDA, the results of Stage 1 indicated public support for the

recommendations of the Consultative Committee, and 'urged for the early implementation of the WKCD project'. But, question marks hover over how much public support the district genuinely received from Hong Kong people.

'The city has never been prepared and equipped with the confidence and competence to develop a "profitable" art hub in cultural and social terms. We definitely need a diversity of democratic and quality cultural space more than a super high dose of art venues squeezed within one locality,' says Fung.

In a city of over seven million, only 7,412 documents, including 6,688 questionnaires were gathered. The WKCD authority conducted 66 public engagement events including one student forum, one youth forum, three public forums, and 61 focus group meetings. In addition, a questionnaire was developed by the project consultant and the Public Policy Research Institute (PPRI) of the Hong Kong Polytechnic University (PolyU) that covered the overall look, ambiance, facilities and activities, programme and education-related activities, travelling to and from the WKCD, travelling within the WKCD, and planning design principles. The PPRI also conducted face-to face interviews to capture the views of Hong Kong residents and visitors.

During Stage 2 of the public engagement exercise in 2010, three designs were unveiled from British Foster + Partners, the Dutch Rem Koolhaas' Office for Metropolitan Architecture, and Hong Kong's Rocco Design Architects.

Foster is well known to Hongkongers for his previous work in the territory: the Hongkong and Shanghai Bank Headquarters (1979–1986), Chek Lap Kok Airport (1992–1998), and the HACTL Superterminal (1992–1998). On the Mainland, the company built the Beijing Airport (2003–2008), Jiushi Corporation Headquarters in Shanghai (1995–2001), and the UAE Pavilion in Shanghai for the Shanghai Expo 2010.

But, what of Hong Kong's need for arts and cultural facilities at West Kowloon? Supporters of the district say that it's always good to have more spaces for art and culture, and that whenever an opportunity arises such as West Kowloon there's scope for good things to happen. But, among other things, critics of the conceptual plans say that the emphasis on parkland shows no connection with 'culture' and that 'the district will contribute nothing'. They see it as a misallocation of public funds, and a showcase that won't yield any social, cultural or economic benefit for local people. But Fung says: 'There is no conflict between art and

the funds being spent on other things like social security. Hong Kong is rich enough to appropriate the right amount for social security.'

According to a 2010 street survey conducted by the Chinese University of Hong Kong, 44 per cent of local residents thought the WKCD has nothing to do with their lives, and among the 56 per cent who said that the WKCD was related to them, less than 30 per cent thought they would enjoy the cultural and recreational facilities.

'Art and culture are always treated as side dishes to Hong Kong's daily nourishments,' says Fung of Rocco Design.

Meanwhile, back in 2006, when the project was overturned, a survey of 310 tertiary students revealed that only 25 per cent of interviewees 'usually' or 'occasionally' view cultural performances, and 55 per cent said they 'seldom' or 'never do so'. One student from PolyU said: 'There are very few art lovers in Hong Kong. I don't think there will be any visitors after the facilities are completed. I'm not interested at all. If I go there, it will be for the shopping.'

There is also the question of whether the arts and culture are truly important in 'positioning a city in the premier league'. And, will such a district in Hong Kong expose people, locals and visitors to arts and culture and foster pluralistic and progressive thinking – and is this kind of thinking that the Hong Kong and Central governments actually want?

The world's 'premier cities' in art are London, New York and Paris. The former has the National Portrait Gallery, the Tate Museum, the Tate Modern, The Royal Academy of Arts, the Hayward Gallery and the Saatchi Gallery to name a few. Meanwhile, New York has the Metropolitan Museum of Art, the Solomon R. Guggenheim Museum, and the Museum of Modern Art, and Paris has the Centre Georges Pompidou, Musée du Louvre, and Musée d'Orsay. Even Amsterdam, which has a population of 740,000 to Hong Kong's seven million, outstrips the territory in terms of reputable art museums: The Dutch capital has the Rijksmuseum, the Van Gogh Museum and the lesser known Stedelijk Museum of Modern Art.

In Asia, Japan has plenty of art museums country-wide such as the National Museum of Modern Art Tokyo, The National Museum of Western Art, The National Museum of Art Osaka and MOA Museum of Art, and many more small museums covering various cultural themes, like the Sumo Museum, Yokohama Doll Museum and Shin-Yokohama Raumen Museum. In Singapore, there is the National Museum of Singapore, Asian

Civilisations Museum, Singapore Art Museum, and the largest contemporary design museum in Asia, the Red Dot Design Museum. Meanwhile, Hong Kong's current offerings include the Hong Kong Museum of Art in Tsim Sha Tsui and the further afield Art Museum of the Chinese University.

Justina Yung, a researcher at the PPRI says that she doesn't think Hong Kong will become strong in art in 10 or 20 years. 'When you visit museums in London, New York and Paris, the displayed items have been accumulated over centuries, I don't think the West Kowloon district can make it work within 10 years. Art always relates to history and cultural appreciation and Hong Kong has a short history, and overly pragmatic residents,' she says.

The third and final stage of the public engagement took place at the end of 2011. But the development of West Kowloon is likely to be lengthy, and which structures are built first and which later is likely to spark public debate which will also slow down the project as may staff appointments.

The former CEO of the WKCD, Briton Graham Sheffield, was appointed in March 2010 for a three-year term in August 2010, but resigned in January 2011, citing health reasons. He was replaced by Michael Lynch, CBE, AM, the chief executive of London's Southbank Centre from 2002 to 2009, who had previously had a long career in arts administration in Australia.

In the meantime, critics of the West Kowloon Cultural District draw attention to the fact that everything apart from the arts part – that was supposed to be the core – has been built, that is, Union Square, a 12 million sq ft development that includes 5,866 residential units totalling 6.5 million sq ft, 2,490 serviced apartments, the 1 million sq ft Elements shopping mall, the Ritz Carlton and W Hong Kong Hotel which collectively have 2,230 hotel rooms, and 2.5 million sq ft of grade-A office space, the latter which the Urban Land Institute, a non-profit education and research institute that advises on land use practice, describes as 'the office buildings that you see in the heart of the financial district with lots of brass and glass fixtures and huge, expensive lobbies ... often occupied by banks, high-priced law firms, investment banking companies, and other high-profile companies with a need to provide the trappings of financial success.'

Union Square is a who's who of Hong Kong property developers. Two of its best known buildings include the International Commerce Centre (ICC) and Elements shopping centre, and these structures, plus the Kowloon MTR,

are developed and managed by the Mass Transit Railway Corporation (MTRC), though the ICC is owned and jointly developed by MTRC and Sun Hung Kai Properties (SHKP), which is controlled by Thomas and Raymond Kwok. The MTRC and SHKP are the two major landlords of Union Square.

The 118-floor, 484 m ICC skyscraper which combines commercial space, a luxury residential development, modern retail, and two six-star hotels, the Ritz-Carlton and W Hong Kong was completed in 2010. Upon completion, it became Hong Kong's tallest building, with the fourth highest roof in the world, after the Burj Khalifa in Dubai, Taipei 101 in Taiwan, and the Shanghai World Financial Centre. Its presence in West Kowloon illustrates the expansion of Hong Kong's business district. The ICC is directly across from 2 International Finance Centre (2 IFC) in the Central business district – 2 IFC was co-developed by SHKP. Meanwhile, the Elements middle-class shopping centre opened in October 2007, slogans for which include 'Shop till you drop', and 'Why be plain?', sits atop Kowloon MTR Station.

The MTRC was established in 1975 and listed on the Hong Kong Stock Exchange in 2000. Prior to its listing, the company was wholly owned by the Hong Kong government, which still maintains a majority stake in the company. The company also owns several shopping centres, having followed a formula of developing its properties next to its railway stations. Many stations are incorporated into large housing estates or shopping complexes.

Meanwhile, SHKP is one of Hong Kong's largest landowners with a land bank of about 46.7 million sq ft, according to the company website, most of which is in the process of land use conversion for residential development. Its investment property portfolio generated gross rental income of HK\$12.6 billion in 2010/11. The company was publicly listed in 1972.

The MTRC and SHKP are the two major landlords of Union Square. In addition to developing and managing ICC, Elements and Kowloon Station, the MTRC also co-developed luxury residential block Sorrento completed at Union Square in 2003. The Sorrento contains five towers, the tallest of which is 75 floors and 256 m tall. Meanwhile, SHKP developed The Arch, the 81-floor, 231 m tall skyscraper so-named because its Sun and Moon towers join at the 69th floor and floors above to form an arch. It was completed in 2006, and the 68-floor 270 m Cullinan residences completed in 2008 and 2009, which *Time* magazine said, 'could well qualify as the world's most

expensive apartments'. Accommodations at the Cullinan range from studios to three bedrooms at a rental of up to HK$110,000 per month.

Rounding off the Union Square development is the Harbourside, a 75-storey 255 m tall residential skyscraper developed by Hang Lung Properties completed in 2004, and the Waterfront, developed by a consortium led by Wing Tai Asia and completed in 2000.

The handful of major land developers and their pursuit of profits accounts for the changing cityscape of Hong Kong and the increasing uniformity of districts irrespective of their history and letters of complaints to the local newspapers about the proposed development.

Union Square has nothing to do with ordinary Hong Kongers. The WKCDA has proposed WKCD's integration with neighbouring areas, in Kowloon, but this seems like a token gesture to appease locals. However, the WKCD does seem to serve the needs of visitors and city workers coming through Kowloon Station.

Are the arts and commerce mutually exclusive? While still in his post, Sheffield said that the Barbican and WKCD 'share the same template in the sense that they are both multi-arts, they both will have some commercial income from things that go on like catering, retail and so on. The one thing that people always forget is, yes, you do get government funding, but you also have to earn a lot of your own money through commercial income, through sponsorship, through box office... So it's in the multi-arts nature, the complexity of it, the scale of it... West Kowloon will probably be about four times the size of the Barbican.'

The election of another foreigner, Swede Lars Nittve, was announced in June 2010 and he took up his post as executive director of the district's M+ Museum in January 2011. Nittve was previously the first director of London's Tate Modern in 1998 and Stockholm's Moderna Museet.

'I guess there's hope because of [Lynch and Nittve's] experience at the Barbican, but these are Western people who have so little to do with Asian culture. We should be working closer with China or the Chinese diasporas. It smacks of running back to daddy, the big colonial masters,' says art writer Engel.

She and others are concerned that West Kowloon will be a showcase for big international names at the expense of Hong Kong artists.

'I've never seen any Hong Kong art at auction... [though] there was huge art in China commissioned 10 years before the handover to document and to

be a kind of a painterly record of important people involved,' says Engel. 'There was that fantastic photograph of the Brits and Chinese on their two sides and right in the middle, was former Chief Secretary Anson Chan in that red dress. And someone took a photograph and blew it up to an enormous size. That was painted by a Hong Kong artist.'

Others say that though art has never been a priority in Hong Kong this doesn't stop art from being produced here. They say that the reason that Hong Kong art hasn't gained much attention is because Hong Kong is seen as a marketplace; that people are more interested in what Hong Kong can offer them, than in Hong Kong itself. To understand local art, they say, one needs to understand the local context.

Engel says she would like to see Hong Kong art become like the gritty New York scene where people 'come in and do outlandish things'. She adds that 'the Village in New York is possible because no one is watching the artists. The artists do what they want. They have a chance to build a community and meet each other. At Fo Tan, the artists are talking to each other; they are eating together at the canteen and so on. There is no referee. And that to me is what sparks a great art movement.' But, she adds

that Fo Tan is under threat because of property development which seems a contradiction given that the same property developers have shown support for the WKCD.

'As soon as you get a place which is attracting people out to a place, the property developers jack the prices up immediately. This is in every city, but particularly in Hong Kong. The Fo Tan group's predecessors were in Oil Street... the Cattle Depot is always under threat because the government will never tell them you can stay there or you can't. So, they are there month by month and so they don't want to put in anything into the infrastructure,' says Engel.

'Art took off in France after the revolution and started in the 1880s, 1890s; art in New York was post war – there is always a reason. Japanese art was fascinating until before the bombs, now it's devolved into manga and anime with little girls with big eyes doing superhero things. Hongkongers have never been in charge of their own fate, and the word "handover" says it all,' she says. 'You get one colonial power and then another. I find Hong Kong artists extremely interested in their own identity. They are Chinese but they are not communists. They are Chinese but they don't want to speak Mandarin. They are Cantonese. I think everyone is looking for

who we are ... how to find ourselves. It's almost like the 1960s in the US when everyone was busy with the quest, "Who am I?"' Engel says that maybe from this can come great art, but asks if there is there enough pain here? That's often a necessary factor in creating great art, she says.

References

West Kowloon Cultural District (WKCD), West Kowloon; Web: www.wkcda.hk

4: FOOD

Yau Tsim Mong

A market runs through it

Food at Temple Street sums up Hong Kong's past

Though not formally recognised as a 'cultural corridor', many say Temple Street is deserving of the accolade. Its elements – street market, temple and other public buildings, music halls, eateries, fortune tellers – are interesting on their own, but combined they form a cultural tapestry popularised in legendary Hong Kong films such as *The Queen of Temple Street* (1990), *The Prince of Temple Street* (1992) and *The God of Cookery* (1996). More recently, *Infernal Affairs* (2002), starring Andy Lau and Tony Leung, tells the story of a police officer who infiltrates the triads, and a police officer who is secretly working for the same gang, while *One Nite in Mongkok* (2004), tells the story of a killer from the Mainland who rescues a hooker and flees cops and gangsters.

'Temple Street has been labelled in the West as a kind of Chinatown triad zone like Little Italy in New York. It's related to gangsters, drugs, and prostitution. In some cases it's true, in others it's a stereotype,' says Winson Kwan, an award-winning documentary maker who shot footage on Temple Street over a year for a documentary *Dragon Inn, The Hideout in Temple Street*. The film was selected at the Banff World Television Awards 2006 and the International Documentary Festival 2006 in Amsterdam; Kwan now works part-time as manager of the Mido eatery on Temple Street that he featured.

Temple Street was also the backdrop of the 2008 TV series, *C'est La Vie, Mon Cheri*, which starred female singer and actress Fiona Sit. The story, which unfolds over 29 episodes, follows the

life of Kit who becomes good friends with a family who sing in Temple Street for a living. The image of Temple Street – part truth, part media-perpetuated myth – has been used as a symbol of working-class Hong Kong on TV and film, in the same way as the fictional Walford was pivotal to London's East End in British soap *EastEnders*.

But, what is 'culture'? According to the United Nations Educational, Scientific and Cultural Organisation (UNESCO), culture is 'a set of distinctive spiritual, material, intellectual and emotional features of society or a social group', that encompasses, in addition to art and literature, lifestyles, ways of living together, value systems, traditions and beliefs. Meanwhile, 'intangible cultural heritage' includes traditions lifestyles learned from our ancestors and passed on to our descendants, such as folk tales, music, performing arts, social practices, rituals, festive events and traditional crafts.

The name of Temple Street refers to the temple that's found along it which is dedicated to Tin Hau, Goddess of the Sea, built by local fishermen in 1865, and relocated to the current place in 1876. A series of halls in Banyan Tree Park – Yau Ma Tei Shu Yuen, Kwun Yum Lau She Tan, Kwun Yum Temple, Tin Hau Temple, and Shing Wong Temple – are rented by different families.

According to Hong Kong folklore expert Chou Shu-chia, there are 102 Tin Hau Temples in Hong Kong. The presence of one on Temple Street is unsurprising. The 200 m street between Yau Ma Tei and Jordan is bordered by Man Ming Lane to the north and Public Square Street to the south, and intersected by Wing Sing Lane and Tung Kun Street. Shanghai Street and Portland Street run parallel to the west and east of Temple Street. A street to the west beyond Shanghai Street is Reclamation Street where the original coastline was.

The temple is just one aspect of the street. Temple Street is most well known as a street market. Further constituting the 'marketplace' – food aside – are nearby buildings surrounding the street such as the Yau Ma Tei Fruit Market north of Temple Street, built in 1913 and has functioned as a wholesale fruit market since 1965, its busiest hours of business are between four and six in the morning; the Yau Ma Tei Police Station built in 1922, the Broadway Cinematheque and Kubrick bookshop, and the Jade Market. These surrounding features bring together coolies, sex workers, triads, policemen, locals and tourists. The presence of the UNHCR on nearby Shanghai Street also introduces

asylum seekers and refugees into the mix. Some of them live in the cheaper priced accommodation in the area.

Amid Hong Kong's hawker stalls, shops and shopping malls, the street market is yet another place to find a bargain. Street markets on Kowloon include Temple Street and Ladies' Street (which caters mainly to women), Fa Yuen Street – sometimes referred to as Sneakers Street, Sai Yeung Choi Street South and Dundas Street. Another name for Temple Street is Men's Street. Stalls selling new and secondhand items: socks, underpants, clocks, bags, electronic gadgets, tools, and luggage compete for the eye and wallet. Females are present in stalls selling women's underwear, sex toys, and both vintage and modern-day pornography – and many shoppers are females. The stalls are set up at about 5 p.m. The road is pedestrian-only from about 3 p.m., but the market really comes alive after the sun goes down.

If Temple Street to tourists is about the street market, to locals its about the food, which runs the gamut of hawker stalls to *dai pai dong* and different styles of restaurants illustrating the affect other nations have had on the territory.

'Food plays an essential role. Temple Street shares a lot of similarities with Chinatowns all over the world. It is an adventurous, touristic, nostalgic, noisy, exotic, sleazy place in which there is a mixture of ancient and chic, hot and spicy, dynamic and motionlessness and sweet and sour,' says Kwan.

He says the street can be read as a chronology of Hong Kong's historical and culinary past. 'The old Yau Ma Tei was a beach and bay gathering point for many Tanka fishermen. The typhoon shelter became an exotic water area where restaurants on boats offered indigenous seafood dishes,' Kwan says, adding that according to the first generation owner of the Mido, the usual closing hour of the café was at 2 a.m. Back in the 1950s a lot of the customers were local fishermen. They would visit with the family after work.

Previously, there were numerous street hawkers in the Banyan Tree Park surrounding the temple. They sold popular street food such as *siu mei,* steamed dumplings of pork, prawn or both; beef balls, fish balls, squid balls; eggplants, peppers and tofu stuffed with fish meat; as well as offal; and airy balls of sweet dough, *gai daan jai,* 'little chicken eggs'. Director Stephen Chow Sing-chi drew on this background in the 1996 film *The God of Cookery* which he also directed and starred in. In the film. His character lives in Temple Street, where two rival hawkers, Goosehead and Turkey, compete to see

who can sell the most of their specialty dishes: beef balls and 'pissing shrimp'. Chow manages to unite the two vendors by creating a new dish out of the two recipes, which the three then sell together – it's a typical Chow film with a feel-good ending.

But, since the 1980s, tight health regulations and other forms of lease versus licensed hawker restrictions have put a burden on the mobile food culture and many of the stalls have moved to indoor markets amid concerns about the safety of street food, yet arguably to clear space and change the image of the city as well. The hawker stalls that were once located in the park have been rehoused in the Woosung Street Temporary Cooked Food Hawker Bazaar.

'It has long been the general consensus within the Hong Kong government that street hawking is an urban problem which should be contained and eventually eliminated … The recognition of street hawking as part of the urban picture is well illustrated by the designation of certain streets as prohibited to hawking and all others not marked as such as open to the street traders,' writes Josephine Smart in *The Impact of government policy on hawkers: A study of the effects of establishing a hawker permitted place* (1986).

According to the government, a licence is required for hawking. There are two categories of licence: fixed-pitch and itinerant. At the end of December 2011, the number of such licensees in the urban area were 6,190 and 262, respectively.

And, then there are the *dai pai dongs*. The name is popularly misused to refer to any informal, inexpensive eatery on the street with foldable tables and stools and plastic tableware. But these licensed food stalls take their name from the actual licence given by the government which was bigger than those normally issued, as a photograph of the licensee was required to appear on the document.

'Most of the… [*dai pai dong*] stalls were located at Yau Ma Tei. They were dispersed around Jordan Road, Temple Street, Woosung Street, Parkes Street and Pilkem Street. Many of them sold Chiu Chow food such as beef tripe, beef balls, fried oyster cakes, and fish cakes. Many operated only at night with Temple Street and Portland Street becoming the famous food markets… *Dai pai dong* stalls produced some novel food… some of these are no longer available while others have been included in the menus of established eateries,' writes Cheng Po-hung in *Early Hong Kong Eateries*. The book, published in 2003, features old photographs of Hong Kong eating establishments from the

collection of Cheng, an expert on Hong Kong history. It focuses on the history of eateries and food culture in Hong Kong from the late 19th century to the 1970s.

Moving on from Temple Street's hawker stalls and *dai pai dong* is the Mido Café managed by Kwan, Temple Street's most famous *cha chaan teng*, (tea restaurant), and *chaan sut* (food chamber) types of eateries which came into their own after 1945, he says.

'*Mei doh*' [the Cantonese pronunciation of Mido] means 'beautiful city'. At that time – 1949 or 1950 – Hong Kong was rebuilding. The owner thought Hong Kong was beautiful, a kind of promised land,' says Kwan.

Both styles of eateries serve *sai chaan*, otherwise known as 'soy sauce Western food', that came to Hong Kong when the West went to China and then the southern Chinese came to Hong Kong – long before 'fusion' became modish.

The restaurant is on the ground and first floors of a four-storey building. The owners of the café and staff would have previously occupied the upper floors of the building, though today they are rented out. These tenement buildings, or *tong lau,* of between two to four storeys and 15 feet wide, date from the late 19th century to the 1960s and are unique to southern China. Most have been demolished to make room for skyscrapers. As is customary for this type of eatery, the cashier is located at the entrance and diners pay at the counter before they leave. A stairwell is located on the right-hand side of the eatery. On the left are decorative wrought iron window railings, old photographs of the café and the neighbourhood, and glass display cabinets from where Chinese and Western pastries and snacks such as egg tarts, fruit cake, turnip cake, and congee were once served to go. Upstairs is even more atmospheric with its high ceilings and 270-degree view of the temple and tree-lined street below.

Kwan says, 'Reclamation Street, two streets away, used to be the coastline. In the 1950s, most customers were working on boats. A lot of fishermen would come and have dinner. The place was packed at night until 2 a.m. Now last orders are at half nine. The food at *chaan sut* tends to be better than at *cha chaan teng in* terms of quality and choice in dishes served. Mrs Wong [the owner] will not be happy if it's referred to as a *cha chaan teng*. It's actually a *chaan sut*. It serves proper meals.'

He says that food is always related to the economy and offerings at the Mido follow that of the British and their various colonial outposts.

Traditionally very little Cantonese food was provided. The times of consumption among diners were also in step with the British: when the supervisor took his afternoon tea so too would his Chinese workers.

Specials are pasted on the walls on long strips of paper while the actual menu is split into: soup, hot drinks, cold drinks, sandwiches, toast, Chinese food, beer and drinks, grill, seafood, chicken, curry, egg, rice and spaghetti, fried noodle and white or rice noodle, and soup noodle. The British concept of tea and toast has been retained.

'Hot drinks' include cocoa, Ovaltine and Horlicks, while 'toast' includes French toast, toast with butter, and toast with jam. In keeping with the period decor, Coke is served from glass bottles with a straw.

Western dishes include the baked pork-chop rice; the dish for which the Mido is best known. It's is an oven-baked dish of sweet and sour spare ribs with fried rice and eggs, topped with a homemade sauce made with fresh milk. 'Mrs Wong insists on doing things authentically. People have to wait 15 minutes for the baked rice because they really cook it. They could use a flame gun, but they'd rather close the business than do that,' says Kwan.

Meanwhile, Chinese dishes include sweet and sour pork ribs, beef with oyster sauce, chicken with vegetables, squid with vegetables, prawn with vegetables, and beef with vegetables. 'The menu items are more or less the same [as they have been]. The baked rice has been there for 60 years and the curry too. Some things, like the fried wonton with dipping sauce are new additions, according to outside trends,' says Kwan.

Because of its past, seafood is ubiquitous on the street beyond the Mido too. Hairy crab, shrimp, cuttlefish, and clams are just some types that are found at the rehoused hawker stalls, outdoor eateries, and the restaurants on the street. At the five branches of Hing Kee restaurant around Temple Street which specialise in clay pot rice dishes (*boh jai faan*) – the clay pots feature mussels, clams, or squid. The eatery evolved from a roadside stall which cooked its clay pot rice on a charcoal fire.

Temple Street's stalls use real clay pots to cook the rice in as clay allows for greater ventilation of steam so that the ingredients are more evenly heated, which, in turn, promotes a thorough mixture of flavours. The *Mingpao* newspaper featured an article by Chiu Lai-fa who described *boh jai faan* as 'premodern fast food', a vivid description of the old-fashioned looking receptacle in which

the dish is cooked and eaten. Popular choices are mushrooms, chicken, pork, ribs, and egg cooked on top of the rice, accompanied by spoons of soy sauce, and garnished with spring onions and ginger – the dish can be prepared in 15 minutes. Several can be shared between diners or one consumed per person. The dish is especially popular in the winter.

Just as the cooked food centre, *dai pai dong*, and the Hong Kong-style cafés such as the Mido illustrate Hong Kong's past, so too do the foreign foods such as the Japanese and Southeast Asian foods served at restaurants on the street. These foods started to influence local food in the late 1970s and early 1980s and feature on the street as well.

Takoyaki, Japanese dumplings, ramen, sushi, seasoned baby octopus and beef bowls are found in snack shops, food stalls, supermarkets and restaurants. Meanwhile, Southeast Asian food such as Indian curry fish balls, samosas, satay, Hainanese chicken rice and fried Thai shrimp cake are found at the food stalls on the street.

Among the many sweet offerings of Yuen Kee Dessert House, opposite the Mido, are those from Taiwan. After the lifting of martial law in Taiwan in 1987, eateries specialising in Taiwanese food mushroomed in Hong Kong as Taiwanese tourists and businessmen used the territory as a stopover on their way to the Mainland. Specialties of the dessert house reflect this with their selection of black glutinous rice soups, grass jellies, sago soups, and mixed jellies.

'We have lots of tourists from Japan, Taiwan, and the Mainland as well as locals,' says an employee at the 30-year-old family business, demonstrating how integrated other nationalities have become on the street.

Further constituting an idea of 'marketplace' is the musical element to Temple Street which is flanked with Cantonese opera businesses with colour photographs of the star singers in glass display cabinets around the entrances. It costs about HK$20 to enter these smoky dimly-lit music boxes. There are also open-air karaoke stalls, where mostly middle-aged men and women sing into the night. Passersby can opt to sing a song in Cantonese, Mandarin, or English as well, though most walk on by. The 'Madonna of Asia', Cantopop star Anita Mui (b.1963–d.2003) once performed Chinese operas and pop songs from such a stage.

In addition, there are the stalls of numerous fortune tellers – another grassroots cultural outgrowth. They charge from HK$50 to HK$500 to read your face, palm, or tarot cards. One elderly woman is among them who feeds a cage full of

little white birds crushed up instant noodles which she picks at herself, before putting them to work selecting her clients' fortunes from numbered sticks that correspond to Chinese or English text.

What lies ahead in the future of Temple Street?

References

Mido Café, 63 Temple Street; Tel: 2384 6402; Open: 8.30 a.m. to 10 p.m.

Yuen Kee Dessert, G/F 64 Temple Street; Tel: 2384 3659; Open: 1 p.m. to midnight

Hing Kee, G/F 19 Temple Street (and at no's 14, 15, and 21); Tel: 2384 3647; Open: 6 a.m. to 1 a.m.

Cheng Po-hung, *Early Hong Kong Eateries,* 2003, Hong Kong University Press

Kwun Tong & Sham Shui Po

Soul food

The noodle's popularity in Kowloon is unaffected by health consciousness

The noodle is nothing new to Hong Kong. In fact, the Chinese have feasted on them for over 2,000 years. Among other things, the Chinese believe that the length of the noodle stands for a long life, and that by eating them the diner will live longer. This superstition, the wide availability of noodles and the fact that they are regarded as a soul food, part of the cultural heritage of Hong Kong, means that their popularity lives on despite growing concern about the health aspect.

'Noodles are made of starch or carbohydrates, the same group as bread, rice, potato and pasta, and starches are just a different word for carbs, which your body converts to glucose for energy. Rice and noodles were fine in the olden days when people worked so hard, but now, our lifestyles are very sedentary,' says Mag Ma, a nutritionist and founder of Aroma Routine, adding that unless a person exercises for five hours a day, they don't need so many calories from starch. According to her, a healthy diet is good water, more whole food, more fruit and vegetables, rich in vitamins and minerals, phytochemicals including enzymes and probiotics and healthy fats in the right proportions.

But the noodle can be found everywhere in the world, though they are present in some places more than others. 'In China, there is an invisible line separating the north from the south. In the north, wheat-based products like noodles, breads, and dumplings are consumed. In the south, it's mostly rice,' says Francis Lo, chairman of the Young Chef's Association, explaining that when northerners immigrated to Hong Kong they brought with them their love of noodles.

Today, noodles of all kinds are available across Hong Kong, notably in the beef brisket noodle shops of Fu Yan Street in Kwun Tong and the trio of Wai

Kee pork liver noodle shops in Cheung Sha Wan in Sham Shui Po.

Among the noodles available at both locations are the ubiquitous instant noodle, dried or precooked noodles fused with oil which are cooked or soaked for a few minutes in boiling water. Instant noodles were launched in Japan in 1958, under the 'Chikin Ramen' brand name; and in 1971 Nissin introduced 'cup noodles'. In polls, the Japanese have voted instant noodles the most important Japanese invention of the 20th century. But, according to the World Instant Noodle Association, it is China, including Hong Kong that is the world's number-one consumer of instant noodles. The country consumed 451.7 million packets or cups in 2008, though this figure was down from 2006 and 2007 perhaps because of growing awareness of instant noodles' high carbohydrate and low fibre, vitamin and mineral content, as well as their high levels of saturated fats, sodium, and MSG. The main brands of instant noodles in China are Ting Yi, otherwise known as Master Kong, Hwa-Long, which means Chinese Dragon, and Bai-xiang, which means White Elephant.

'These types of noodles go back to the 1950s and 60s. Nissin noodles were the first instant noodles to arrive in Hong Kong,' says Lo.

Meanwhile, vermicelli, spaghetti, and macaroni were post-war arrivals in Hong Kong which World War II allies brought to Hong Kong.

According to Deh-Ta Hsiung's *The Chinese Kitchen,* there are four main types of vermicelli. *Mai fun* are the thin rice noodles popular in China. They hail from Guangdong province and are translucent when cooked. The name for 'rice noodles' is the same as for 'rice flour', the main ingredient. Rice noodles are made from ground rather than dried rice, and the rice used for noodles is usually of a higher grade than what is used for flour. Another variable is the time noodles are hung in the sun before being packaged. *Mai seen* hails from Yunnan province and is also made from rice, but it is thicker than *mai fun* and turns white when cooked. Meanwhile, *Min seen* is vermicelli made from wheat. Noodles made from wheat dominate in North China, while rice noodles are used more widely in the south. The last type of vermicelli is *fun see*, made from mung beans, and which becomes translucent when cooked.

'Whether noodles are healthy or not depends on what they are made from. The more refined, the worse they are. Refined or processed carbs are devoid of vitamins and minerals. They have no enzymes and probiotics nor phytochemicals. The

processing of noodles if they are then deep fried is even worse. Egg noodles are usually deep fried, and usually contain no egg, just colouring, while rice noodles are very processed,' says Ma.

Like noodles, spaghetti and macaroni are popular in Hong Kong and the same health pointers apply. Local fast-food chains Maxim's, Café de Coral, and Fairwood have embraced all three. Meanwhile, McDonald's has also adopted macaroni onto their breakfast menus in the territory. As well as featuring in basic soups, macaroni is cooked in water and then washed of starch, and served in clear broth with ham or frankfurters, and eggs. These dishes are often a course in the much-favoured breakfast or lunchtime set menus, and are available at *cha chaan teng* throughout the territory.

In Kwun Tong, the trade in Chui Chow-style beef noodles developed in tandem with the emergence of the district as a manufacturing centre in the 1950s. Chiu Chow cuisine originated from the eponymous city close to Hong Kong in the coastal region of Guangdong because some of the traditional import-export companies in Sheung Wan were run by Chuichownese. This seafaring people introduced upmarket Chiu Chow cuisine to Hong Kong, but the manual labourers of these companies who were employed to carry goods to and from the ships and who were also Chuichowese could not afford this type of food. Factory workers had to feed on beef brisket, an inexpensive boneless cut taken from the breast section of the cow beneath the first five ribs, which was and remains an affordable and tasty dish. Beef tripe or stomach noodles are also popular in Kwun Tong, as are soup noodles that contain other types of offal. Kwun Tong's 565,000 people jostling for space on just 11 sq km of land hasn't been bad for business. Meanwhile, at Wai Kee in Sham Shui Po, it is pork that is usually ordered – though available toppings at this trio of Cheung Sha Wan noodle shops include beef, pork, ham, sausages, luncheon meat, chopped spicy beef, and fried eggs. There is one *zai* vegetarian option that is ideal for Buddhists who are practicing *ahimsa*, or non-violence towards living creatures.

Fu Yan Street, a green-tarpaulin-covered lane close to Kwun Tong MTR station is a centre for beef brisket noodles in Kwun Tong, where patrons can choose between indoor or alfresco seating at four noodle shops. Fu Yan Street is easily missed. More of a lane than a street, it is best located by its proximity to the adjacent Yue Man Square Rest Garden, a leafy retreat frequented mostly by district elders. The garden is topped and tailed by a bus depot and cornucopia of snake restaurants to the

north and Yue Man Square to the south. Another signpost is the bookstall at the southern extremity of the lane and park where you can borrow or buy new and used paperbacks. The noodle shops are just metres beyond it and date from the early 1970s, a long existence made possible because the vendors own their shops. Each of the eateries is a family affair run by father and offspring to be passed on to the next of willing kin.

A motley crew of customers patronises the lane, from uniformed security guards and school children to groups of ladies, and single men. With their high-decibel cries of 'Come in, sit down!' the proprietors still usher in hungry mouths from neighbourhood businesses like they used to. The noodle shops have benefited from the closure of several of the district's large restaurants in the past few years and as the reputation of the eateries has swollen, patrons have begun to trickle in from beyond Kwun Tong as well. There's not a foreigner in sight though an index finger capable of pointing is all that is required should any wish to eat there.

'Beef brisket is like regular beef – a protein source, with zinc and vitamin B12, B6 iron and niacin, while liver meat contains high levels of essential nutrients including vitamins A, C and D, riboflavin, thiamine, vitamin B12, iron, copper, phosphorus, and selenium. But liver meat also contains high levels of metals and other contaminants and may not be the best choice for pregnant women,' says Ma, adding that she would be very careful about the intestines of animals as they need to be cleaned very thoroughly.

Meanwhile, Wai Kee which opened in 1957 on Pei Fo Street, is still a no-frills blue-collar eatery with stainless steel surfaces, weathered foldable tables and stools, and chipped retro mosaic tiling underfoot. A total of 1,000 customers are served each day across the three Wai Kee outlets. 'Some come for the noodles as many as three or four times a month for breakfast, lunch, or dinner; or whenever there's time to eat in between,' says Chan of his customers.

'Tea and coffee, Malaysian toast, pork liver and beef noodles' reads the shop's business card. Malaysian toast is thick slices of white bread topped with *kaya*, pronounced *ga yeh* or *ga yeung* in Cantonese, a sweeter-than-sweet spread. Its consistency is reminiscent of the English lemon curd which traditionally accompanies tea. Likewise, *kaya* is taken with tea or coffee. At Wai Kee it is made daily for consumption the following day. The recipe inherited from Chan's father uses chicken eggs, duck eggs, sugar and butter. The ingredients

are mixed with water before being steamed for two hours.

The two more recent eateries are brightly lit, long, narrow, functional spaces with light green plastic stools that match the tiles underfoot. They're situated side by side on Fuk Wing Street, a broad road that up to about 20 years ago had numerous factories and toy retail outlets surrounding it. As the demand for toys tailed off, the street turned to the business of food. Today, a cornucopia of Cantonese, Chinese, Vietnamese, Thai and barbecue restaurants line its pavements.

'Pork is a neutral meat in Chinese medicine. It can be used in a very wide number of different applications: pork bone for soups and stocks … Internal organs are not prized as highly but apart from being a topping for a noodle dish, pork liver is used in congee. Different parts of the animal can be roasted, fried, barbecued, whatever,' says Lo. In fact, Chinese prefer pork to all other meats and Hong Kong is at the top of world polls for pork consumption per capita – there is less of a tradition of eating beef, one explanation being that oxen help farm land. Chinese Buddhist practitioners refuse to eat beef and also abstain from eating animal entrails.

In the morning, pork is ordered in the guise of luncheon meat or SPAM otherwise known as 'shoulder of pork and ham' (or 'something posing as meat') with fried egg noodles. As the day progresses, diners are more likely to opt for the finely sliced pork liver noodles for which the eatery is known. 'Very hot water and a big fire are used to cook the livers or other ingredients. They're plunged into the bubbling water as soon as a customer places their order so the taste comes out very quickly,' says Chan, adding that the soup is key to the taste of the dish.

Meanwhile, back in Kwun Tong, a bowl of beef brisket noodles comprises three primary elements: the noodles, the soup, and the brisket. The cooking time of the noodles which are sourced from specialist shops is all-important, just 15 seconds, as opposed to the four to five hours required by the muscly meat. The brisket is cooked with herbs as star anise, liquorice root, and tangy mandarin peel.

Ma says that at a *dai pai dong*, you usually get a one-plate meal with 75 to 80 per cent of rice or noodles and the rest meat, with no vegetables. According to her a good proportion should be 2/3 vegetables and 1/3 meat plus two to four tablespoons of rice or noodles, and she says that she

would recommend avoiding MSG, soy sauce and oyster sauce for a 'cleaner diet'.

Star anise is one of the most important spices in the Chinese kitchen. It was brought to China by early Portuguese settlers from Indonesia. The southern Chinese use it as one of the ingredients for cooking meat. Its seeds are recommended as a diurectic and for constipation, lumbago, hernia, and bladder complaints. In the West, meanwhile, star anise is popularly imbibed. Pernod, a spirit whose flavour is dominated by the aroma of anise is one case in point. Mandarin peel is a signature of Chiu Chow cooking. The majority of it comes from Guangdong and Fujian provinces given its requirement of a warm and dry winter climate to grow. It is regarded by Chinese doctors as a panacea. Dried mandarin peel is commonly used as a seasoning when braising meat, and, like star anise, is usually discarded after cooking.

Surprisingly, the brisket and beef tripe, the latter which is also popular on Fu Yan Street, come from different carcases. The brisket originates in cows from the Mainland while the cow stomachs are sourced from both Australia and Mainland China.

Offal, which includes most internal organs other than muscles and bones, can be considered as waste that is thrown away or as delicacies depending on the cultural context. In many countries it's accepted in true 'you-can eat-all-the-pig-except-the-squeal' fashion that no animal part should go to waste. With regards beef offal in the United Kingdom, a classic dish is steak and kidney pie. In Italy, consumption of entrails and internal organs is fairly widespread in dishes such as fried or stewed brain or boiled intestines. Cow's intestines are also very traditional in Spain. Offal in general in Australia is most commonly eaten in meat pies. Food regulations since 2003 have lifted the prohibition of offal in the meat standard which had previously banned such things as snout, genital organs, lips, lungs, and scalp.

'All kinds of offal have been used in Cantonese cuisine for thousands of years. Recently, people have begun to watch out for things like cholesterol. So, eating cuttlefish and squid is lessening,' says Lo, though the consumption of duck and goose offal such as liver is on the rise. Squid is more popular than cuttlefish as a restaurant dish in Hong Kong, but shredded cuttlefish is a popular snack. And while there are benefits to eating liver – for example, animal liver is rich in iron and Vitamin A, raw liver pills can be taken as a dietary supplement to counter fatigue, and cod liver oil is used for

arthritis, multiple sclerosis, and to prevent rickets in children – liver is very high in cholesterol.

In 2008, the Hong Kong government's Department of Health launched its EatSmart campaign to promote a healthy lifestyle to prevent diet-related diseases such as cancer, high blood pressure, heart disease and stroke. According to the website, this is especially important given findings that 40 per cent of Hong Kong people eat out for lunch at least five times a week, while more than 90 per cent wish to be offered healthier food choices in restaurants. EatSmart restaurants support the 'more fruit and vegetables initiative' and the '3 Less initiative', the latter which refers to dishes which have less fat or oil, salt and sugar and indicate this with logos beside the dishes which adhere to this.

According to Lo, be this as it may, Hong Kong is not as aggressive as promoting health awareness as countries in the West – just 577 restaurants are listed on the EatSmart website, of the tens of thousands in Hong Kong. 'There's not a lot of health consciousness promoted in the media. [Customers at the beef brisket and pork liver noodle shops] are generally unaffected by Western media though this depends a bit on age. Younger consumers are likely to be more affected,' he says.

'There is a lot of room for improvement for Hong Kong people's diets. People are very stressed and always on the go, and they eat out a lot of the time,' adds Ma who says that it's not just what you eat but when you eat it that is important, and that when you eat influences what you eat. 'When people wait too long and become too hungry, for example, have lunch at eat at 2 or 3 p.m. or dinner at 9 or 10 p.m. which is typical of Hong Kong people, they usually go for refined carbohydrates for an instant pick-me-up, because the reptile brain in the limbic system has taken over. Whereas, when we are less hungry, we are capable of making better food choices. We will think "Maybe I'll have a salad", because the more developed part of the brain is responsible for making better choices.'

What's the draw? The *dai pai dong* are part of Hong Kong's intangible cultural heritage, which is easy to see from Kwun Tong's beef brisket noodle shops. Customers are divided fairly equally among the four beef noodle establishments there, with the noodle shops each serving some 1,300–1,500 customers a day, say staff. Peak hours are at lunchtime and dinnertime, though there are usually a handful of patrons at each of the shops at every other time of day as well. Of all of the noodle shops, Hup Hing is the best known, generating excited

chatter on Internet forums in Hong Kong; others are Ming Kee and Dong Kee. Established in 1972, Hup Hing is the longest running of the shops, with a loyal following for its two main offerings: beef brisket soup noodles, fat, white *ho fun* noodles swimming in tea-coloured broth garnished with spring onion and fried onion bits; and the other-worldly-looking beef stomach soup noodles known as honeycomb tripe, which sits squarely on a bed of wiry egg noodles.

The atmosphere at the *dai pai dong* is infectious not only because of the soul food that they serve, but the relaxed and informal eating environment. Though what they serve differs, at the noodle places of both Kwun Tong and Sham Shui Po, diners *daap toi*, or share a table, which brings people together.

'*Daap toi* is about being comfortable with one another. The Chinese are a communal culture, not an individual one. Because of the sheer price of land, in lower food culture eateries it is very common to share tables,' says Lo. This eating etiquette was adopted by Hongkongers since the days of the genuine *dai pai dong*, which were numerous in the territory after World War II when the government issued licences to families of deceased and injured civil servants allowing them to earn a living by operating food stalls – though others had existed

as early as the late 19th century – and were found across Central, Wan Chai, around the racecourse in Happy Valley, and assembled beside piers.

In 1956, due to the fact that some licensees had begun to let out their stalls, the government stopped issuing new licences. Licences could no longer be inherited, they could only be passed on to spouses upon the licensee's death, and if the licensee did not have a spouse, the licence would expire. Another reason for the demise of the *dai pai dong* from the Hong Kong cityscape was a public hygiene campaign whereby in 1983, the government began buying back licences. Since most of the licensees were aged, and licences are only legally transferable to the spouses of holders, many returned their licences for payment. But, today, the term *dai pai dong* is used to describe any food stall operating on the roadside with foldable outdoors seating regardless of whether the owners actually have a 'big licence' or not.

Back to Cheung Sha Wan, Chan of Wai Kee says: 'There used to be other traditional places to eat selling specialised food in the area, but they've branched out. They're like any other restaurant now,' adding that it's not just the passage of time that threatens the food cultures at Kwun Tong and Sham Shui Po districts, but growing economic prosperity which has entailed a growing awareness

of health and a more selective attitude towards certain types of food which previous generations were oblivious to.

Regardless, comfort food at local-style eating places looks set to remain part of Hong Kong, and rightly so.

References

Fu Yan Street, Kwun Tong

A basic bowl of beef brisket noodles on Fu Yan Street starts at HK$18. First servings are at 11.30 a.m. daily; last are at 10 p.m. though at restaurant Hup Hing you can snack until midnight.

Wai Kee Coffee and Noodles: G/F 165–167D Pei Ho Street/ G/F 62 Fuk Wing Street/ G/F 66 Fuk Wing Street, Sham Shui Po; Tel: 2387 6515; Open: Mon-Fri 6.30 p.m. to 8.30 p.m., Sat, Sun & Public holidays 6.30 p.m. to 7.15 p.m.

At Wai Kee, combination bowls of noodles are priced at HK$23 with additional toppings priced at HK$13 each.

Deh-Ta Hsiung, *The Chinese Kitchen,* 2002, St Martin's Press

EatSmart (Department of Health); Web: restaurant.eatsmart.gov.hk

Kowloon City

Chowing down

Chiu Chow food is alive in Kowloon city while other food styles and businesses join the culinary party

Chiu Chow includes the region of Guangdong province and the nearby provinces in southeastern China, and so large is the Chiu Chow diaspora that the Chiuchownese are found across Hong Kong from Sheung Wan and North Point on Hong Kong Island to Kwun Tong in Kowloon.

The Chiuchownese are also in Kowloon City. The district developed in 1860 at the sanction of Hong Kong when Kowloon was ceded to the British. Back then, ships sailed from all over China en route to Hong Kong. Situated on the eastern part of the coast, Kowloon City was a convenient place for the Chiuchownese to travel to by boat. Some of them worked as coolies aboard shipping vessels, while others ran small businesses. A second exodus of Chiuchownese to Hong Kong occurred in the 1950s due to fears of communist rule on the Chinese Mainland.

'The refugees banded together in tight communities speaking their own dialect which set them apart from the Cantonese. This allowed their traditional ways, including their recipes, to live on,' says Charles Kwan Wing-kei, a long-time former resident of Kowloon City. Dialect and cuisine are just two of the outgrowths of Chiu Chow, which is hailed to be one of the cultural centres of the Lingnan region, a geographical area that covers Guangdong, Guangxi, Hunan and Jiangxi provinces. Tea, opera, music, the lion dance, and embroidery are others.

'With their arrival, the refugees from Chiu Chow brought their cuisine: high cuisine for the wealthier business owners and street cuisine like beef brisket or offal noodles for the coolies who couldn't afford the pricier food,' says Kwan. According to Cheng Po-hung in his book *Early*

Hong Kong Eateries, 'In the 1960s, almost every "rice store" in Hong Kong, groceries selling dried foods as well as uncooked rice, was owned by a person from Chiu Chow, and between the 1950s and the 1970s, Chiu Chow restaurants in Hong Kong rose from 200 to 800. Chiu Chow food continued in popularity in the 1970s and 1980s a time when there were numerous sizeable Chiu Chow restaurants. The most famous were the extant Leung Hing in Western and Shung Hing Chiu Chow Restaurant in Sheung Wan.'

Unsurprisingly for an area with a large Chiuchownese population, Kowloon City is rich in their cuisine, be it at the groceries or market on Nga Tsin Wai Road, or the restaurants and dessert places or cake shops elsewhere in the area. Chiuchow cuisine hails from Chaoshan, a region in the north-easternmost area of Guangdong province, which includes the cities of Chaozhou, Shantou and Jieyang.

The Chiu Chow presence is lessening because the Chiu Chow population of Kowloon City has changed drastically in the last 20 to 30 years. 'Unlike in the 1950s and 1960s, there were not many new immigrants coming from this part of China due to the change in immigration policy of the Hong Kong government. Some long-term residents also improved their economic conditions and moved out of the district,' says Kwan. 'The younger Chiuchownese generation brought up in the district were localised like people from other parts of China. They could no longer speak the native dialect of their parents and picked up eating habits similar to all others in Hong Kong. Many of them have also moved out of Kowloon City.'

Nonetheless, at the Chiu Chow groceries on Nga Tsin Wai Road – a major road linking Kowloon Tsai in Kowloon Tong and Kowloon City which cuts the whole of Kowloon City – there are aluminium trays of fish balls, fish cake, shrimp, prawn, and crab balls which are served by the roll or catty (500 grams), all which are typically Chiu Chow. There's a shark's fin shop packed to the ceiling with a variety of different sized fins, dried seafood like scallops, cuttlefish, and mussels for insertion in soups; and fish and eel bladders too. A few shops on are sweet pink and white rice bun rolls stamped with Chinese characters, cockles and preserved mustard greens; and even preserved pig-head skin.

Other groceries offer steamed Chiu Chow chicken, duck, and goose meat, cut to order and served with *lo sui* sauce. This sauce, which contains at least 50–60 glasses of water and which typically dates from a restaurant's first day of business, is a

presence in every Chiu Chow restaurant kitchen. Insiders say it is replenished with coriander, dark soy sauce, rock sugar, rose wine, salt, and sugar daily, and also cassia, fennel, ginger, liquorice root, Sichuan chilli, spring onion, star anise, unskinned onion, and zedoary. Among the grocery shops is one where you can sit at a small communal table and snack on turnip cake and fried tofu.

The grocery shops look onto the Kowloon City Municipal Services Building. Built in 1988, the building is also an important Chiu Chow food landmark. The indoor markets of Hong Kong are called 'wet' markets, because of the routine spraying and washing of the floors and surroundings, or *gaai see*, which means 'street market' in Cantonese. Hong Kong's wet markets generally combine butchers, fishmongers, and fruit and vegetable stalls – usually separated across two levels: fish and meat on one level; and fruit and vegetables, flowers and clothing on the other. Live animals such as fish and chicken are sold and then killed in front of the customer.

A food court is located on the third floor of the wet market and includes several restaurants. 'Unlike at the food courts of other wet markets, where different restaurants serve the same kind of food for lunch and dinner, different foods are served at different times of day at the one in Kowloon City,' says Kwan. 'Because of this, competition between the restaurants is minimal, and the district lives up to its reputation as a food hub.'

An escalator leads up to the food court which is a cavernous canteen-space with a high ceiling, quite different from the more modern food courts of other districts. On both ends, the space is flanked with the food stalls of different businesses selling very different kinds of foods. Diners of all ages sit in between at a variety of seating and eating surfaces for their informal get-togethers over food. The female employees of one of the stalls clean and de-shell prawns at a small round table, their plastic buckets and containers adding colour to the scene.

Though seemingly separate, the Chiu Chow grocery shops of Nga Tsin Wai Road and the market are interrelated; some of the original stall holders where the groceries are now located sell their wares inside the wet market. Originally, these unexciting market buildings housed only a food court and indoor market following the government's policy to clear the streets of hawker stalls. However, as time went by, facilities broadened to include a library, leisure facilities, and space for various government departments.

The 60-year-old Chong Fat Chiu Chow is one place in Kowloon City to sample Chiu Chow food. A family business, it was originally located in the district of Wong Tai Sin. The dated decor recalls its past: Diners sit in rectangular booths, over a mosaic tiled floor. There are ancient wall-mounted fans, a cashier's booth at the entrance, and hand-written menus on the walls. Waiters come and go at the beginning and end of a meal bearing miniature cups of strong bittersweet *tieguanyin*, a variety of Oolong tea originating in the 19th century in Fujian province. Colloquially, it's known as *gongfu* or *gam gam* tea.

'Although in the past Chiu Chow food was fatty and oily, nowadays it is commonly regarded as being healthy. This is because oil is not often used in large quantities and there is a heavy emphasis on poaching, steaming, and braising. Another reason is its emphasis on seafood and vegetarian dishes,' says Kwan, adding that this is a consequence of the two different cultures that have influenced the Chiuchownese.

'The first [influence] is that of the Tanka who lived aboard boats and travelled around Southeast Asia four to five hundred years ago, while the second is that of the ethnic minorities from the mountainous area between Chiu Chow, Fukian, Hulan, and Xian Xi in the western part of Chiu Chow, who had populated the area for thousands of years,' says Kwan, adding that because they were poor and lived on the mountainside, they were treated as barbarians by most of the Chinese Tang people. They survived on what the mountain's slopes could give them.

Notwithstanding a new healthiness, Chiu Chow restaurants in Kowloon City are having to compete. Chong Fat Chiu Chow is unusual among Chiu Chow eateries in Hong Kong as it's famous for its *dah lang* canteen style food, which dates from when labourers hungry and in a hurry, would simply point to order what was mass produced and already cooked. Today's diners pick from dishes of old including: big-eyed fish, cold congee, cuttlefish, duck, goose, octopus, pork legs, sausages, and tofu. One, sometimes two, white-apron-clad chefs preside over a spectacular set up of about 11 bubbling pots of various types – a precursor to the open modern kitchen. In an effort to save space typical to Hong Kong, seafood is piled onto shelves to the side, while hot pots are below.

Today, the restaurant still caters to labourers. '[They] might come here for a meal or two,' says Chan, restaurant manager, but he adds that the

clientele has diversified to include office workers from elsewhere in Kowloon during the day.

'It's usually quite quiet at lunchtime. People queue up at night when we lay on an extra 10 staff. Night-time customers typically earn above average incomes and drive by private car to Kowloon City from other districts. The restaurant also does a lot of tourist business: Japanese customers and tourists from South-East Asia, Singapore, Malaysia, and Thailand; even Europeans,' he says.

This is impressive in an area where the presence of the Chiuchownese is being challenged. 'Most Chiu Chow businesses were established 20 or 30 years ago, but most of their bosses are now dead and no one is keen or able to take over, so the businesses just die away,' says Chan.

Another factor in the decline of the Chiu Chow businesses on the client side, is the closure of Kai Tak airport, which once ensured that restaurants were crammed full every day of the week – demand, that Chan and others say the restaurants have only on weekends now.

'There are cheap meals and expensive meals. If you want cheap food, you can order *dah lang* or small simple dishes and not eat seafood. But, we have very good quality seafood, shark's fin and abalone. Mainlanders looking for quality

food might come in and eat a HK$6,000 dinner without blinking. We have a very steady supply of good quality seafood,' says Chan, adding that the restaurant does business with Lei Yue Mun in Kwun Tong district, and Sai Kung in the New Territories and does business transactions in cash, meaning that in a bad economy the restaurant helps the seafood suppliers a lot. Because of this, the suppliers tend to give their best catches to the restaurant, to be seen in the white polystyrene boxes and red and blue plastic tubs at the eatery's entrance. One way to get around the more prohibitive prices is to order seafood as part of a dish, as in the oyster omelette, made from 'pearl oysters', so named because of their small size. The pan fried 'cake' is thick, due to the addition of potato starch, eggs, and dried granular onion.

Some of the seafood dishes include fried crab bites and shrimp balls with Chiu Chow sweet sauce. The sauce is made from brown sugar and water boiled with onion oil. Seafood is also served cold in dishes such as big-eyed snapper served cold with Puning bean sauce – the sauce is also known as yellow bean sauce. In this dish, the fish is steamed for 10 minutes with salt and ginger and then chilled in the fridge and the skin torn off. Another cold dish is the cold crab in which a male crab – reportedly

firmer than the female, and, therefore, more expensive – is steamed for 18 minutes. The crab is then cooled, chilled in the fridge and served with Zhenjiang vinegar, if required. One of these crabs costs about HK$300.

'The expense of the ingredients in the Chiu Chow kitchen has meant that many of the restaurants have had to shut down. They haven't been able to compete with Cantonese eateries who offer breakfast and afternoon tea in addition to lunch and dinner, or the Thais who continue to move in to the area,' says former resident Kwan. There are also the new gentrified places in the district which include frozen meat shops, Japanese, Korean and Taiwanese groceries, European delicatessens, Western wine and cake shops, and Western restaurants rented by those attracted by the still relatively lower rental prices in Kowloon City than many other districts.

While *dah lang* can be ordered at Lok Hau Fuk it's a very small part of their overall takings. Head chef Chan supervises 10 cooks at the restaurant which has 50–60 years of history and serves Chiu Chow delicacies such as shark's fin and abalone or dishes such as eels wrapped in Chinese kale. Preserved ham is inserted into the eel pieces which are then wrapped inside the vegetable and steamed.

Alternative Chiu Chow dishes at other of Kowloon City's restaurants such as Lok Hau Fuk, Nam Kee Restaurant, and Pan Chiu Hin Restaurant include steamed or fried Chiu Chow style dumplings with shrimp, coriander, and carrots; and fried tofu and spring onion sauce – the sauce is made from spring onions, Chinese leek, and soy sauce. Other dishes include pomegranate chicken and mustard hot pot. In the first, fried egg white is used to wrap a filling of fried chicken, ham and mushroom, and the sauce uses a corn starch base. In the second dish, only the centre part of the mustard green vegetable is used. Chiuchownese women have long favoured the vegetable, and believe that consuming it will bring love into their lives. It's a popular ingredient in soups or in its preserved form as an appetiser.

Returning to the mustard hot pot dish and attesting to the luxuriousness of its offer, Lok Hau Fuk head chef Chan says the salted Jinhua ham, named after the city in Zhejiang province, is preserved for at least six months. But, 'it can be substituted with another ingredient such as chicken,' he says. The sauce in this dish is thick since it is made from potato starch and water, and the dish is garnished, like so many Chiu Chow dishes, with a butterfly carved from carrot. Orange or white carrots are typically used for carvings since

these root vegetables are simple and easy to cut. The chefs prepare the carvings, storing them in cling filmed containers and plunging them into boiling water as required.

It's a far cry from the minimal preparation and cooking methods of other places. But, while Chiu Chow restaurants are losing out to, what some call, less sophisticated Hong Kong-style diners, or *cha chaan teng*, they can compete when it comes to dessert.

'Unlike in Cantonese food, desserts are popular in the Chiu Chow kitchen. In early Chiu Chow food, there were always two desserts in every meal. The first would be solid, like a sweet bread, while the second would be a liquid dessert such as a sweet soup,' says Kwan, adding that a special occasion dessert is steamed edible nest of cliff swallows.

At the popular Chiu Chow Hop Shing Dessert, sweets include yam with gingko nuts, in which the vegetable is steamed, mashed and sweetened to form a dessert that resembles and tastes like cake dough. It is often served with gingko seeds which are separately fried in ginger onion oil and then boiled with sugar. The fried onion oil gives the dessert its pleasant fragrance. Other desserts are the green bean jelly; and glutinous sesame balls; and water chestnut congee.

Other Chiu Chow sweets such as cakes, sweets, pastries, and buns can be bought at Kwai Yu Woo Kee Chiu Chow bakery, to be taken away. The shop on South Wall Road was set up by Yeung Po from Guangdong province and has been in business for 50 years. Today, it competes with the offer of new gentrified Western cake shops in Kowloon City.

'We're all happy when we eat sweet things, and sweets are easy to make. If you make a dish sweeter or not so sweet, people accept it. But if you make a dish salty or not so salty, people don't like it. It's easier to find a balance in sweet foods,' says Rocky Yeung, who runs the business and is the son of the founder.

The bakery's edge over competitors is arguably its products that are linked to Chiu Chow festivals such as the Hungry Ghosts festival around August, Mid-Autumn Festival around September, and the Lunar New Year in January or February. At these times, the Chiuchownese buy specific foods and go to the temple.

'People in Chiu Chow used to use wheat and grains from their harvests to appease the gods. Today, they use models of the five most important animals in the Chiu Chow tradition: pigs, ducks, chickens, cows, and fish, made from sesame, as some of the worshippers are vegetarians.

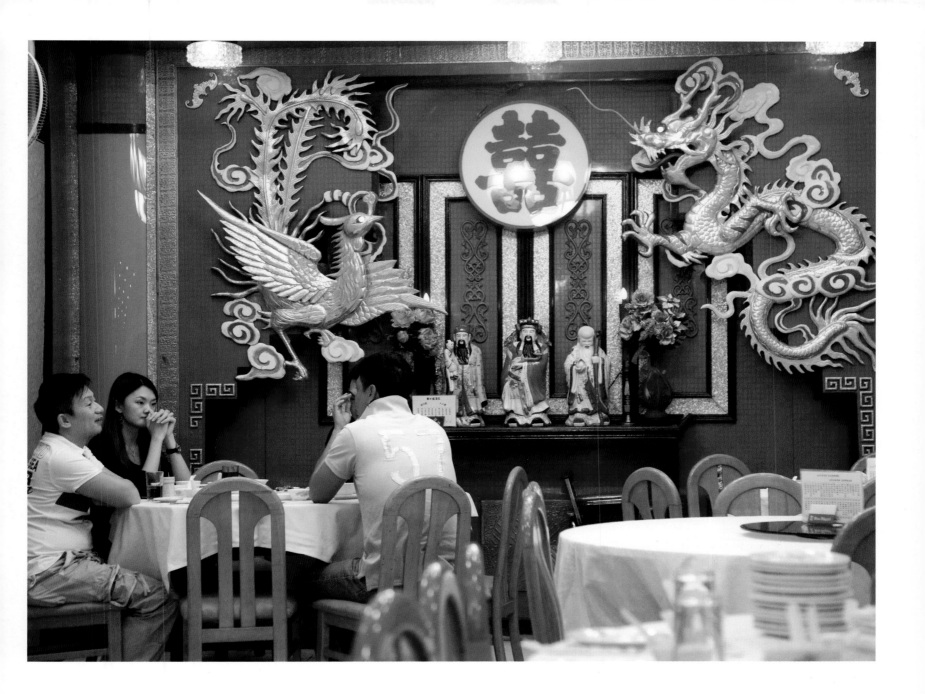

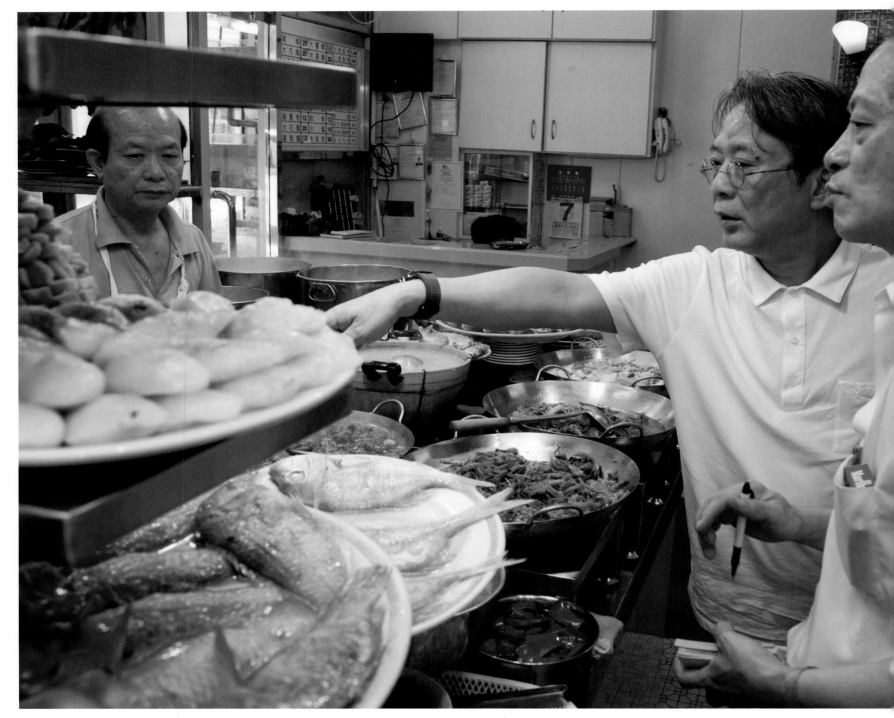

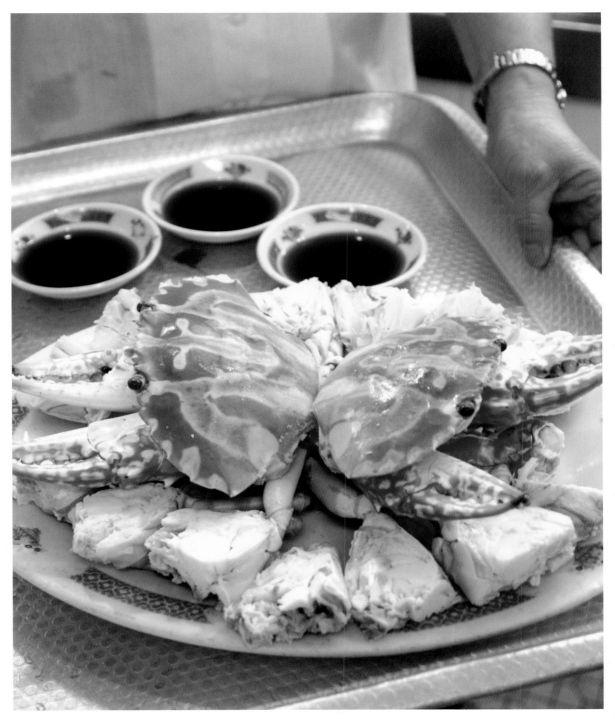

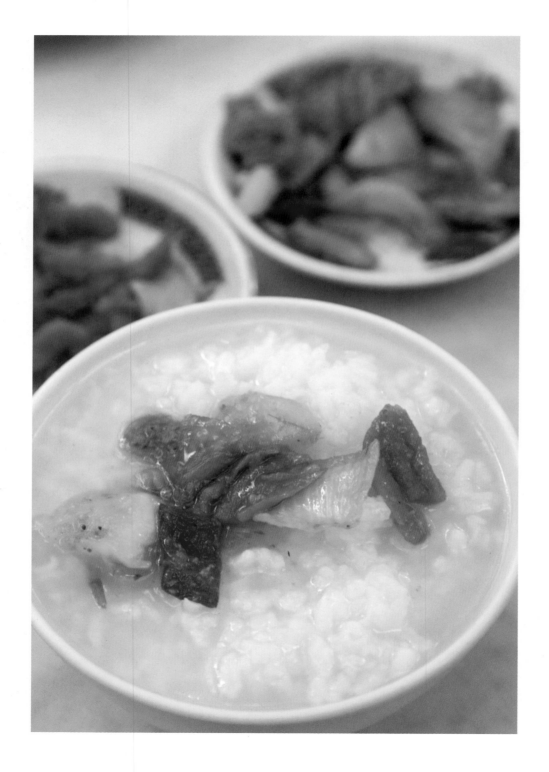

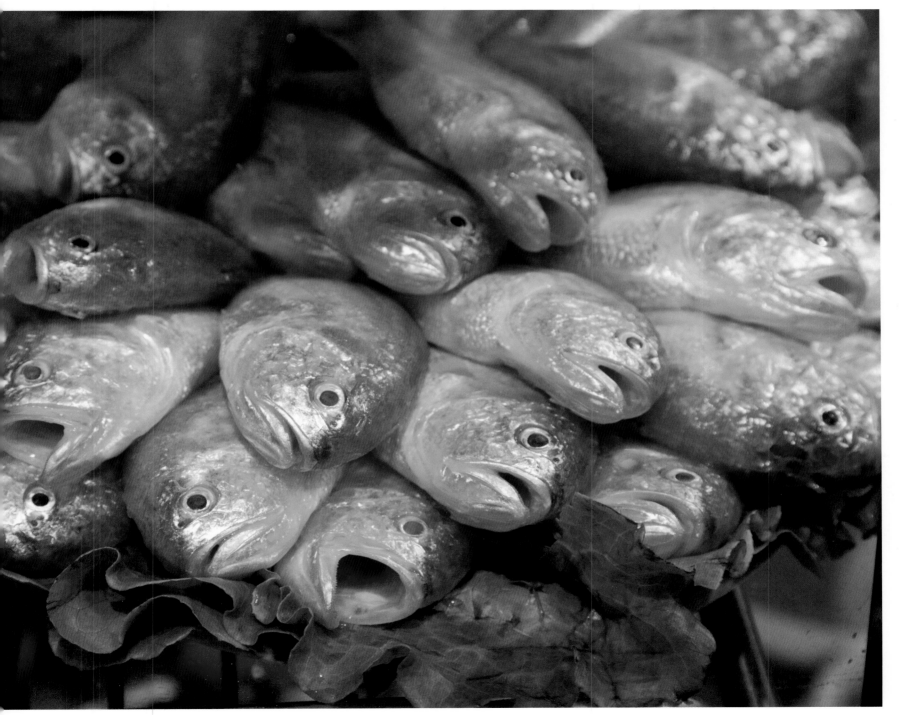

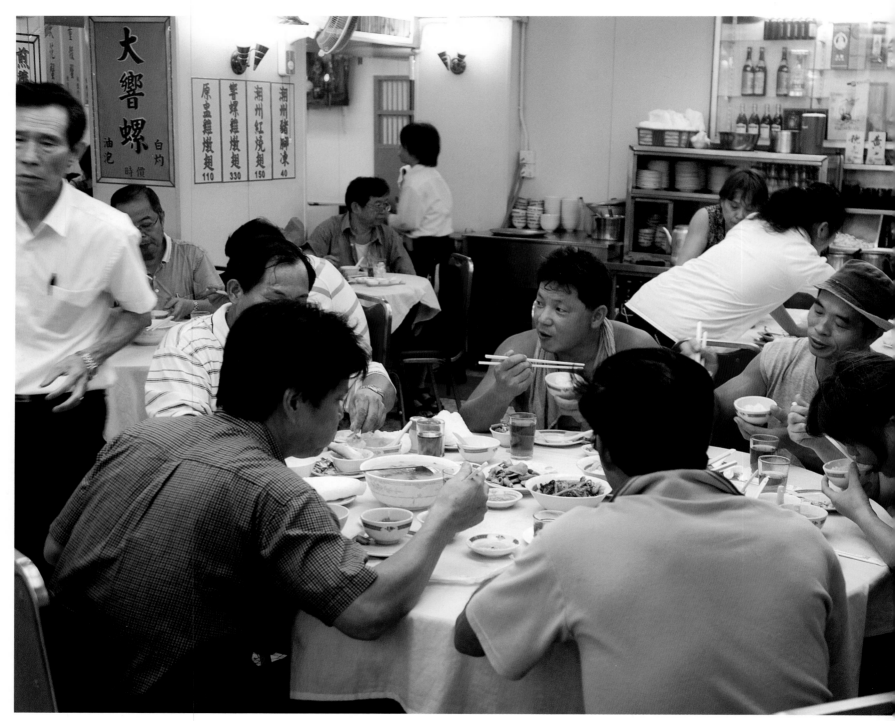

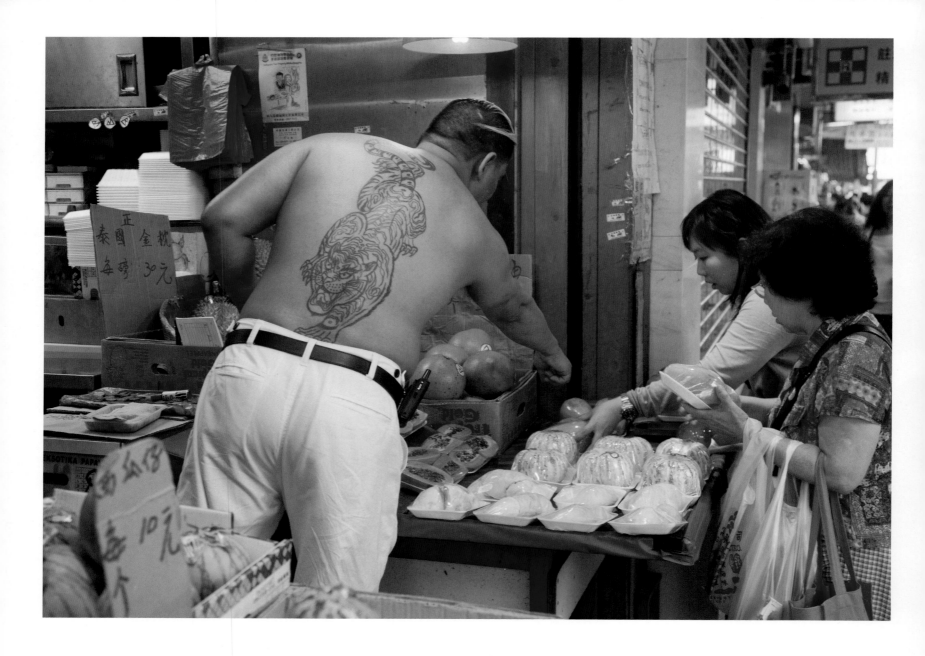

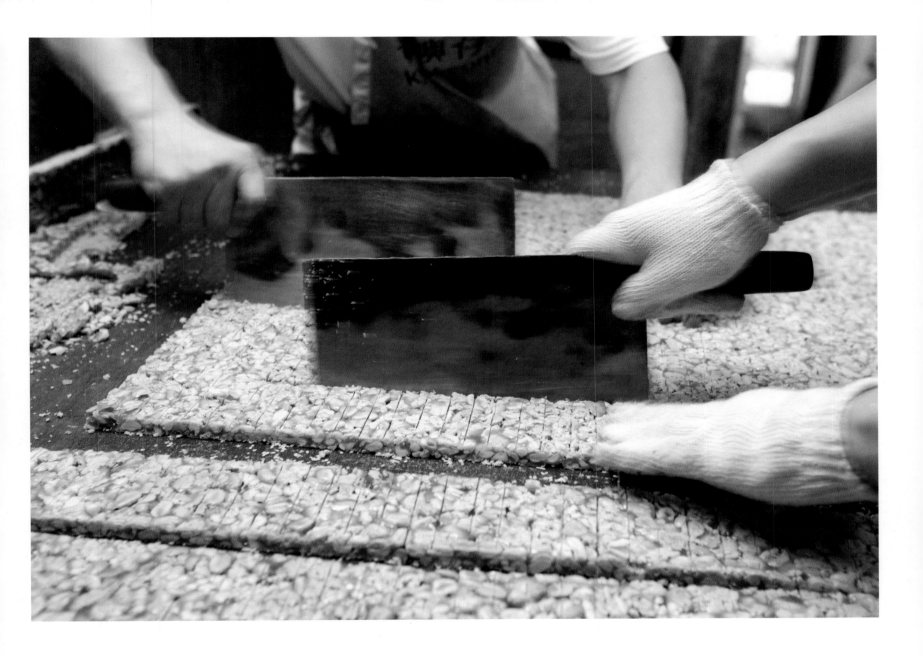

204

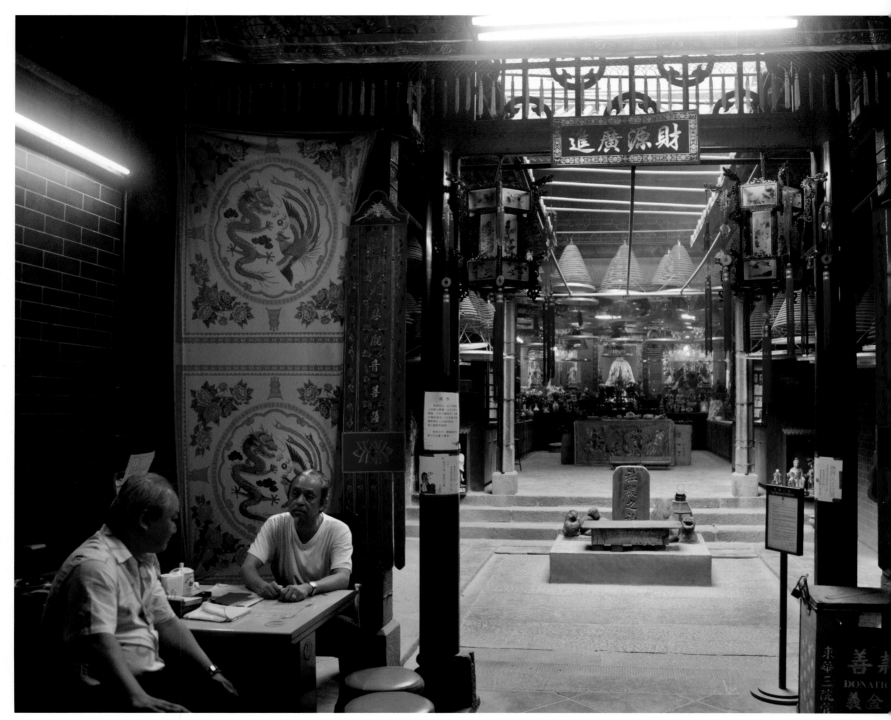

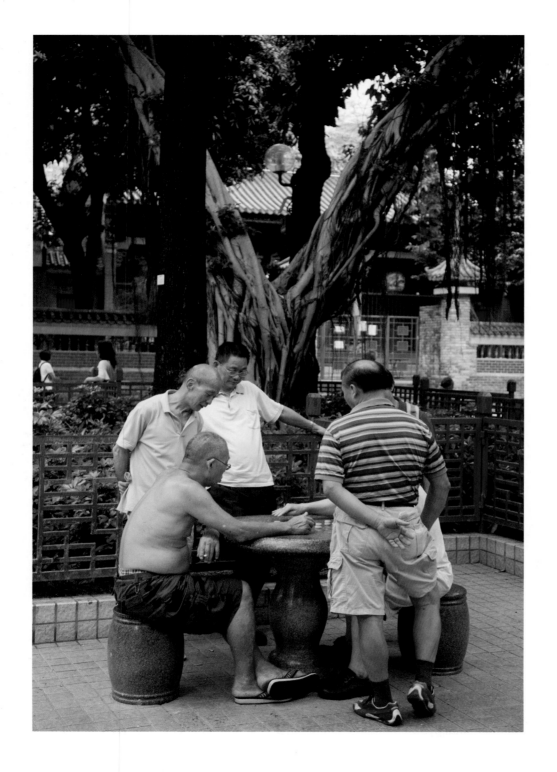

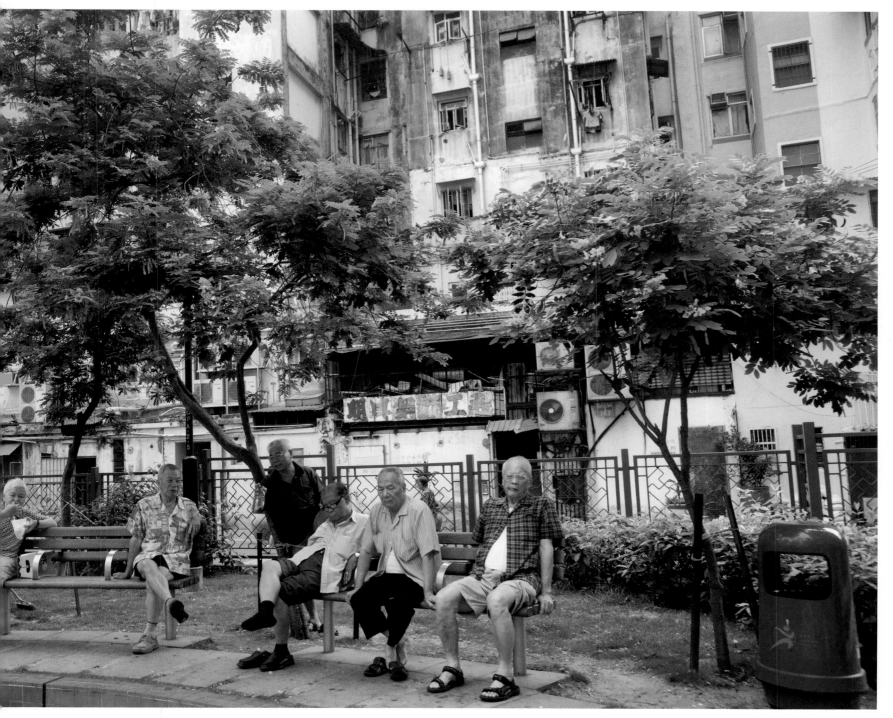

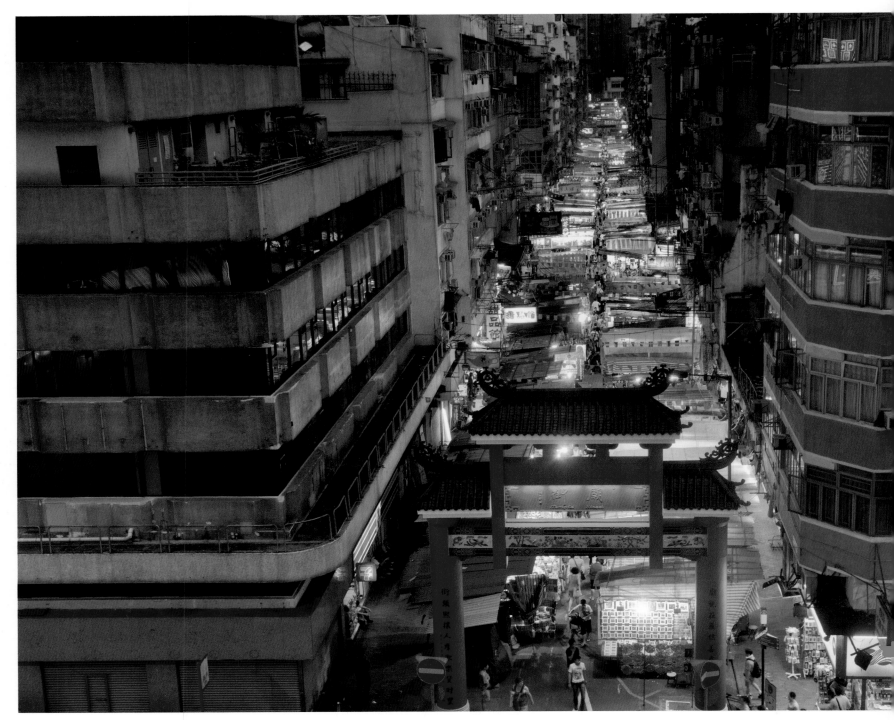

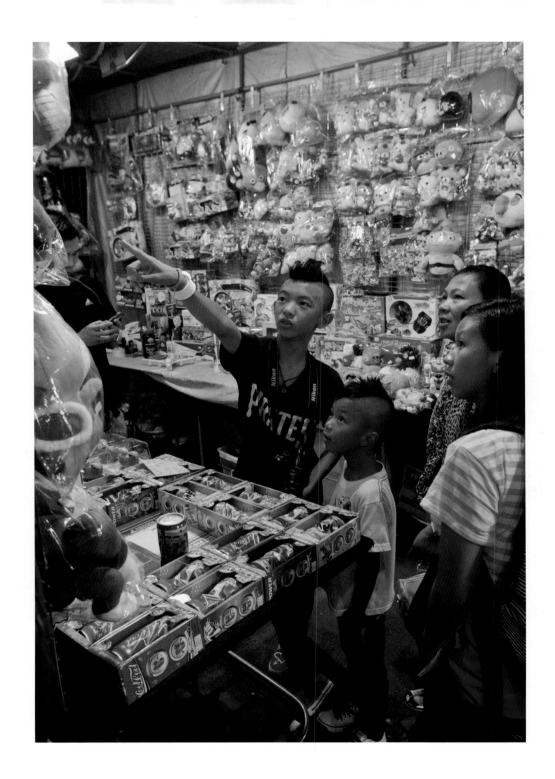

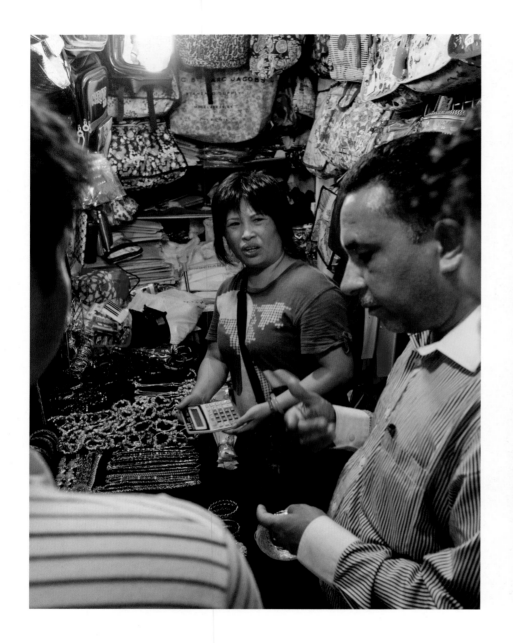

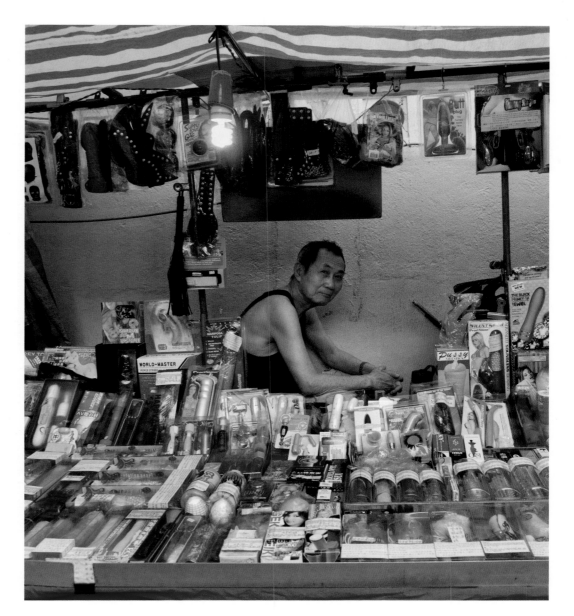

215

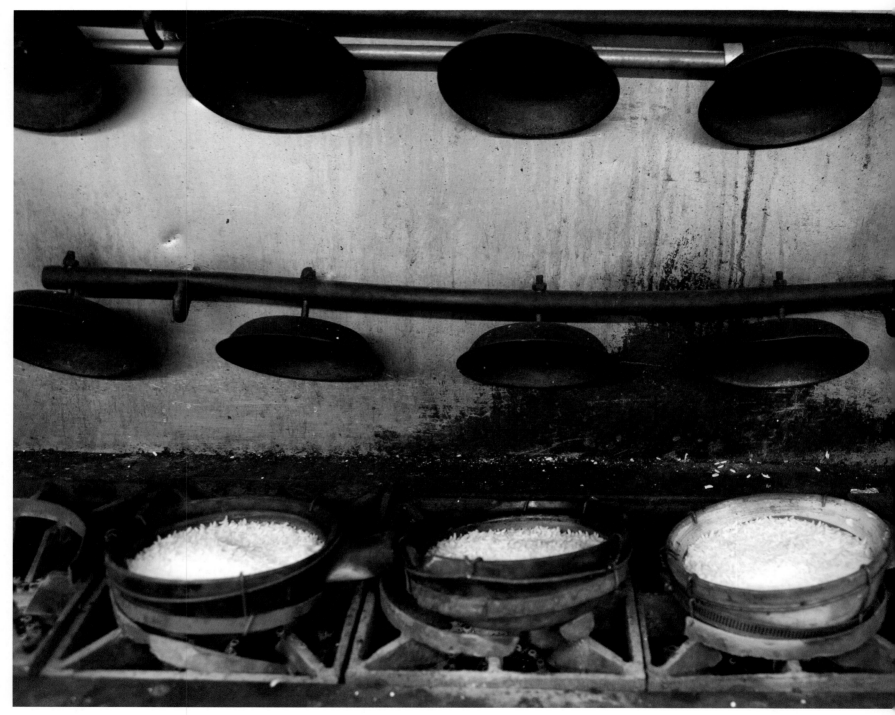

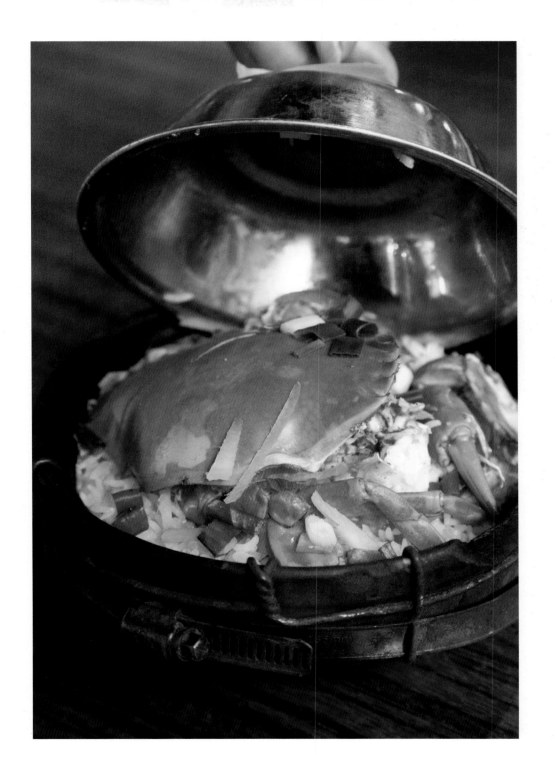

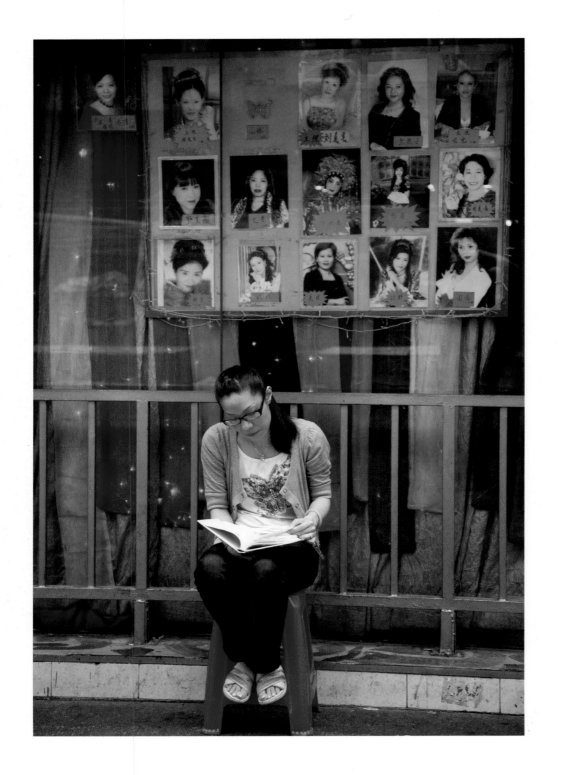

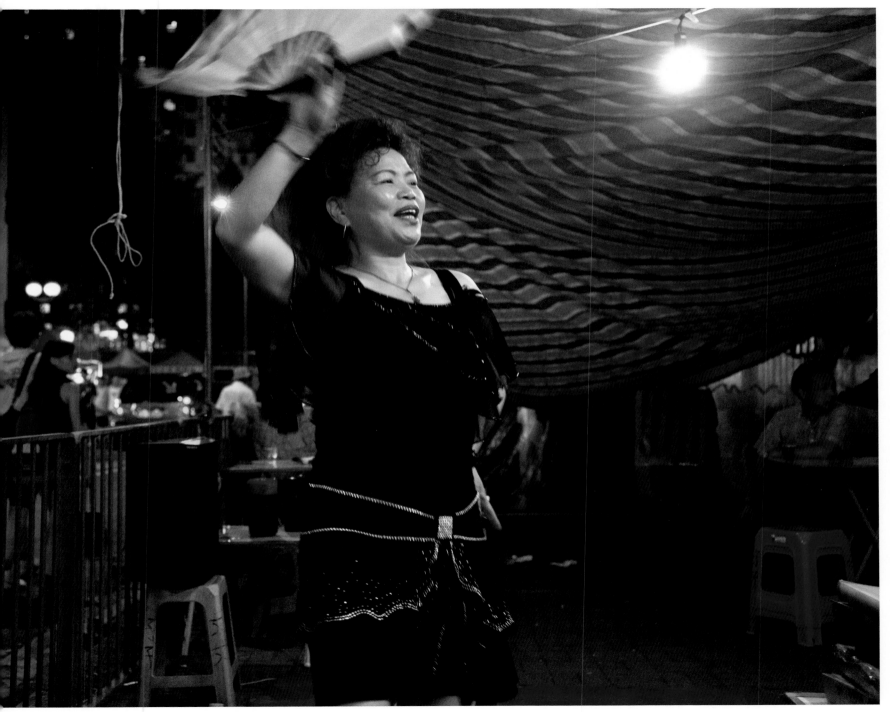

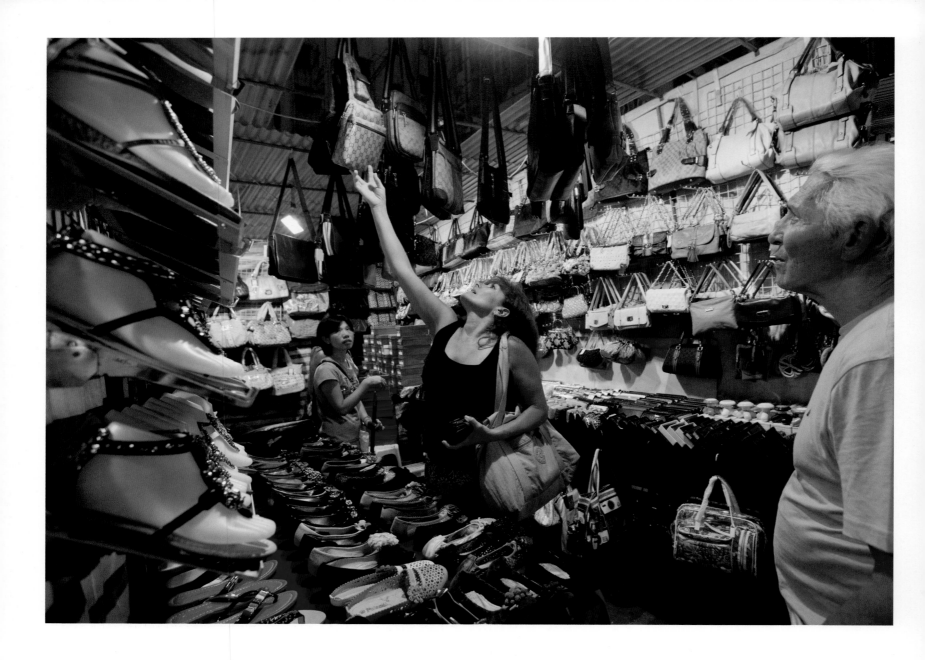

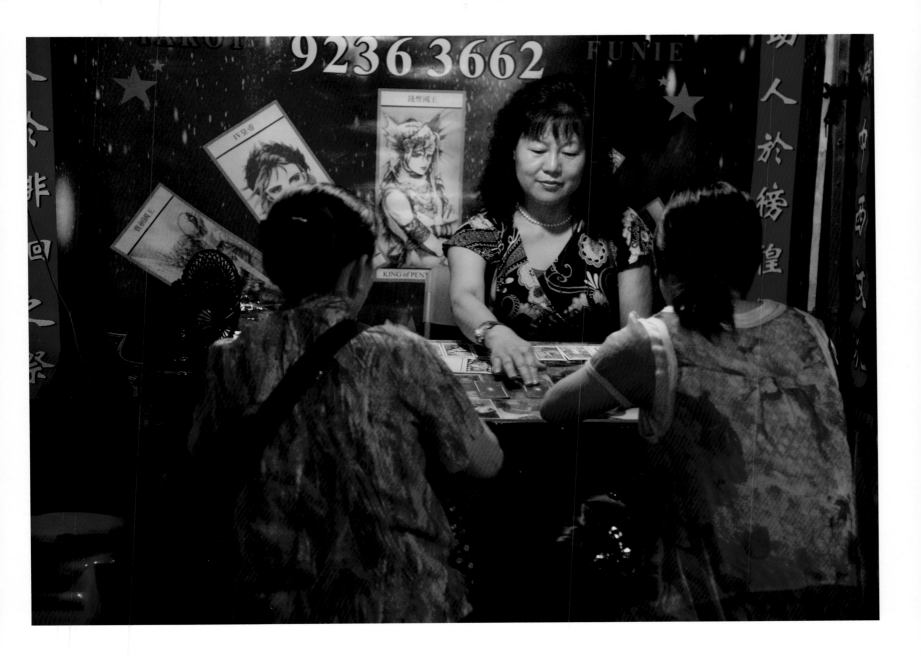

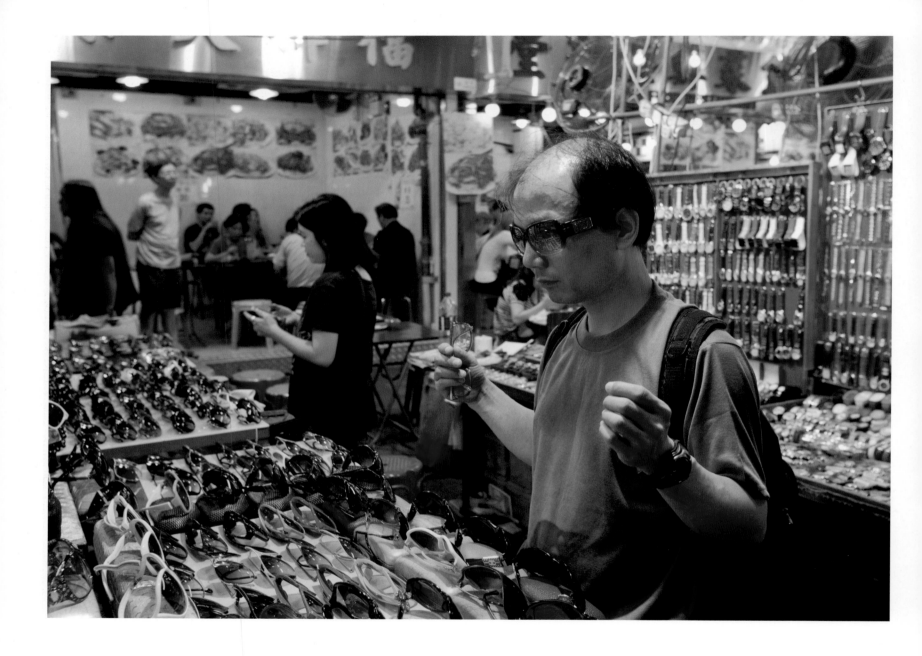

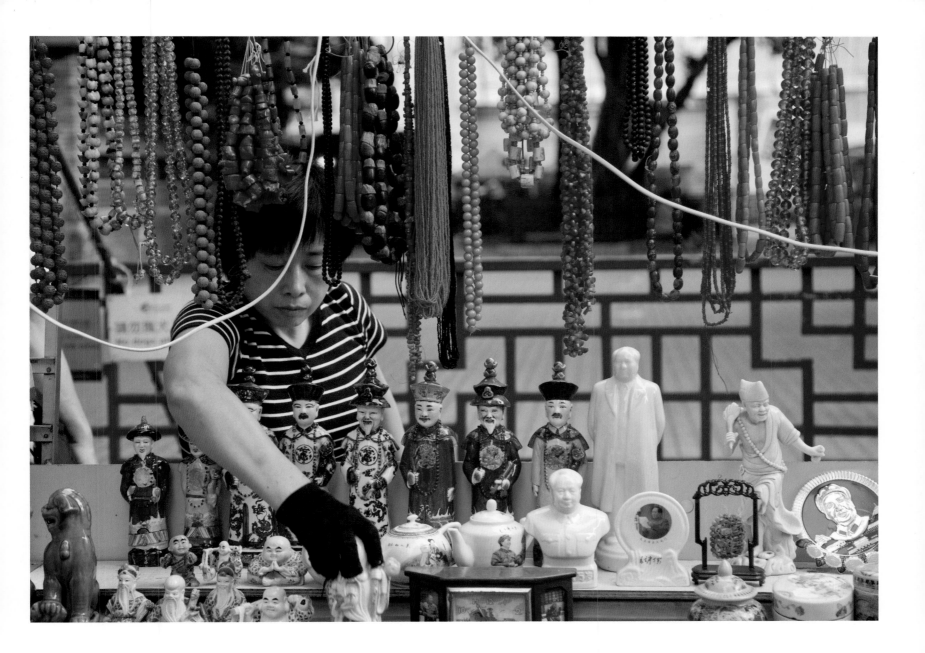

For big festivals such Ching Ming, or Ancestor's Day in April, Winter Solstice in December, or Lunar New Year in January or February, the Chiuchownese normally sacrifice all five animals; for less important festivals just three,' says Yeung.

Sugar towers available from the bakery are also popularly placed on altars. These white concoctions are made from pure sugar and are placed on altars for up to about a year. The towers are changed and replaced on such days as the Feast of Souls and Lunar New Year, and the sugar towers are also placed on altars at some weddings.

Yeung says the basic grain products were some of the earliest on the production line, one example of which is the *hung tou guo* which contains glutinous rice. 'During the harvest, people would cook it with sugar and it'd become a very simple and basic pastry. Other early products include the breads that use sweet potato, which after baking resembles some Western breads,' he says.

He adds that traditional products are used to form new fusion combinations – 'a piece of soft sweet might be used to wrap a hard piece, and be eaten like sushi. These combinations are separated in their boxes to prevent the moisture from the soft sweet seeping into the hard candy, which would make the hard candy less crunchy,' he says.

According to him, other of the shop's best buys include the banana roll, green bean pastry, peanut candy, and kumquat cake.

But, Yeung says that while business has come a long way since the first grain products, some basics are still observed, such as the use of a wooden chopping board to absorb excess oil.

References

Chong Fat Chiu Chow Restaurant, 60–62 South Wall Road, Kowloon City; Tel: 2383 3114; Open: daily 11 a.m.-midnight

Lok Hau Fuk, 3 Hau Wong Road, Kowloon City; Tel: 2382 7408; Open: daily 11 a.m.-11 p.m.

Nam Kee, G/F, 4 Nga Tsin Long Road, Kowloon City; Tel: 2716 1221/ 2383 5011; Open: daily 11 a.m.-11 p.m.

Chiu Chow Hop Shing Dessert, G/F, 9, Lung Kong Road, Kowloon City; Tel: 2383 3026; Open: 12.30 p.m.-1 a.m.

Kwai Yu Woo Kee Chiu Chow Bakery, G/F, 59, South Wall Road, Kowloon City; Tel: 2382 1673/ 2382 7895; Open: daily 8 a.m.-8 p.m.

Kowloon City Municipal Services Building, 100, Nga Tsin Wai Road, Kowloon City; Open: daily 6 a.m. to 2 a.m.

Cheng Po-hung, *Early Hong Kong Eateries*, 2003, Hong Kong University Press

5: FASHION & SEX

Sham Shui Po

Hanging by a thread

Trade in Cheung Sha Wan is in rags as business moves north

Sham Shui Po was one of the earliest developed districts in Hong Kong and, therefore, one of its earliest business centres. Settlements existed in the district as early as 25 BC. Sham Shui Po district today includes Shek Kip Mei, Sham Shui Po, Cheung Sha Wan, Lai Chi Kok, Yau Yat Chuen and Stonecutter's Island.

In 1898 there was already a market in Sham Shui Po village. Records dating from 1900 to 1920 state that the main industries of the district were farming, horticulture, and fishing. After 1920,

modernisation and industrialisation of the district took place, and then in the 1960s the industries and population of Cheung Sha Wan boomed, and it became a manufacturing centre.

'The boom in industry was largely to do with textiles and was supported by the influx of Shanghainese arriving in Hong Kong after the Chinese civil war of 1949. This arrival of immigrants provided the territory with added human and monetary resources and new skills. Later, other similarly skilled entrants entered the market from Guangdong province,' says Felix Chung, chairman of the Hong Kong Apparel Society, a non-profit association for small and medium-sized garment traders and manufacturers based in Lai Chi Kok. He says that they were businessmen who saw a simple economic structure with a potential to make money, so they went in. Most of the early businesses around Cheung Sha Wan Road – a major road which passes through Cheung Sha Wan and ends near Lai Chi Kok; Un Chau Street – next to Cheung Sha Wan MTR station; and Pei Ho Street – near Lai Chi Kok

Road – were family run. By the 1960s, some of the garment and fabric businesses were fairly mature with factory space of between 2,000 to 3,000 sq ft.

'It started as early as the 1950s, but the golden period of the garment industry was in the 1970s – I'm talking about manufacturing, "Made in Hong Kong". There were not really any other areas with the ability for garment manufacturing,' says Chung, adding that the factory owners from Shanghai were wealthy people who had been involved in the garment industry back home. 'They brought money and technology and set up the same businesses in Hong Kong. Textiles and garments were exported to Africa, Europe, and America. The cloth shops were mainly located in Yu Chau Street, and Kee Lun Street. At that time, textile exports amounted to more than half of Hong Kong's total exports.'

The Shanghainese began by manufacturing simple items. 'Textile companies were knitting fabrics and doing basic pants, shirts, whatever... nothing very fashionable. For the most part these were not for the Hong Kong market but were mostly for export to European countries and the United States,' he says.

But, in the late 1980s, due to the sheer volume of exports, a quota system was introduced. The imports were affecting Western garment industries, but after restrictions on quantity more value was added. One of the reasons for the success of the industry was its flexibility. According to Chung, when American buyers came with sampling requirements they could almost guarantee to meet their needs; and with a good legal system it was easier to do business.

Today, the legacy of this heyday lives on to some extent. Cheung Sha Wan Street and cross streets Wong Chuk Street and Nam Cheong Street are still lined with shops selling wholesale clothing and the odd bag or belt, while Lai Chi Kok is for trading – where the buying offices and trading offices of the garment export companies are located. Both are within walking distance and form a supply-chain area. 'San Po Kwong [in Wong Tai Sin district] is similar to Cheung Sha Wan, but not on the same scale,' says Chung.

With a cursory glance, the long rectangular shops in Cheung Sha Wan look identical. In fact, the layout of the two-storey shops is almost always the same. The ground floor is the showroom, at the back of which is a stockroom – usually with a sewing machine and steamer – and an elevator leading to the upstairs stockroom. The shops typically have 'retail racks' of 'wholesale leftovers' at the

front of the shop or on the pavement fronting the businesses.

For textiles, Cheung Sha Wan Street, Wong Chuk Street, Nam Cheong Street, Yu Chau Street and Ap Liu Street are focal points. Yu Chau Street also has fabric stalls, and is good for haberdashers selling items such as ribbon and other trimmings, zips, buttons, fastenings and decorative patches.

'The garment industry in Hong Kong and the Chinese Mainland is dying and looks set to die out in three to four years. Fifty to sixty per cent of businesses will close this year,' says Michael Li, director, Sun Hoi Garment International Ltd.

According to Li, there are two kinds of factories. Those run by Hong Kong people who have an office in Hong Kong and a factory on the Mainland, and those run by Mainland locals. 'The Hong Kong people put the money they made from their heyday in the stock market and real estate. They're not making a margin on their factories and for the past few years have been doing business at cost. If they don't have a next generation to follow they will just close their businesses and survive on the money earned in better times. Only the big guys will survive,' he says, adding that the Chinese Mainland factories are facing competition from cheaper countries.

An example of a Hong Kong business is Bukky Aki Fashion. 'Normally, about 50 pieces of retail are sold in a day,' says Junie Lam of the typical 800 sq ft-wholesale garment shop on Cheung Sha Wan Road. Lam grew up in the industry – her father founded Bukky Aki Fashion about 20 years ago, and before this he had a shop in Lai Chi Kok. The Lams own a factory on the Mainland with plenty of warehouse space to which Lam senior travels by train once a week. Hong Kong shops mostly buy accessories from China as they are cheaper there.

According to her, small shops buy five to six pieces per style and three to 10 different styles, meaning about 60 items for between HK$8,000 to 9,000. Meanwhile, large shops buy about 200 to 300 pieces and spend about HK$10,000 to 20,000. 'The shop has a bargaining range of within HK$5. The items are then sold on at around a 300 to 400 per cent mark up,' she says.

According to Lam, different shops in Cheung Sha Wan target different customers. Shops targeting the Japanese feature 'very fashionable clothes', while those targeting Africans have bright coloured garments often in red, green and yellow or gold.

Both the Lams and the customers design the clothes. They buy magazines such as *Jillie*, *Sweet*, and *Soup* to familiarise themselves with the latest

fashions in Japan and Korea which they then sell on, sometimes even to customers from these countries. 'Japanese fashions are more suited to the Chinese body type. We also copy from Korea for the same reason,' says Lam. She uses 100 per cent cotton or polyester, viscose mixes, and rayon to make the mostly 'one size fits all' garments. Each item bears a washing label and paper tag bearing the garment's production dates and the wholesale and retail prices.

The customers from Japan come from all over the country – Okinawa, Osaka, not just Tokyo. Some chain stores send shop reps every two weeks to look for styles that they like, says Lam. 'It's a globalised industry. Hong Kong products sell to everywhere in the world,' says Chung. There are also customers from Hong Kong such as those from the popular local fashion chain store In and Out which sells fashion for adults and has several factory outlet shops across the territory.

But the business is changing. According to Chung, Hong Kong's garment industry today has competition unlike in the 1960s, 1970s, and early 1980s when everything was 'Made in Hong Kong'. 'There were no real competitors ... maybe a little from Taiwan and Korea, but Hong Kong was the major garment export area in the world at that time,' he says.

Gail Taylor, associate professor at the Institute of Textiles and Clothing at the Hong Kong Polytechnic University, says that the trade figures of Hong Kong garment exports are similar in quantity to about 12 or 13 years ago, but the number of people employed has shrunk considerably in the same period.

The truth of Taylor's and Li's words is seen on the streets of Cheung Sha Wan, where the many empty shops show the effect of the handover and financial crisis of 1997 and the 2003 SARS episode on business. Shop rental is about HK$60,000 per month – much cheaper than it was in 1997 when rent was about HK$100,000. But, even cheaper rents have not been able to compete with those on the Mainland, and some businesses have already moved. Meanwhile, Li says that the Chinese economy is getting more mature. 'Young people [in the Mainland] are not entering the industry because migrant would-be workers are not leaving their villages to work in Guangdong province any longer as the salaries where they live are now comparable and they want to be close to their families,' he says.

Back in Cheung Sha Wan, Lam, a twenty-something, second generation to the business, is

an exception. But she agrees that it's also about the money. She says that more expensive retail is in the 'mostly retail malls' where tenants pay HK$150 to 200 per sq ft. The standard lease for the wholesale shops in the area used to be three years but is getting shorter. Two years is now the standard and temporary rental of even one month rental is available in the area. Other solutions include shops being divided into two or three separate spaces making it cheaper for businesses to lease them. Above the shops are residential buildings, some units of which are also empty. Many people from the shops once lived in these units and had factories above them. The survivors are those who bought their shops a long time ago, and who are therefore not affected by rental fluctuations. With so many of the long established wholesalers moving out of the area, retailers are moving in. Spaces where fabric, clothing and haberdashery items were once sold are now used to sell carpet, they say.

'The main concern is always cost. The increase of labour costs, rent, material costs. We cannot control these costs. In doing exports, we cannot transfer the increased costs to the end buyer, because the economies of Europe and the US are still not so good,' says Chung.

Today's competition comes from Southeast Asia – Thailand, Malaysia, Singapore and Cambodia – and Bangladesh in South Asia. 'Garments are very price driven. Thirty years ago, Hong Kong was cheap and competitive. It's a labour-intensive industry and if it's too expensive, you need to go elsewhere,' says Li. His company's garments are designed in Hong Kong, made in Cambodia and exported to Europe, after the company decided to establish a factory in the Southeast Asian country which is just two hours from Hong Kong and from where all garments are tax free to Europe.

But, Li says that formal-wear business will stay in China as the workmanship there is very good, but that casual-wear business is going elsewhere. 'Casual wear is moving to the Muslim countries such as Bangladesh and Pakistan, and then Cambodia and Vietnam,' he says.

Meanwhile, Chung says that all Southeast Asian countries are having problems with manufacturing, not just Hong Kong or the Chinese Mainland. 'Vietnam has huge inflation and increased labour costs. Thailand is losing competitiveness compared to China. Thailand is not cheap compared to Vietnam, Cambodia or Bangladesh and their technology and supply chain is not as good as China's. They are in a very embarrassing position.'

Chung is not pessimistic though. 'For merchandising, design, and shipping there are still many people working in this industry,' he says. Chung says that in time products will be higher priced and more fashionable. 'The future of Cheung Sha Wan? That's difficult to say. Let the market show the market's power. The market will decide the future,' he says.

Meanwhile, 'Places will close down in Cheung Sha Wan, but not completely. Hong Kong companies will stay competitive if they manage their companies well in terms of sourcing and design,' says Li. 'Hong Kong is no longer a manufacturing hub. But, sourcing, designing and meetings will be held in Hong Kong. Buyers would rather pass through and stay in Hong Kong than elsewhere,' he says.

Lam is the most optimistic of all three, saying that in the future a second generation of younger people like herself will come to the area and the business model will change. Her father's shop offers an example, with a point-of-sale system with an accessible interface which allows the creation and printing of the receipt, although they still work with a ledger to account the transactions too. According to her, there are not many new customers and the shops don't have marketing strategies, but this may also change.

References

The textile, garment, and haberdashery shops of Cheung Sha Wan are mostly open Monday to Saturday from 10 a.m. to 8 p.m. Some businesses are also open on Sundays.

Bukky Aki Fashion Company, G/F, 218 Cheung Sha Wan Road, Sham Shui Po

Hong Kong Apparel Society; Web: www.hkapparel.com.hk

Yau Tsim Mong

Striking a pose

Message of Mong Kok fashion goes largely unnoticed

The beauty of youth is often striking and the way the young clothe themselves and posture can also be attention grabbing. This is so in Mong Kok, where some say the get ups form a fashion subculture called 'MK fashion'. The 'MK' stands Mong Kok, but most of the wearers don't actually live there. They live all over Hong Kong, but frequent southern Kowloon for its entertainment.

A general definition of a 'subculture' is 'a group of people with a culture, distinct or hidden, which differentiates them from the larger culture to which they belong'. Clothing is one form of demonstrating membership to a subculture; mannerisms and ways of speaking are others. Subcultures are social but are also typically self-absorbed. They are about

taking an inner characteristic to the extreme or becoming someone different altogether; like playing dress-up as children or mask wearing.

There are those who say MK fashion is a subculture. In a 2010 online poll on MK fashion by the China Business Centre of the Hong Polytechnic University (PolyU), 85.7 per cent of respondents acknowledged the existence of the MK fashion subculture. For most of those who do, MK fashion is an amalgamation of two subcultures: Japanese – Japan is everywhere in Hong Kong – and Hong Kong triad societies, as seen in screen portrayals in films such as *Young and Dangerous* (1996) and its sequels, directed by Andrew Lau.

'The heavy presence of triad gangs in Hong Kong films and TV series has been notable, and triad culture has influenced fashion,' says Gail Taylor, associate professor at the Institute of Textiles and Clothing at PolyU. 'The government warnings on radio urge us not to glorify the triads, or in other words, encourage young people to think their lives are glamorous, but, lifestyle and appearance affect

young people's attitudes towards fashion. It is inevitable.'

Many Hong Kong locals say that while MK fashion is distinctive, there is no 'uniform'. Outfits for both males and females might include black, denim, and chain accessories draped over the exponents' hips. These elements are not new to adolescents: black is a 'disappearing' colour that has long been popular among teenagers, while denim has been the fabric of the young since the 1950s when James Dean popularised it as the symbol of the teenage rebel. The use of chains recollects the punk era of 1970s London – itself a subculture – Michael Jackson, and, more recently, the hip hop scene. All of these elements indicate a toughness associated with a particular socio-economic group.

Other outfits spotted on a walk around the main locus of MK fashion, the Trendy Zone shopping centre on Nathan Road, and streets in Mong Kok such as Sai Yeung Choi Street South and Fa Yuen Street, might equally include a worn-looking red and white chequered fitted shirt worn over jeans for males or a tight fitting hoodie with hip hugging jeans for females.

Jennifer Lo, a 20-something journalist, says that MK fashion is: 'Hip, urban, elaborate', though with a negative connotation of 'being overdressed in bad taste", and is quick to say that she doesn't do the look. 'It's typical for MK fashion girls to wear fake nails, long fake eyelashes, coloured contacts, miniskirts and bling-bling accessories. Alternatively, MK guys often dress up like gangsters with their hair dyed in bold colours and wear torn jeans,' she says.

Other common elements are the decoration of bodies with earrings and tattoos. While some ask if MK fashion is really a genre at all, the attitude remains, on the one hand, 'Look how tough I am!'/ 'Back off'/ 'Leave me alone', but also, 'Come here'.

Despite its apparent intention of coolness, the PolyU poll on MK fashion found that 75.3 per cent of respondents said MK fashion was 'uncool', 10.4 per cent thought it was 'cool' (15.6 per cent said 'they didn't know what MK fashion was'). These statistics underline MK fashion's status as a subculture – to the mainstream, MK fashion wearers are 'the other' – and point to the values of Hong Kong people generally: that it's good to wear a smile, fit in, be well educated, and have money to buy branded clothes, or, at the least, that excessiveness or the display exemplified by MK fashion wearers is not valued; remnants of Confucianism, perhaps.

Journalist Lo says that she thinks MK fashion *is* a subculture. 'It's quite a distinctive fashion style that stands out from the crowd but isn't very mainstream. You can feel right away if he or she is dressing MK today. If you're among an elite circle, for example, your university friends – then dressing MK is not very desirable,' she says.

The 'come here' aspect is an indication of the MK fashion adherents' erotic capital, which is displayed more than in other places in Hong Kong where the mainstream culture values not just gender roles, but specifically the chastity of women. Males in Mong Kok may wear sleeveless T-shirts and tank tops which show their shoulders and arms, while females flaunt their legs in barely-there skirts or thigh-hugging jeans and wear their hair mid-back long, loose, and straight. In so doing, though they appear to rebel against society, they are actually aligning themselves to ascribed-by-society gender roles.

Caricaturing gender through clothing can have serious effects on gender politics. Some say that the most extreme form of caricaturing is done by cross-dressers; others that women overly feminising themselves or alternatively, masculinising themselves by wearing trousers, can be equally as extreme. Wearing skirts and dresses has yet to move into the mainstream for men; though the *cheung saam* started out as a loose riding outfit for Manchurian males before it became an eroticised female national dress. In China today, the *cheung saam*, or *qipao*, is experiencing a revival with '*qipao* clubs' emerging across the country in which the members take to the streets in their dresses on certain days.

Other forms of dressing aim to neutralise gender or sexuality such as the childishness of females in Hong Kong illustrated by adult women's long hair, miniskirts, knee-high socks, and use of childish props such as cuddly toys. Some say that dressing and behaving as a young girl is a witting or unwitting ploy to elicit a protector response in males. Certainly, the concept of *gong nui*, meaning 'Hong Kong girl' plays on the above, though it is sexualised to greater and lesser degrees in individual cases or situations. 'The *gong nui* is a term with negative associations. She is a princess who pretends to be a cutie to get what she wants. She wants to be taken care of and expects the man to have a good job and to pay for everything,' says one local man.

Another example of caricaturing through clothing which, like females wearing trousers is now taken for granted, is mainstream office wear.

Essentially a uniform, its intention in colour and cut is to lend authority to the wearer and give importance to the tasks that he or she performs, validating the wearer's subscription to full-time labour.

MK fashion is not the first fashion subculture nor will it be the last. Fashion subcultures have existed in the East and West, defining various eras. All seem to work as a release or form of escapism with the wearers seeking to transcend their daily lives. For example, the dandy male of late 18th- and early 19th-century Britain placed great importance upon physical appearance, refined language, and leisurely hobbies.

Another example which originated in London, and peaked in the early to mid 1960s, was the mod subculture. They wore tailor-made suits with narrow lapels and skinny ties, black turtlenecks and berets, the males and females sometimes hard to differentiate as some male mods enhanced their appearance with eye shadow, eye liner and lipstick, while female mods dressed androgynously with short haircuts, men's trousers or shirts, flat shoes, and little makeup – like British model, Twiggy.

Professor of English Ken Gelder who teaches courses in subcultural studies at the University of Melbourne, Australia, says that there are six ways that subcultures can be understood: negative relations to work; negative or ambivalent feelings towards class; association with territory rather than property; movement out of the home and into non-domestic forms of belonging; stylistic ties to excess and exaggeration; and refusal of ordinary life and massification. For these reasons, subcultures can be seen as negative due to their criticism of the dominant culture. 'Sex and creativity are often seen by dictators as subversive activities,' as American novelist Erica Jong wrote. MK fashion contains elements of both.

Do Gelder's views apply locally? MK fashion is most apparent within the borders of Mong Kok, but as many adherents don't actually live in the district, their homes are further afield, in the Tuen Mun, Tin Shui Wai and Yuen Long districts in the western New Territories. These places are marginalised, as Mong Kok was in the past. Affluent people don't usually live there. This plays to Gelder's theory of often negative relations to work; negative or ambivalent feelings towards class; association with territory rather than property.

According to government statistics, in 2010 there were 96,100 people classified as low income in Tuen Mun, and 128,000 in Yuen Long, out of a total number of 1,205,000 in Hong Kong. Tuen

Mun and Yuen Long districts are among the top five districts with the lowest income; in Yuen Long, the ratio is 23.5 per cent, the highest among all of the 18 districts in Hong Kong.

Conventional dressers are judged by the brands that they wear, and, as a result, conclusions are made, true or false, about their bank balances. But for much subculture fashion the cost of an outfit is not immediately obvious. It can be quite expensive, but in Mong Kok fashion this is often not the case. Creativity, or how cool, tough, punk, or MK an outfit is, are of greater importance.

As previously mentioned, MK fashion is thought to be a combination of Japanese and Hong Kong triad subcultures. In Japan there is great tolerance towards dressing up, and fashion subcultures – as can be seen at Harajuku, the Shibuya area of Tokyo.

Among the best known of Japan's subcultures are the 'Lolita girls' of Tokyo who appear to some to be inspired by nymphet fantasies – though many say the outfits are inspired more by Victorian children's clothing.

In Lolita fashion, wearers dress like pre-pubescent girls in knee-length skirts or dresses, blouses, petticoats, and knee-high socks or stockings. Teddy bears and dolls are often carried.

Females sport ponytails, cosmetics to make their eyes look wider and them, younger, and rouged cheeks giving them a doll-like appearance like the ones they sometimes carry. There are even male Lolita fashions which include knickerbockers and other styles of short trousers, knee-high socks, top hats, and newsboy caps.

'There are many theories why Japan has been particularly open to sub-cultures. Firstly, Japan has the reputation for being relatively conservative, so there is the element of escapism from reality to fantasy as in 'cosplay,' says Taylor of the PolyU. 'Cosplay' stands for costume play – wearers dress up as characters drawn from anime, manga comics or videogames.

'Secondly, the contributions of the culture, industry, past designers, and the education system offer rich assortments of inspiration. Most importantly, perhaps, Japan has always been seen as relatively prosperous, so the matter of discretionary income (also, free time and the ability to use it) is of relevance to at least the younger age group,' she adds.

Today, more than sixty years after its defeat in World War II, Japan is everywhere in Hong Kong with Japanese cartoons, comics, video games, TV shows, movies, pornography and fashion popular

across the territory. Some say that there is a no more Japanese place in Hong Kong today than Mong Kok – though it is Causeway Bay with its huge Japanese department stores that bears the moniker of 'Little Tokyo'.

Lau Fong, former researcher at the CBC who designed and conducted the online poll on MK fashion and who now works as a research analyst for Li & Fung says, that to older residents of Hong Kong taking cues from Japan may be unwelcome owing to memories of the Japanese occcupation of Hong Kong, but that national sentiment was not a consideration under British rule, and after the Pacific War it was business as usual for the territory.

'After WWII, most countries in Asia banned the import of Japanese cultural products, a ban that was only lifted in the Mainland and Taiwan in the 1990s. But, as early as the 1950s Hong Kong restarted cultural exchanges with Japan,' he says. 'This was perhaps because anti-colonial movements have never been strong in Hong Kong, as it is an immigrant society, and the immigrants arrived knowing that it was a colony, unlike Taiwan or Mainland China.'

Icons of popular culture in the West such as singers Björk and Madonna, and, more recently, Lady Gaga have regularly played with the subversive resulting in their enduring popularity as poster girls of the alternative. The Grammy award-winning musician Björk has compared the controlling nature of the fashion industry to fascism. 'I like the creative angle where people express themselves. But I don't like it when it's too much of people being told what to do… magazines telling women to starve themselves, and they obey! 'Or they're "out of fashion" which is the worst crime you could ever commit!'

Hong Kong has its own 'alternative' icons. The late Cantopop singer Anita Mui Yim-fong was a fashion chameleon during her lifetime, while singer Faye Wong is known for her rotating styles. Former fashion editor Winifred Lai and Hilary Tsui Ho-ying, wife of Cantopop singer Eason Chan Yik-sun are also touted as trend setters. Wong has been the cover girl of such magazines as the Asian versions of *Vogue, Marie-Claire, and Elle*, and has also been asked to endorse various beauty products. But, how genuine is the subversiveness of these people? Is their subversiveness integrated into them? Or has it been adopted for commercial or other reasons?

'Hong Kong is not a very fashionable place. Most people don't think about fashion. We look to Japan and Korea and follow what they are doing,' says one Hong Kong local. Taylor agrees. 'Hong

Kong's industry was primarily based on trade, hence the matter of local trends is quite particular, and most trend ideas come from elsewhere, typically Paris, Milan, New York, Tokyo, and on occasions Shanghai, Beijing or Seoul... Much of what is 'admired' and adopted by youngsters with a keen interest in local fashion appears to be derived from Japanese design,' she says.

But things may be changing. 'For those who enjoy local flavour, there is a definite following for designers capable of distilling things which are distinctly Chinese or, more specifically, Hong Kong Chinese,' Taylor says, though adding that this following is very small.

In Hong Kong 'from a consumer perspective, there is the youthful subcultural influence which stems from political, social, economic and other factors as elsewhere. As for the designers, Hong Kong has its radical and mainstream, avant garde or conservative elements as elsewhere; this has been recognised by the Hong Kong Trade Development Council, for example, in their promotions of the "New Force", which, essentially, introduced up-and-coming young designers with a different perspective,' says Taylor.

'The situation is changing: years ago, very few design-oriented entrepreneurs launched their own labels and had their own design signature; today, it would appear that the level of prosperity and quest for individuality has changed things somewhat,' she says.

She adds that the nuances or differences are numerous. 'If you take, for example, Henry Lau (Spy) you will see that his style was not exactly subversive, but that he did have the inclination to change the system. William Tang did something similar in his early career; various others (Peter Lau, with his China Flag statement, for example) have periodically bucked the system in similar fashion to, for example, Vivienne Westwood in London or Jean-Paul Gaultier in Paris.'

Fashion subculture membership can be liberating, helping wearers and non wearers to express themselves through what they wear. The clothing triggers responses in the wearers and observers, and this can be used to create dialogue to identify and remedy social ills.

In Hong Kong society, which discourages individuality, MK fashion is a deviation from the norm. The contemplation it provokes is fleeting, falling into all too easy classifications of 'different' or 'alternative', 'good' or, more commonly, 'bad', after which reflection on the meaning of an outfit normally tails off. 'Perhaps MK fashion should be

regarded as home-grown fashion that deserves some degree of appreciation,' says Lo, adding that Hong Kong people are slaves to Western luxury brands and fashion labels such as H&M and Zara.

Though not usually exercised, the freedom and power of clothing for self-expression could be encouraged for the enrichment of society. The question is whether people recognise and utilise the freedom that fashion offers.

References

Census and Statistics Department

Hong Kong Trade Development Council; Web: www.hktdc.com

Lolita Fashion, Web: www.lolitafashion.org

Yau Tsim Mong

Body of evidence

Sex workers gratify carnal appetites if not hearts and minds

Sex will never go out of fashion, and nor probably will sex for money. It's something that has long been available in Hong Kong and still thrives in the territory. Mostly, it is female sex workers who are seen and heard, or rather, heard about because there are many more of them than their male counterparts. But there are also male sex workers in Hong Kong who are servicing both the male and female market.

'In any place where the divide between rich and poor is big, like in Hong Kong, there is a lot of sex work,' says 'Adam', a male sex worker. Adam works part-time as a sex worker and the rest of the time at a local lesbian, gay, and bi-sexual organisation. He identifies as gay, and says he worked at the male sex workers' union Midnight Blue before he decided to become a sex worker himself.

In a city that doesn't sleep, Mong Kok and Yau Ma Tei are two of the last places to nod off. Day and night, the main thoroughfares such as Nathan Road, Argyle Street, Shanghai Street, and Portland Street, Sai Yeung Choi Street, and Tung Choi Street heave with residents, shoppers and tourists who come for the markets, eateries, and shops – and sex.

The street, 'foot massage parlours', 'hair salons', 'saunas' nightclubs, 'karaoke bars', and brothels are all places out of which sex workers operate. According to Zi Teng, a sex workers' concern organisation established in Hong Kong in 1996, there are an about 500 brothels, massage parlours, and motels where over 1,000 sex workers service anywhere from 10,000 to 20,000 clients daily. Zi Teng says there are an estimated 20,000 sex workers across Yau Tsim Mong and Sham Shui Po in Kowloon; and in Wan Chai on Hong Kong Island and Tsuen Wan in the New Territories, but that a closer approximation is impossible as many sex

workers arrive in Hong Kong on seven-day tourist visas and new groups enter weekly.

In Hong Kong, female sex workers are known locally as *gai*, while male sex workers are known as *ngap* which mean 'chicken' and 'duck', respectively. 'Society treats the workers as animals,' says Zi Teng. But there has been a transition from the term 'prostitute' to 'sex worker'. 'It's a change in name only, but the first step in changing society's perspective,' says Zi Teng.

'There are many kinds of sex work in Hong Kong ranging from escorting to BDSM (Bondage & discipline, sadism & masochism),' says Adam, adding that across the male and female sex workers, there are also many types of service providers. He says that some sex workers at nightclubs charge a few thousand Hong Kong dollars per client and they'll have several in one night, and, therefore, earnings of HK$30,000–40,000 a month – well above the HK$10,000 average in Hong Kong – but that most do not earn so much. 'A street walker might earn as little as HK$45 to $100 per client,' he says, adding that these are usually Mainlanders who can't rent places of their own.

Adam says that as a part-time sex worker, he has between one and four clients a month and charges HK$1,200 minimum for two hours – his price goes down to HK$700 when he's working full-time.

Previously, there were very few male sex workers. 'You could charge a few thousand dollars each time. There was no Internet, so sex workers were hard to find, but the economy was good. It was before 1997. The asking price dropped dramatically as more people got into the industry after it became easier for Mainlanders to get tourist visas. The Hong Kong sex workers are very unhappy about this,' says Adam. According to him, there are currently only a few hundred male sex workers in Hong Kong, though this figure changes every week, as do the actual individuals as many are from the Mainland.

Zi Teng agrees that the economy influences sex services: 'Because of the credit crunch, clients aren't as willing to pay for sexual services. There's a lot of competition between the sex workers who are consequently lowering prices,' adding that the condom is an element of the price war, and that unprotected sex being offered by sex workers as incentive has been reported in the media.

Most male Hong Kong sex workers work out of massage parlours. 'They can only hire people with Hong Kong ID cards. They are only legally allowed to conduct massage. Sex workers at these places are hired without a contract and though they are paid

daily and work eight-to-ten-hour shifts even if there are no clients, and may work there for months at a time,' says Adam, adding that a concentration of these places is between Mong Kok and Tsim Sha Tsui, and between Wan Chai and Causeway Bay. Other insiders say that Kowloon City is an area of activity with male and female Thai and other Southeast Asian sex workers plying a trade there.

Meanwhile, Adam is self-employed and works in hotel rooms or clients' homes. 'The clients are usually up in the room when I arrive, but sometimes we check in together,' he says of the hotels he frequents. 'They're basically sex hotels rentable for two hours. They're gay friendly. Fancy hotels are fine. They don't care. In the past, I have had some bad experiences to do with same sex couples.' Adam adds that sex workers from China also mostly work in hotels and clients' homes. 'They have a place to stay in Jordan – one big building. They cram them in, two, three in one room. Sometimes, if the client doesn't want to pay for a hotel or doesn't have personal space, the sex worker will bring him back to his room,' says Adam.

Sex work is a heated subject. On the one side, there is the view that sex workers or prostitutes are victims of male exploitation and that sex work and pornography objectifies women. But this hardly takes into account the male sex workers who serve female clients. Some say that sex work triggers a fear due to its challenge of the monogamy that mainstream society embraces, and so its proponents must be disempowered by mainstream society. Critics of monogamy argue that it involves a damaging self-denial and is actually unnatural. On the other side, there is the view that sex work can be a bold form of liberation for women – or men – to take control of their lives and earn a living in the way they see fit, and that some choose to do sex work over other forms of work that might be available.

A Hong Kong Christian Service survey in 2009 on the subject of 'compensated dating' – translated from the Japanese *enjo-kosai*, a euphemism for anything from escorting to actual sex – of 600 youngsters aged 12 to 20, found that 34 per cent of the respondents who live in Sham Shui Po, Yau Tsim Mong and Kwun Tong districts said they would consider offering compensated dating as a full-time job. Of these, 60 per cent said they would do it mainly to earn quick cash while 23 per cent said they would do it for their own sexual pleasure. Observation on the Internet reveals that 'daters' range from 16 years and younger to 28 years of age, and include school girls to 'OLs' or 'office ladies'.

This is the recent picture, but the history of sex work in Hong Kong is interesting. For 53 years from 1879 to 1932, sex work was legal in certain designated areas in the territory. Sex workers were required to register for licences and pay taxes like anybody else.

'The brothel business brought prosperity to many businesses, such as that of food establishments, entertainment, beauty salons, fashion houses and transportation. Regular health checkups were mandatory,' writes Yeung Chun-ting in the foreword to Cheng Po-hung's *Early Hong Kong Brothels*. According to Yeung, by 1930, Hong Kong was home to 200 legal brothels and there were over 7,000 licensed sex workers in its 1.6 million population. But, the same year, the government prohibited prostitution, first banning Western prostitutes in 1931; and the following year, so-called 'Big Number Brothels' in Wan Chai. In the early 1900s, Spring Garden Lane and Sam Pan Street in Wan Chai became a red-light district with Western and Chinese prostitutes. In order to attract attention, brothels would display larger than usual street number plates. By 1935, the days of licensed sex work had come to an end, though sex work, naturally, continued.

Later, between the 1950s and the 1980s, prostitution in Hong Kong developed in step with the economy and existed in various places including so-called 'pleasure boats' in Yau Ma Tei typhoon shelter. Sex work in Hong Kong was immortalised in the novel and subsequent film *The World Of Suzie Wong*, a story of a 'hooker with a heart of gold'. In fact, such romantic portrayals of the female sex worker are found across cultures. It has been called 'a flight from typical social mores regarding sexual decency and moral substance', but may not be complete fantasy: Adam admits that he has waived fees in the past for clients he has become attached to; clients who have 'fit every criteria of being a boyfriend,' he says. Still, the 'hooker with a heart of gold' is often portrayed in a sad light, only reluctantly selling his or her body and dying tragically, reinforcing mainstream lifestyle choices.

Despite the greater leniency of the past, now sex work is only permitted within certain strict parameters in Hong Kong, while a host of activities surrounding it are prohibited, such as: 'control over persons for the purpose of unlawful sexual intercourse or prostitution (penalty, imprisonment for up to 14 years); 'soliciting sex' (fine of HK$10,000 and up to six months in prison); and 'living off so-called immoral earnings' (up to 10

years in prison). 'Causing prostitution', meaning procuring or encouraging another person to become a sex worker, is also chargeable by law (up to seven years in prison).

Meanwhile, 'Agents of men-to-men sex work are violating two laws,' says Adam. 'Procuring gross indecency by a man with a man faces a maximum penalty of imprisonment for two years, and if that man is under 21, the procurer faces a penalty of another two years. Procuring others to commit homosexual buggery faces a maximum penalty of two years, and homosexual buggery with or by a man under 21 earns a maximum penalty of imprisonment for life. Homosexual buggery committed, other than in private, faces a maximum penalty of imprisonment for five years.'

According to Zi Teng, there are just two perspectives on sex workers in the territory. 'The sex worker either comes from a really bad home, was raped, or had some childhood experience that affected them leading them to this type of work; or the sex worker is a fundamentally "bad woman" who just really wants men. Perceptions are very extreme. Nobody actually thinks that a normal person from an average background might want to do this type of work.' The organisation says that the reasons sex workers enter the industry in Hong Kong are multifarious. 'There are some girls who just prefer the work to being an office lady or waitress. They can work whenever they want, which is convenient for divorced women who have children.'

'I can honestly say that a huge percentage of the girls are extremely proud of what they're doing. They tell us that but they feel they can't tell society. They feel free and they earn so much more than washing dishes or being a waitress. A lot of the girls' families depend on their salaries. They feel very proud that they are bringing up their children single-handedly without having to accept welfare payouts,' says Zi Teng. But, according to Adam, self-esteem among sex workers can be very low.

'Very, very few let their families know. This may be partly because of the Crimes Ordinance, which states that "Living on the earnings of prostitution of others is a punishable crime for which those found guilty can be charged to up to 10 years in jail,"' says Adam.

'There are sex workers who've raised their children, then when they learn the nature of the mother's work, have not even invited her to their weddings. There are a lot of these cases. Children disown their mothers or don't acknowledge that they are working in the industry,' says Zi Teng. 'The sex workers don't dare to tell their own husbands or

families that they're doing this kind of work. Usually they lie and say they're working at an elderly care centre which is why the hours are so late.'

In terms of clients, those for female sex workers are mostly men, while customers for male sex workers are mostly limited to gay men, though the sex worker may not identify himself as gay. According to Adam, most of his clients are Western male professionals and male tourists from the United States and the United Kingdom. They are mostly middle aged and half of them are married. Meanwhile, 'The majority of women in Hong Kong will not pay for intimacy,' says Yang Yee-shan, author of *Whispers and Moans*, a study of sex work in Hong Kong, and writer of two films on the Hong Kong sex industry.

She says that elsewhere in Asia, in Japan, for example, there are 'host clubs' that cater to women willing to pay for conversation and companionship and where services may include sex. Sex tourism for women attracts them to southern Europe, the Caribbean, Africa, Indonesia, and Thailand. She says that Hong Kong women are very conservative because Hong Kong schools are religious. 'If they do go, they will go to Thailand or Southeast Asia where they have enough distance from their lives to feel psychologically safe.'

In the late 1980s, Yang says that there used to be a host club in Stanley where HK$30,000 to $50,000 was charged to Hong Kong housewives just for drinking, but that she doesn't think the gigolo business will come back to the territory.

However, she says that female sex workers often pay for sex with their male counterparts even though many have partners of their own. 'Most female customers are female prostitutes, not normal female customers. Female prostitutes normally have boyfriends to who they are enslaved. Going to a male sex worker for them is a kind of counselling service. Some of the girls want it, some don't. They might stick with the same male prostitute or use different ones,' she says.

Clearly, as in the past, there's sex work to be had in the territory. Lack of communication between couples is one reason or 'Sometimes the client doesn't even ask for sex. But, there may be other motivations: the wife may have contracted uterine cancer, had her womb removed, and be unable to have sex; but the husband still has needs. Or the client may be really unfortunate looking and unable to find a girlfriend,' says Zi Teng, adding that if you look at history, even a thousand years ago in China sex work existed. Back then, sex workers could occupy quite a high position within the social

hierarchy. The longevity of the profession indicates that it isn't going to go away.

But today, many still question whether sex work is really 'work'. According to Zi Teng, the change in terminology from 'prostitute' to 'sex worker' is a first step in the right direction but one that's difficult to implement. 'Not even the media calls sex workers sex workers. Sometimes it still refers to them as prostitutes, which many sex workers get angry about,' says Zi Teng. According to Adam, 'It depends on who uses the word. "Prostitute" doesn't carry the same negativity if it is used by a sex worker... The word "queer" has been reclaimed by the gay community. It used to be a weapon, but it's been used so much that it has been neutralised,' says Adam.

One reflection of public sentiment is that though Zi Teng is an established non-governmental organisation, the Hong Kong government doesn't recognise it as a charity. 'They think we help sex workers improve their lives, but we don't ask them to change their careers, which [the government] thinks encourages people to enter or stay in the profession.'

References

Zi Teng; Web: www.ziteng.org.hk

Yeeshan Yang, *Whispers and Moans*, 2007, Blacksmith Books

Cheng Po-hung, *Early Hong Kong Brothels*, 2003, Hong Kong University Press

Acknowledgements

Alan Sargent
Amy Lam
Annie Tai
Catherine Tai
Mariam Moore

COMMUNITY:
MULTICULTURAL KALEIDOSCOPE
Asylum seekers, Refugees and Convention
Against Torture claimants
Business owners and employees, residents,
tourists, and business travellers of Chungking
Mansions
Dennis Cheung
Owners' Corporation of Chung King
Mansions
Professor Gordon Mathews
Yau Tsim Mong District Council

NUN'S THE WORD
Albert Cheung
Chi Lin Nunnery
Gordon Li

Howard Ling
Jordan Choy
Leisure and Cultural Services Department
Nan Lian Garden
Wong Tai Sin District Council
Yuen Yuen Institute

LITTLE BANGKOK
Banart
Ben Ho Man-fung
Bert Bulthuis
Centaline
Dr Thomas Wong
HK-Thailand Business Association
Kowloon City District Council
Royal Thai Consulate-General in Hong Kong
Somchit Chimvimol
Tamasorn Bungon
Thai Association
Thai Regional Alliance
Usa Sriubol and Charles Grossreider

CONSUMERISM:
A PLACE TO GO
Champion REIT
Dr Ben Yiu

Great Eagle Group
Jenny Leung
John Herbert
Langham Place
Langham Place Hotel
MORI
Tony Chi
Urban Renewal Authority
Yau Tsim Mong District Council

TRADING PLACES
Kwun Tong District Council
Manfred Yuen
Millennium City
MTRC
Professor Leung
Shui Wo Street market stall keepers
Sun Hung Kai Properties

SIN NO MORE
Antiquities & Monuments Office
Apple Daily
Chinese Temples Committee
Gordon Li
Sik Sik Yuen
South China Morning Post
The Standard
Wong Tai Sin District Council
Wong Tai Sin Temple

ART:
FOR ART'S SAKE
Alec Cham

Centaline
Education Bureau
Eugene Tan
Hong Kong Institute of Architects
Kwun Tong District Council
Osage Foundation & Gallery Group
Task force on Economic Challenges

ARTFUL DODGER
Annie Tai
Antiquities & Monuments Office
Chau Chi-ho
Eddie Lui Fung-ngar
Home Affairs Bureau
Hong Kong Baptist University
Hong Kong Jockey Club Charities Trust
Jockey Club Creative Arts Centre and tenants
New World Develoment
Sham Shui Po District Council
Urban Renewal Authority
Wylie So

TO BE OR NOT TO BE
Bonnie Engel
Cheung Kong Holdings
Cyberport
Hong Kong government
Justina Yung
Louis Yu Kwok-lit
Manfred Yuen
Martin Fung
Office for Metropolitan Architecture
Public Policy Research Institute

ROCCO Design Architects Ltd
Sun Hung Kai Properties
Thomas Chan Man-hung
West Kowloon Cultural District Authority
Yau Tsim Mong District Council

FOOD:
A MARKET RUNS THROUGH IT
Cheng Po-hung
Hing Hee
Woosung Street Temporary Cooked Food
Hawker Bazaar
Hing Hee
Josephine Smart
Mak Kit-yee
Perz Wong
The Mido
Winson Kwan
Yau Tsim Mong District Council
Yuen Kee Dessert House

SOUL FOOD
Café de Coral
Chan
Dong Kee
Fairwood
Francis Lo
Hong Kong Chefs' Association
Howard Ling
Hup Hing
Jordan Choy
Kwun Tong District Council
Kwun Tong locals

Mag Ma
Maxim's
Ming Kee
Nissin
Sham Shui Po District Council
Wai Kee
World Instant Noodle Association
Young Chef's Association

CHOWING DOWN
Manager Chan
Charles Kwan Wing-kei
Cheng Po-hung
Chiu Chow Association
Chiu Chow Hop Shing Dessert
Chong Fat Chiu Chow
Conservancy Association Centre for Heritage
Kowloon City District Council
Kowloon City Municipal Services Building
Kwai Yu Woo Kee Chiu Chow Bakery
Lok Hau Fuk
Nga Tsin Wai Road groceries
Rocky Yeung

FASHION & SEX:
HANGING BY A THREAD
Bukky Aki Fashion
Centaline
Felix Chung
Gail Taylor
Hong Kong Apparel Society
Institute of Textiles & Clothing
Junie Lam

Mr Lam
Sham Shui Po District Council
The Hong Kong Polytechnic University
Michael Li
Sun Hoi Garment International Ltd

STRIKING A POSE
Anita Mui website
China Business Centre
China Daily
Gail Taylor
Institute of Textiles & Clothing
Jennifer Lo
Lau Fong
Professor Ken Gelder
The Hong Kong Polytechnic University
Trendy Zone shopping centre
Yau Tsim Mong District Council

BODY OF EVIDENCE
Adam
Census & Statistics Department
Cheng Po-hung
Cherry
Crimes Ordinance
The Family Planning Association
Hong Kong Christian Service
Midnight Blue
Shan
The Hong Kong Basic Law
Yang Yee-shan
Yeung Chun-ting
Zi Teng

Picture captions